THE PORTABLE
PICASSO

Introduction by *Robert Hughes*

UNIVERSE

The idea of Cubism began in 1907, in a warren of cheap artists' studios known as the "Bateau-Lavoir" or "Laundry Boat," at 13 Rue Ravignan in Paris. It was touched off by a Spaniard, Pablo Picasso, then aged twenty-six. His partner in inventing Cubism was a younger and rather more conservative Frenchman, Georges Braque, the son of a housepainter in Normandy. Picasso already had a small reputation, based on the wistful, etiolated nudes, circus folk, and beggars he had been painting up to 1905—the so-called Blue and Rose periods of his work. But he was so little known, and Braque so wholly unknown, that in the public eye neither artist existed. The audience for their work might have been a dozen people: other painters, mistresses, an obscure young German dealer named Daniel-Henry Kahnweiler, and one another. This might seem like a crushing isolation, but it meant that they were free, as researchers in some very obscure area of science are free. Nobody cared enough to interfere. Their work had no role as public speech, and so there was no public pressure on it to conform. This was fortunate, since they were engaged in a project which would presently seem, from the point of view of normal description, quite crazy. Picasso and Braque wanted to represent the fact that our knowledge of an object is made up of all possible views of it: top, sides, front, back. They wanted to compress this inspection, which takes time, into one moment—one synthesized view. They aimed to render that sense of multiplicity, which had been the subtext of Cézanne's late work, as the governing element of reality.

One of their experimental materials was the art of other cultures. With their appropriation of forms and motifs from African

art, Picasso and then Braque brought to its climax a long interest which nineteenth-century France had shown in the exotic, the distant, and the primitive. The French colonial empire in Morocco had given the exotic images of Berber and souk, dancing girl and war camel, lion hunt and Riff warrior to the imagery of Romanticism, through Delacroix and his fellow Romantics. By 1900, technology in the form of the gunboat and the trading steamer had created another French empire in equatorial Africa, whose cultural artifacts were ritual carvings, to which the French assigned no importance whatsoever as art. They thought of them as curiosities, and as such they were an insignificant part of the flood of raw material that France was siphoning from Africa. Picasso thought they did matter—but as raw material. Both he and Braque owned African carvings, but they had no anthropological interest in them at all. They didn't care about their ritual uses, they knew nothing about their original tribal meanings (which assigned art a very different function to any use it could have in Paris), or about the societies from which the masks came. Probably (although the art historian piously hopes it was otherwise) their idea of African tribal societies was not far from the one most Frenchmen had—jungle drums, bones in the noses, missionary stew. In this respect, Cubism was like a dainty parody of the imperial model. The African carvings were an exploitable resource, like copper or palm oil, and Picasso's use of them was a kind of cultural plunder.

When he began to parody black art, he was stating what no eighteenth-century artist would ever have imagined suggesting: that the tradition of the human figure, which had been the very spine of Western art for two and a half millennia, had at last run out; and that in order to renew its vitality, one had to look to untapped cultural resources—the Africans, remote in their otherness. But if one compares a work like Picasso's *Les Demoiselles d'Avignon*, 1907 (pp. 104–5), with its African source material, the differences are as striking as the similarities. What Picasso cared about was the formal vitality of African art, which was for him in-

separably involved with its apparent freedom to distort. That the alterations of the human face and body represented by such figures were not Expressionist distortions, but conventional forms, was perhaps less clear (or at least less interesting) to him than to us. They seemed violent, and they offered themselves as a receptacle for his own panache. So the work of Picasso's so-called "Negro Period" has none of the aloofness, the reserved containment, of its African prototype; its lashing rhythms remind us that Picasso looked to his masks as emblems of savagery, of violence transferred into the sphere of culture.

With its hacked contours, staring interrogatory eyes, and general feeling of instability, *Les Demoiselles* is still a disturbing painting after three quarters of a century, a refutation of the idea that the surprise of art, like the surprise of fashion, must necessarily wear off. No painting ever looked more convulsive. None signaled a faster change in the history of art. Yet it was anchored in tradition, and its attack on the eye would never have been so startling if its format had not been that of the classical nude; the three figures at the left are a distant but unmistakable echo of that favorite image of the late Renaissance, the *Three Graces*. Picasso began it the year Cézanne died, 1906, and its nearest ancestor seems to have been Cézanne's monumental composition of bathers displaying their blockish, angular bodies beneath arching trees. Its other line of descent is Picasso's Spanish heritage. The bodies of the two caryatidlike standing nudes, and to a lesser degree their neighbor on the right, twist like El Greco's figures. And the angular, harshly lit blue space between them closely resembles the drapery in El Greco's Dumbarton Oaks *Visitation*.

That Picasso could give empty space the same kind of distortion a sixteenth-century artist reserved for cloth with a body inside it points to the newness of *Les Demoiselles*. What is solid, and what void? What is opaque, and what transparent? The questions that perspective and modeling were meant to answer are precisely the ones Picasso begs, or rather shoves aside, in this remarkable painting. Instead of solids (nude and fruit) in front of a mem-

brane (the curtain) bathed in emptiness and light, Picasso conceived *Les Demoiselles* as though it were made of a continuous substance, a sort of plasma, thick and intrusive. If the painting has any air in it at all, it comes from the colors—the pinks and blues that survive from the wistful *misérabilisme* of his earlier work, lending *Les Demoiselles* a peculiarly ironic air: whatever else these five women may be, they are not victims or clowns.

They were, as every art student knows, whores. Picasso did not name the painting himself, and he never liked its final title. He wanted to call it "The Avignon Brothel," after a whorehouse on the Carrer d'Avinyó in Barcelona he had visited in his student days. The painting was originally meant to be an allegory of venereal disease, entitled "The Wages of Sin," and in one of the original studies for it, the narrative is quite clear: at the center, a sailor carousing in a brothel, and on the left, another man, a medical student, whom Picasso represented in other studies with a self-portrait, entering with a skull, that very Spanish reminder of mortality. *Vanitas vanitatum, omnia vanitas sunt.*

In the final painting, however, only the nudes are left. Their formal aspect was a favorite of 1890s' painting, memorably captured by Degas and Toulouse-Lautrec; it is the *parade*, the moment when the prostitutes of the house display themselves to the client and he picks one.

By leaving out the client, Picasso turns viewer into voyeur; the stares of the five girls are concentrated on whoever is looking at the painting. And by putting the viewer in the client's sofa, Picasso transmits, with overwhelming force, the sexual anxiety which is the real subject of *Les Demoiselles*. The gaze of the women is interrogatory, or indifferent, or as remote as stone (the three faces on the left were, in fact, derived from archaic Iberian stone heads that Picasso had seen in the Louvre). Nothing about their expressions could be construed as welcoming, let alone coquettish. They are more like judges than houris. And so *Les Demoiselles* announces one of the recurrent subthemes of Picasso's art: a fear, amounting to holy terror, of women. This fear was the psychic

reality behind the image of Picasso the walking scrotum, the inexhaustible old stud of the Côte d'Azur, that was so devoutly cultivated by the press and his court from 1945 on. No painter ever put his anxiety about impotence and castration more plainly than Picasso did in *Les Demoiselles,* or projected it through a more violent dislocation of form. Even the melon, that sweet and pulpy fruit, looks like a weapon.

* * *

Picasso's *Guernica,* 1937 (pp. 276–7) is the last of the line of formal images of battle and suffering that runs from Uccello's *Rout of San Romano* through Tintoretto to Rubens, and thence to Goya's *Third of May* and Delacroix's *Massacre at Chios.* It was inspired by an act of war, the bombing of a Basque town during the Spanish Civil War. The destruction of Guernica was carried out by German aircraft, manned by German pilots, at the request of the Spanish Nationalist commander, General Emilio Mola. Because the Republican government of Spain had granted autonomy to the Basques, Guernica was the capital city of an independent republic. Its razing was taken up by the world press, beginning with *The Times* in London, as the arch-symbol of Fascist barbarity. Thus Picasso's painting shared the exemplary fame of the event, becoming as well known a memorial of catastrophe as Tennyson's *Charge of the Light Brigade* had been eighty years before.

Guernica is the most powerful invective against violence in modern art, but it was not wholly inspired by the war: its motifs—the weeping woman, the horse, the bull—had been running through Picasso's work for years before *Guernica* brought them together. In the painting they become receptacles for extreme sensation—as John Berger has remarked, Picasso could imagine more suffering in a horse's head than Rubens normally put into a whole Crucifixion. The spike tongues, the rolling eyes, the frantic splayed toes and fingers, the necks arched in spasm: these would be unendurable if their tension were not braced against the

broken, but visible, order of the painting. It is like a battle sarcophagus, cracked and riven, but still just recognizable as a messenger from the ancient world—the world of ideal bodies and articulate muscular energy, working in a flat carved stone space. As a propaganda picture, *Guernica* did not need to be a specific political statement. The mass media supplied the agreement by which it became one, and Picasso knew exactly how and where to insert his painting into that context—through the Spanish pavilion at the Paris World Exhibition, where it was shown in 1937 as a virtually official utterance by the Republican government of Spain. Seen detached from its social context, if such a way of seeing were either possible or desirable (in Picasso's view it would not have been, but there are still formalists who disagree), it is a general meditation on suffering, and its symbols are archaic, not historical: the gored and speared horse (the Spanish Republic); the bull (Franco) towering over the bereaved, shrieking woman; the paraphernalia of pre-modernist images like the broken sword, the surviving flower, and the dove. Apart from the late Cubist style, the only specifically modern elements in *Guernica* are the Mithraic eye of the electric light, and the suggestion that the horse's body is made of parallel lines of newsprint, like the newspaper in Picasso's collages a quarter of a century before. Otherwise its heroic abstraction and monumentalized pain hardly seem to belong to the time of photography and Heinkel 51s. Yet they do: and Picasso's most effective way of locating them in that time was to paint *Guernica* entirely in black, white, and gray, so that despite its huge size it retains something of the grainy, ephemeral look one associates with the front page of a newspaper.

Guernica was the last great history painting. It was also the last modern painting of major importance that took its subject from politics with the intention of changing the way large numbers of people thought and felt about power.

* * *

Picasso liked strong and specific feelings. And the strongest junction of feelings, for him, was sex. Picasso never tried to hide what he felt about it, and no artist—not even Renoir or Rubens—has left such a vivid sexual autobiography behind him. There are tracts of his work where one can follow him almost day by day, through fits of lechery, hostility, yearning, castration fear, fantasies of dominance and impotence, self-mockery, tenderness, and cock-happiness; and his feelings for whichever woman he was with seldom failed to affect his work, when that work concerned the human figure. Part of Picasso's achievement was in creating the most vivid images of sexual pleasure in all modern art. They were provoked by his affair with a blond girl whom he picked up outside the Galeries Lafayette department store in Paris in 1927. Her name was Marie-Thérèse Walter; she was seventeen and he, at forty-six, was in the last bad years of marriage to a querulous and snobbish former ballerina named Olga Khokhlova. He went for this new girl (and she for him) with utter directness and intensity. There can sometimes be a point in the first few months of an affair when one's new lover fills the whole screen, and all physical sensations are modulated through, or have parallels in, the feeling of making love to her; she becomes an image of the world —"O my America, my New Found Land!", as Donne exclaimed. Go a little further and the absolute difference between one's own body and that of one's lover may seem, when making love, to falter and for a moment disappear. This was what Picasso, in some of his paintings of Marie-Thérèse Walter, was trying to find equivalents for. In the paintings her body is re-formed, not so much as a structure of flesh and bone but as a series of orifices, looped together by that sinuous line: tender, composed, swollen, moist, and abandoned (p. 254). The point is not that Picasso managed to will himself into the thoughts of this woman; he was interested in no such thing. Instead, he depicted his own state of arousal, projecting it on his lover's body like an image on a screen. Her body is re-composed in the shape of his desire, and the paintings that result describe a state of oceanic pleasure.

Throughout his career, Picasso's erotic instincts were always getting mixed in with his appetite for fantastic distortion and metamorphosis. The entire availability of his lover's body meant that it could be changed around. "To displace," he said later. "To put eyes between the legs, or sex organs on the face. To contradict.... Nature does many things the way I do, but she hides them! My painting is a series of cock-and-bull stories...."

It was at about this time that Picasso began to mythologize himself as the Mediterranean artist, with a series of etchings called the Vollard Suite (pp. 242–6). One aspect of this cycle is autobiographical or, at least, self-descriptive: the theme of the Sculptor and his Model, she the passive and obliging nymph, he the *genius loci*, reclining on a couch like a classical river-god (pp. 244–5). These prints were Picasso's invocation of the classical past which, as he imagined it, was still visible on the Mediterranean. They let him place himself in Arcadia. He was then a middle-aged man, just past fifty; and one need not doubt that he saw neither Arcadia nor his capacity to fill it stretching away forever. The Vollard Suite is saturated in nostalgia, which, like every other emotion in Picasso's work, is expressed with total candor. It was in fact the last major work of art, by Picasso or anyone else, to be directly inspired by Mediterranean antiquity: the end of an immense tradition that died amid the historical disjuncture, the irony, suffering, and physical ruin brought on by war and peace in the twentieth century.

—ROBERT HUGHES

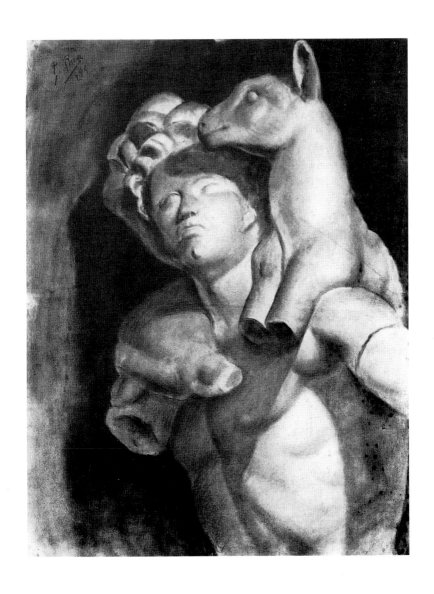

Academic Study · 1895–6
Museu Picasso, Barcelona

The Young Girl with Bare Feet · 1895
Musée Picasso, Paris

Science and Charity · 1895–6
Museu Picasso, Barcelona

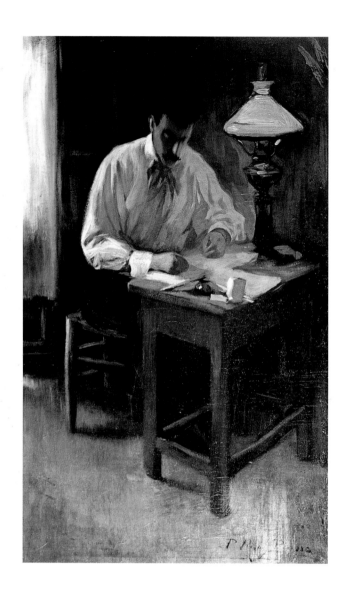

Portrait of Josep Cardona · 1899
Private collection

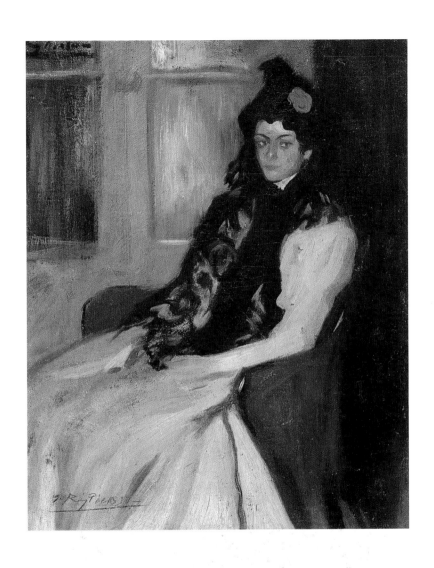

Lola, Picasso's Sister · 1899
The Cleveland Museum of Art

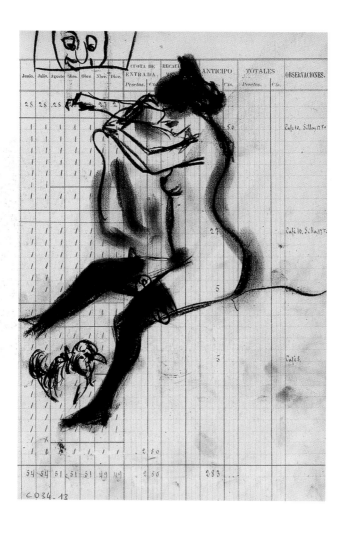

Barcelona Sketchbook, Woman in Black Stockings, Undressing · winter 1899–1900
Musée Picasso, Paris

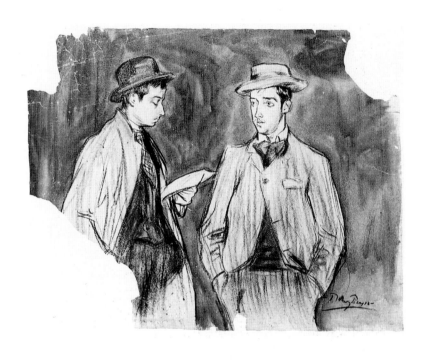

Reading the Letter · 1899–1900
Musée Picasso, Paris

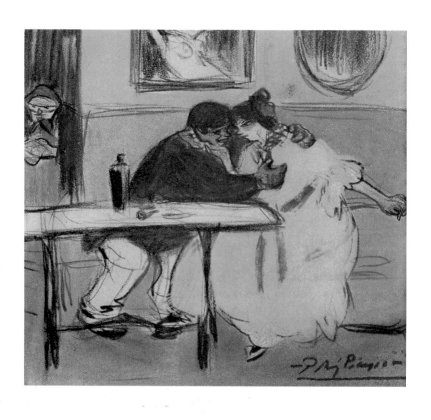

The Couch · 1899
Museu Picasso, Barcelona

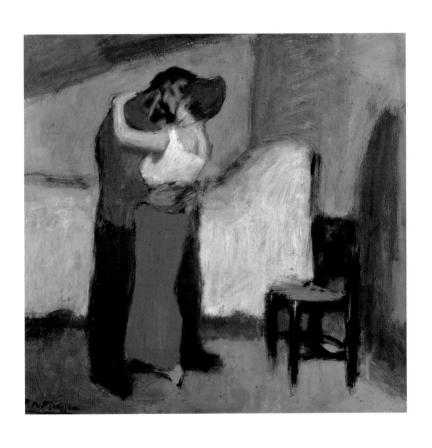

Embrace in an Attic · 1900

Pushkin Museum, Moscow

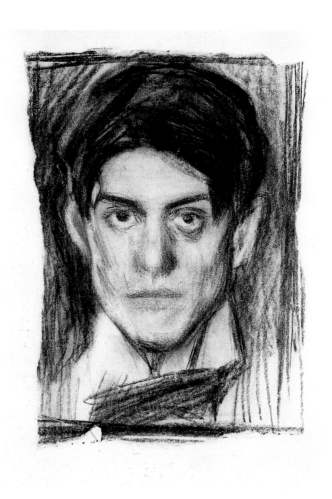

Self-Portrait · 1899–1900
Museu Picasso, Barcelona

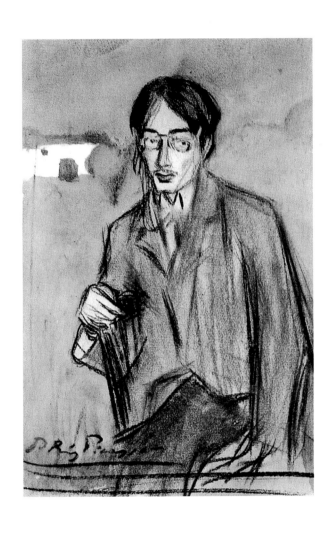

Jaime Sabartés Seated · 1900
Museu Picasso, Barcelona

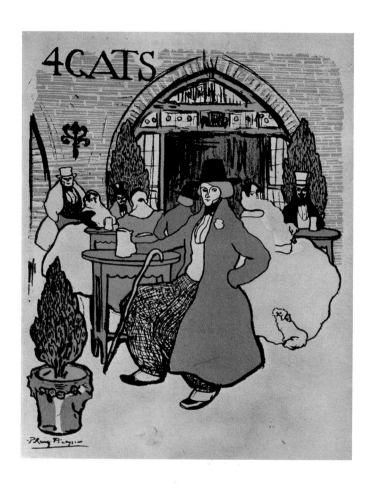

Menu for Els Quatre Gats · 1900
Private collection

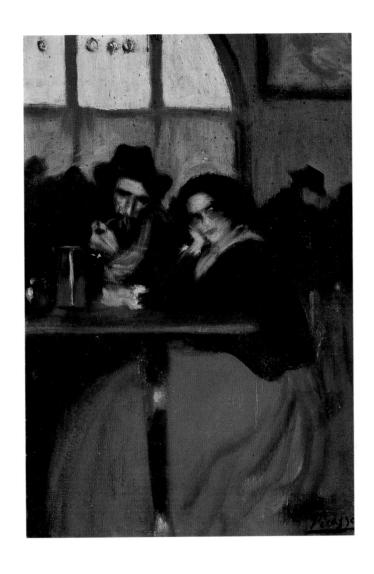

Interior of Els Quatre Gats · 1900
Private collection

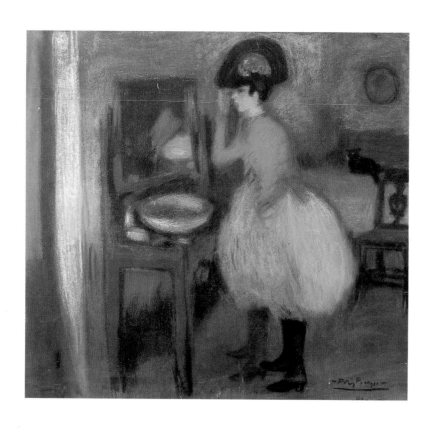

Girl at her Dressing Table · 1900
Museu Picasso, Barcelona

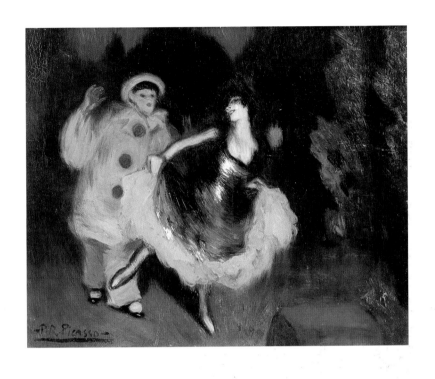

Pierrot and Columbine · autumn 1900
Private collection

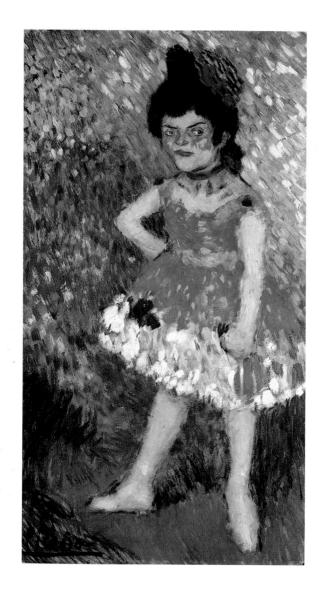

Dwarf Dancer (La Nana) · 1901
Museu Picasso, Barcelona

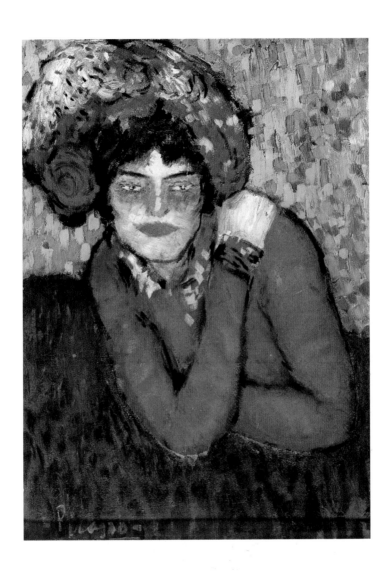

The Prostitute · 1901
Museu Picasso, Barcelona

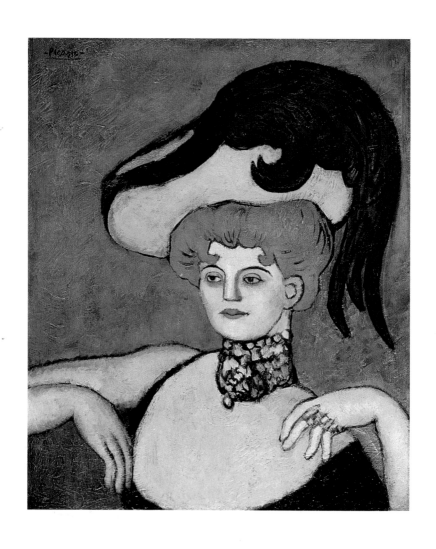

Courtesan with a Jeweled Necklace · 1901
Los Angeles County Museum of Art, Mr. and Mrs. George Gard de Sylva Collection

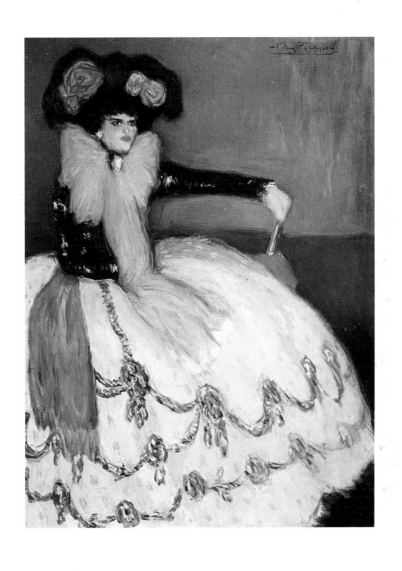

Woman in Blue · 1901
Museo Nacional Centro de Arte Reina Sofía, Madrid

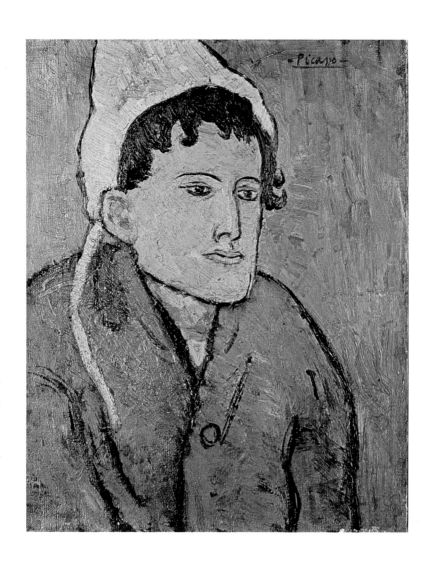

The Woman in a Bonnet · 1901
Museu Picasso, Barcelona

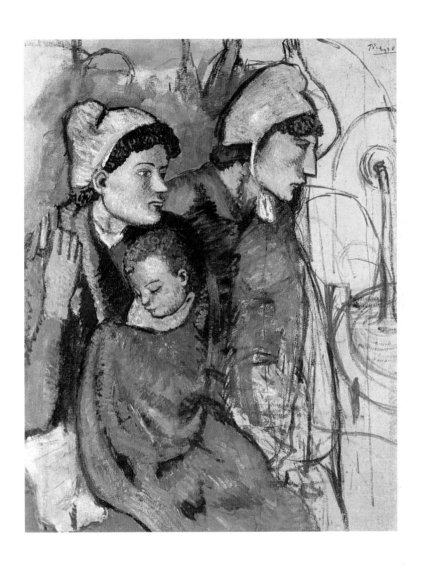

Women at the Well · 1901
Private collection

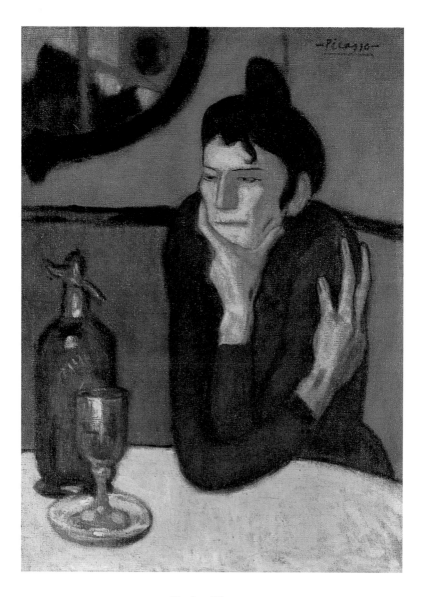

The Aperitif · 1901
State Hermitage Museum, Saint Petersburg

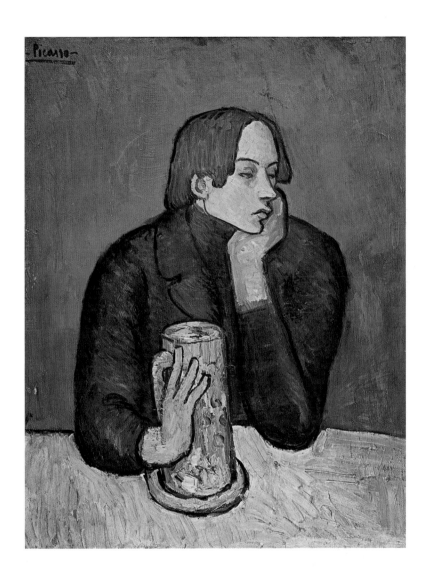

The Glass of Beer (Sabartés) · 1901
Pushkin Museum, Moscow

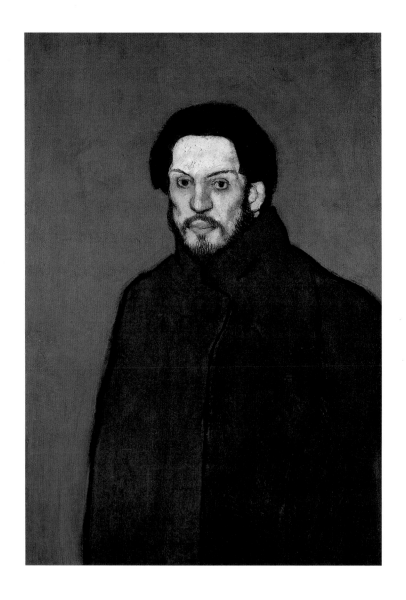

Self-Portrait · late 1901

Musée Picasso, Paris

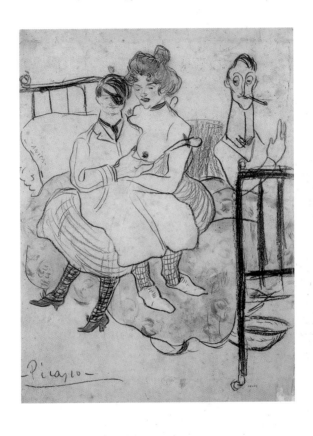

The Brothers Mateu and Ángel Fernández de Soto with Anita · 1902–3

Museu Picasso, Barcelona

Women in Striped Stockings · 1902
Private collection

Erotic Scenes · 1902
Musée Picasso, Paris

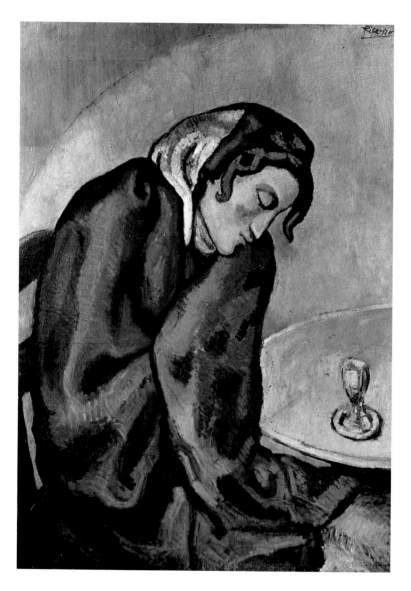

The Sleepy Drinker · 1902
Kunstmuseum, Berne

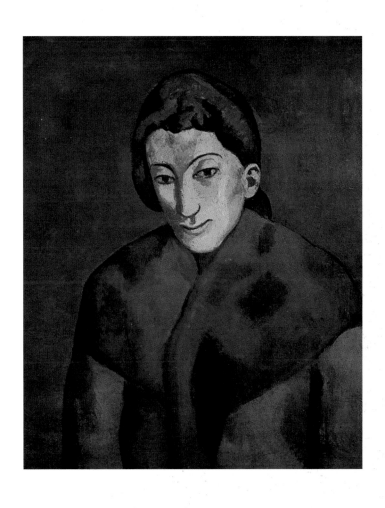

Woman with a Shawl · 1902
Private collection

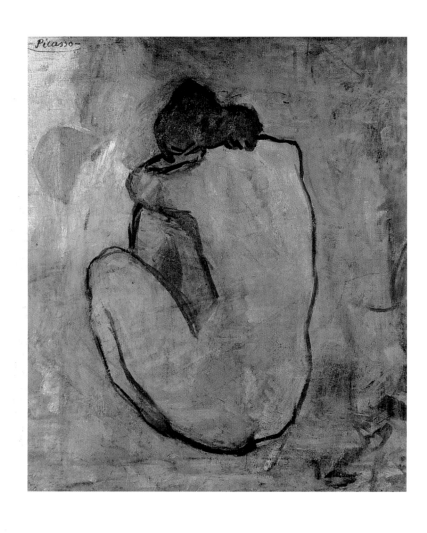

Seated Nude, Back View · 1902
Private collection

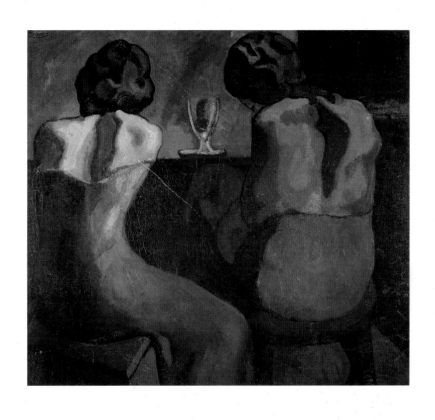

Prostitutes at a Bar · 1902
Hiroshima Museum of Art

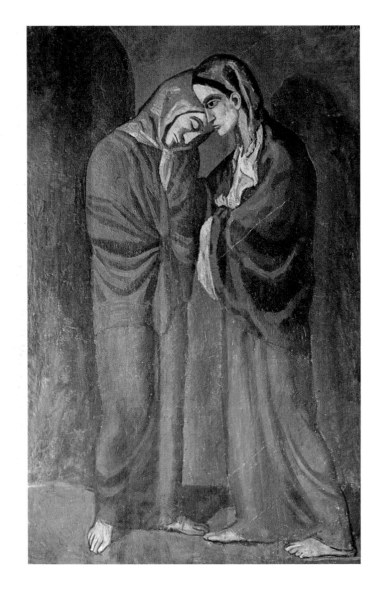

The Two Sisters (The Meeting) · 1902
State Hermitage Museum, Saint Petersburg

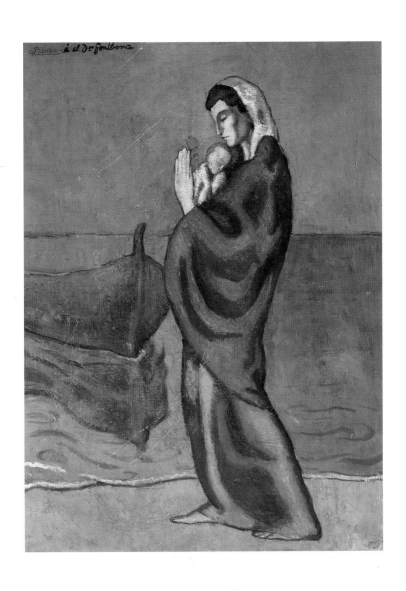

Maternity by the Sea · 1902

Private collection

Couple and Flowers · 1902–3
Museu Picasso, Barcelona
Woman at a Bidet · 1902–3
Museu Picasso, Barcelona

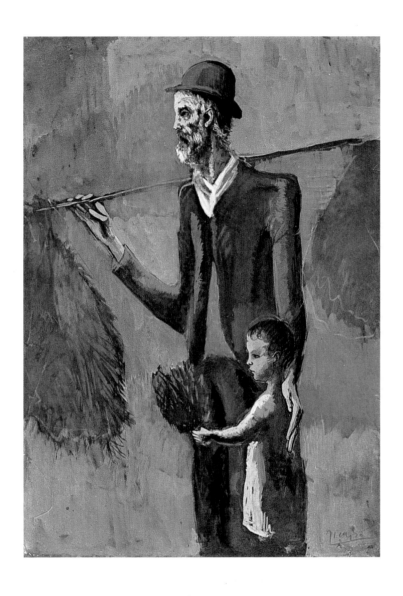

The Mistletoe Seller · 1902–3
Private collection

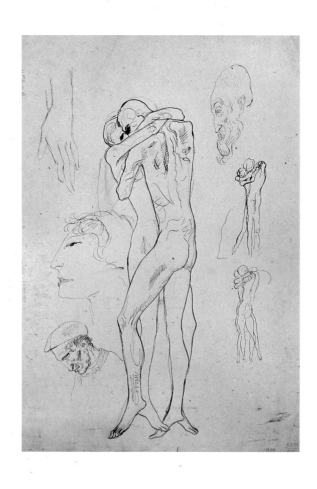

Studies of Couple Embracing and Heads · 1902–3
Marina Picasso Collection, courtesy Galerie Jan Krugier, Ditesheim & Cie, Geneva

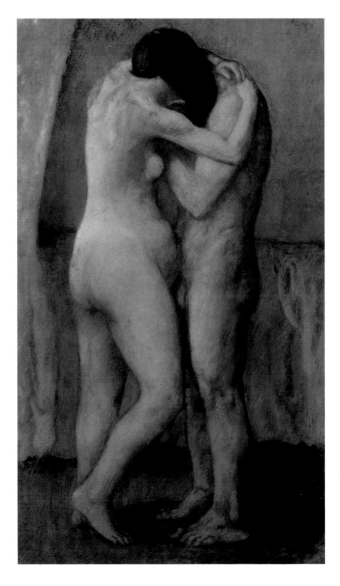

The Embrace · 1903
Musée de l'Orangerie, Paris, Collection of Jean Walter-Paul Guillaume

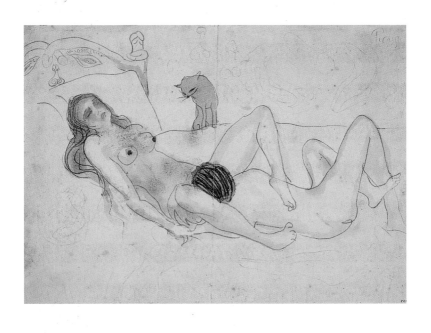

Two Figures and a Cat · 1902–3
Museu Picasso, Barcelona

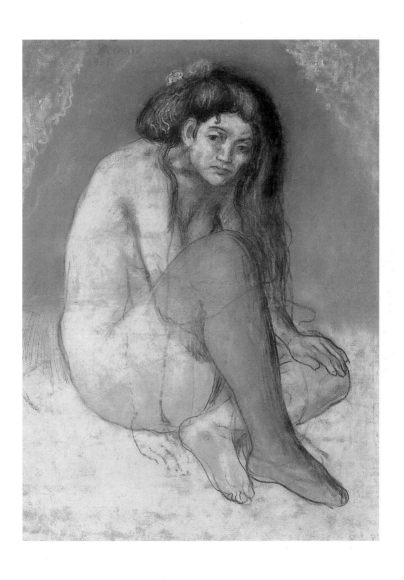

Nude with Crossed Legs · 1903
Fondation Socindec, Martigny

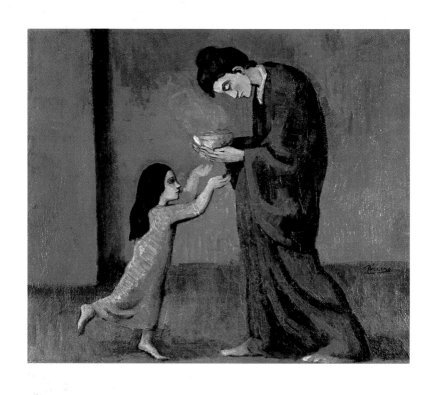

The Soup · 1903
The Art Gallery of Ontario, Toronto

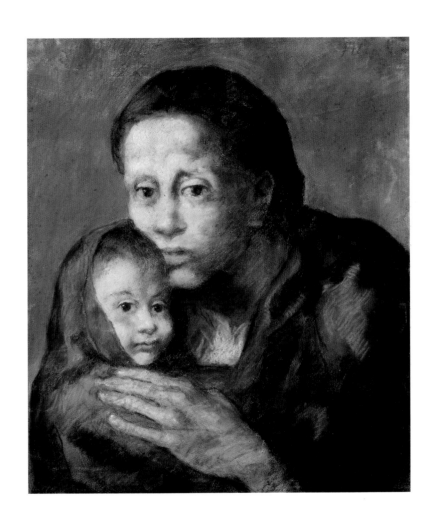

The Disinherited Ones · 1903
Museu Picasso, Barcelona

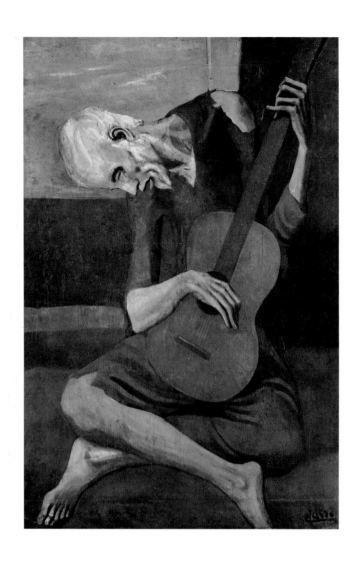

The Old Guitarist · 1903
The Art Institute of Chicago

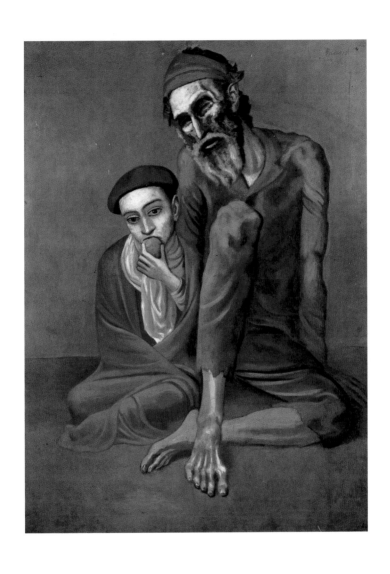

The Old Jew · 1903
Pushkin Museum, Moscow

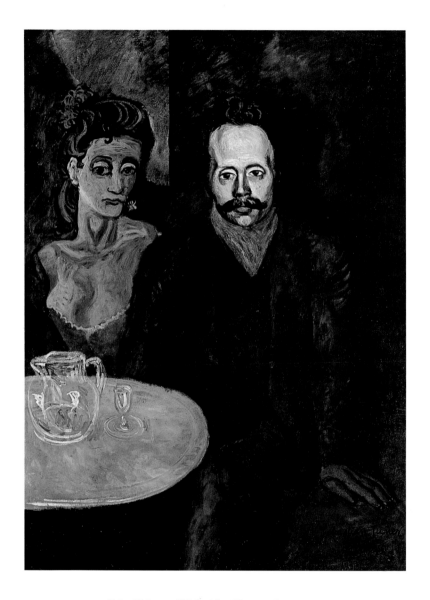

Sebastià Junyer Vidal with a Woman · June 1903
Los Angeles County Museum of Art

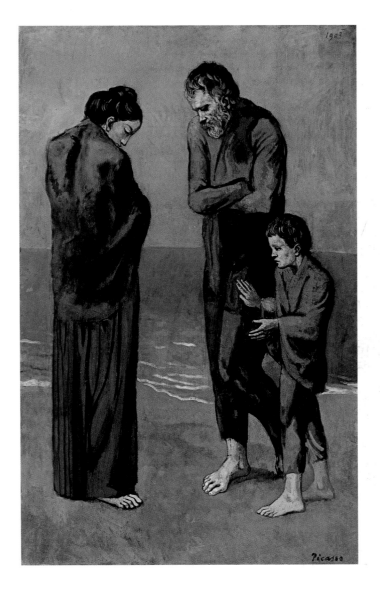

The Tragedy · 1903
The National Gallery of Art, Washington, DC, Chester Dale Collection

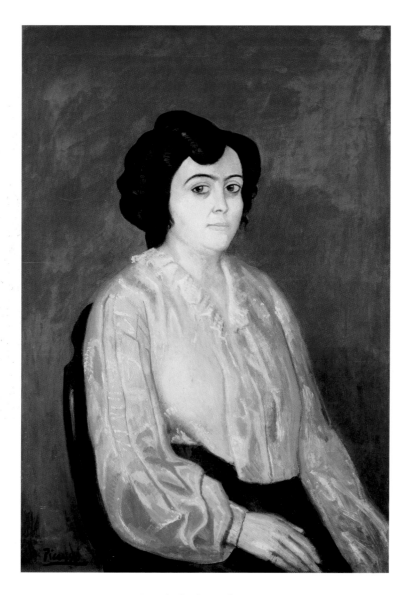

Portrait of Señora Soler · 1903
Staatsgalerie Moderner Kunst, Munich

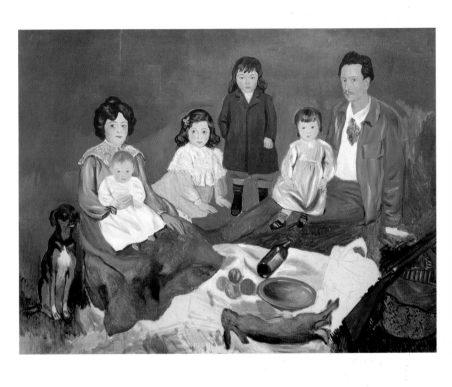

The Soler Family (Le Déjeuner sur l'Herbe) · summer 1903
Musée d'Art Moderne, Liège

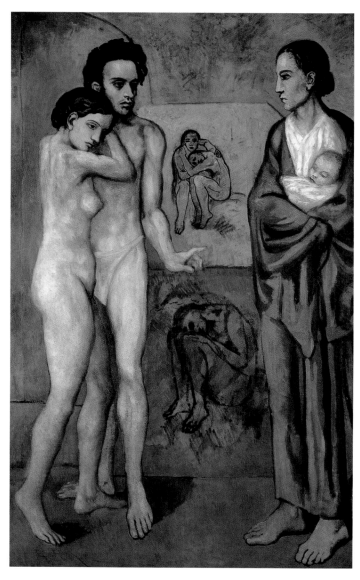

La Vie · May 1903
The Cleveland Museum of Art

The Madman · 1904
Museu Picasso, Barcelona

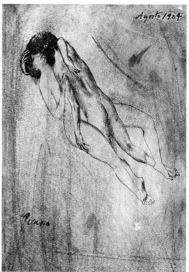

Sleeping Woman (Contemplation) · autumn 1904
Private collection
The Lovers · August 1904
Musée Picasso, Paris

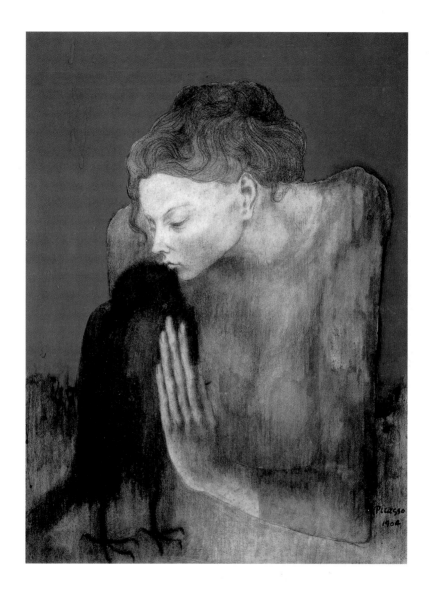

Woman with a Crow · 1904
Private collection

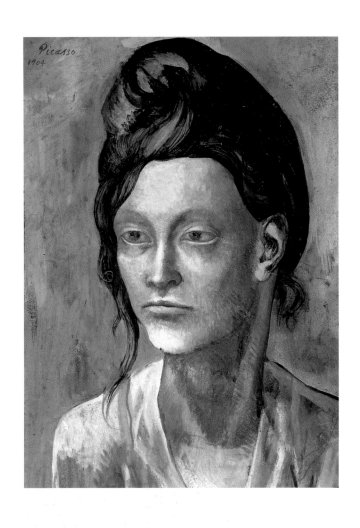

Woman with a Helmet of Hair · 1904
The Art Institute of Chicago, Gift of Kate L. Brewster

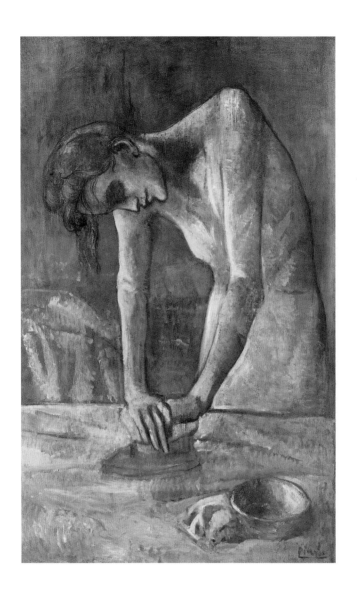

Woman Ironing · 1904
Solomon R. Guggenheim Museum, New York

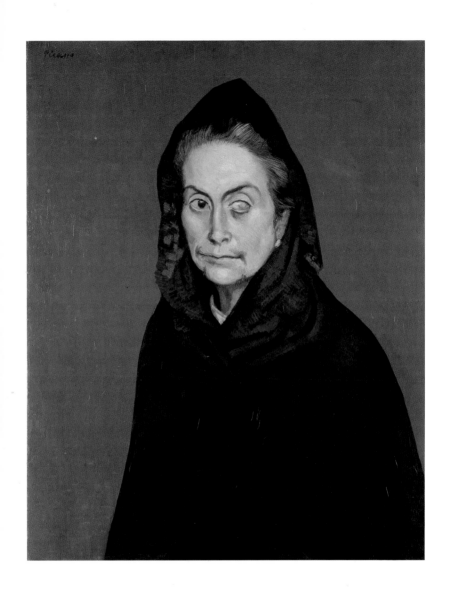

La Celestina · March 1904

Musée Picasso, Paris

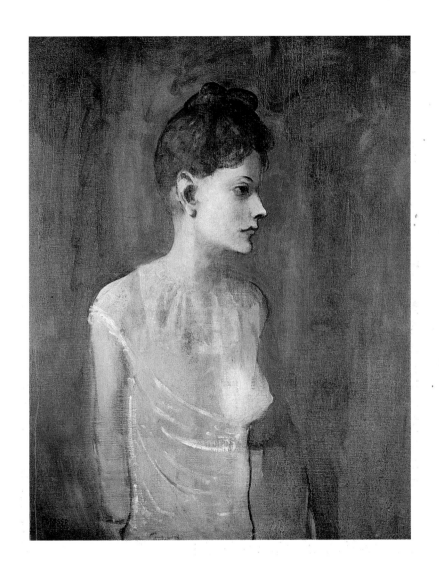

Woman in a Chemise · 1904
The Tate Gallery, London

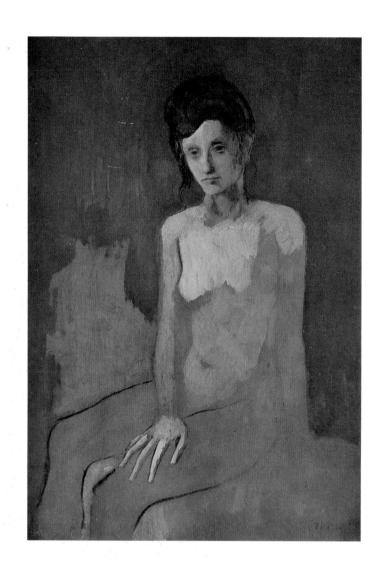

Seated Nude · 1905
Musée National d'Art Moderne, Centre Georges Pompidou, Paris

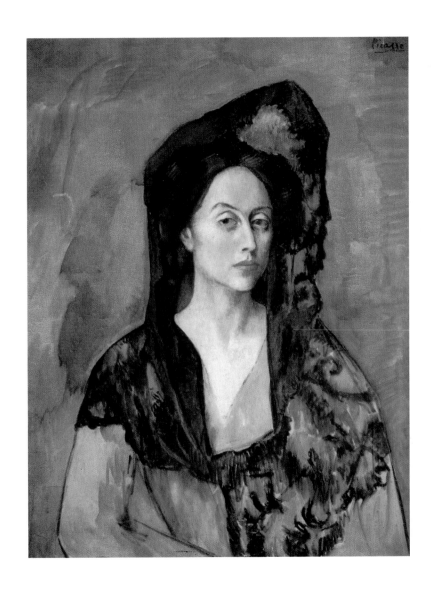

Portrait of Benedetta Canals · 1905
Museu Picasso, Barcelona

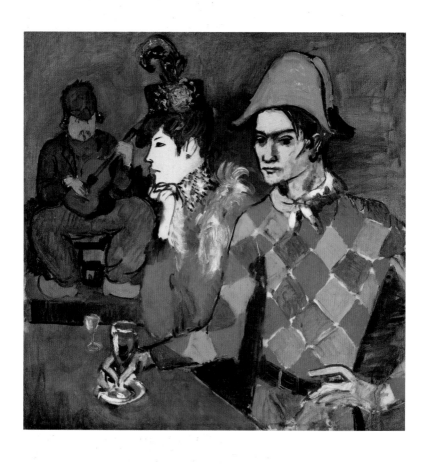

Au Lapin Agile · 1904–5
The Metropolitan Museum of Art, New York,
The Walter H. and Lenore Annenberg Collection

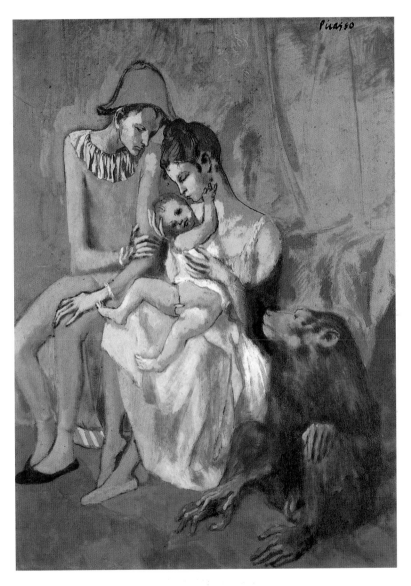

Family of Acrobats with a Monkey · 1905
Göteborgs Konstmuseum, Göteborg

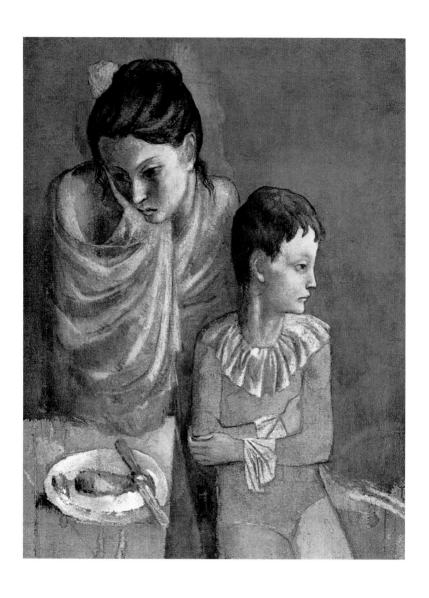

Unhappy Mother and Child · early 1905
Staatsgalerie, Stuttgart

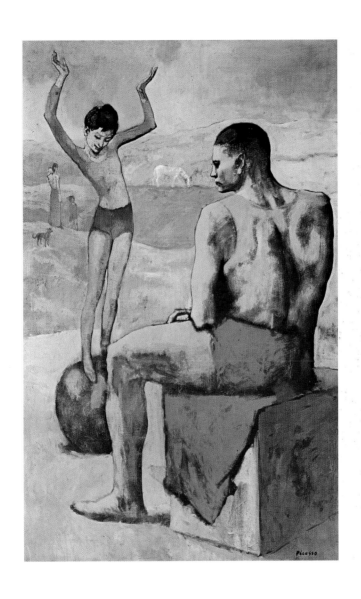

Acrobat on a Ball · 1905
Pushkin Museum, Moscow

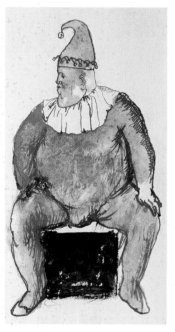 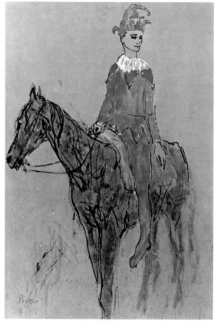

Fat Clown Seated · 1905
Marina Picasso Collection, Galerie Jan Krugier, Ditesheim & Cie, Geneva
Clown on a Horse · 1905
Private collection

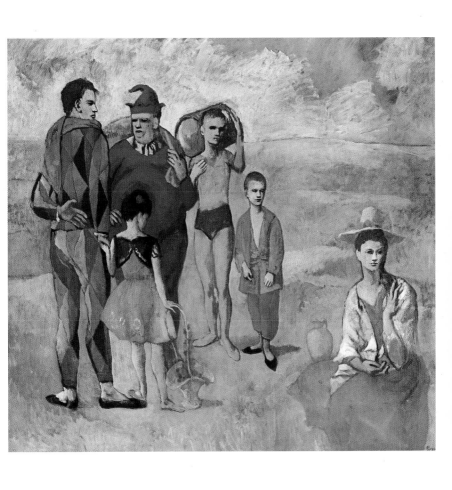

The Saltimbanques · 1905
The National Gallery of Art, Washington, DC, Chester Dale Collection

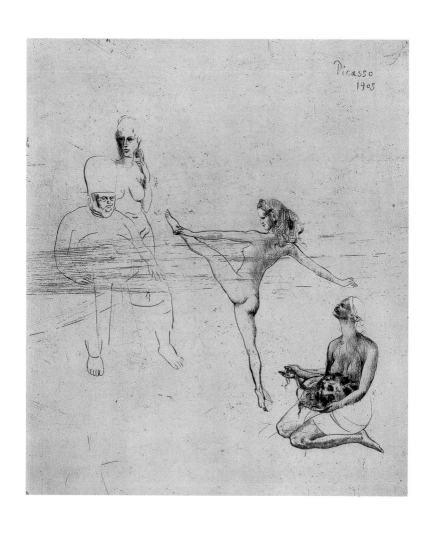

Salome · 1905
Musée Picasso, Paris

76

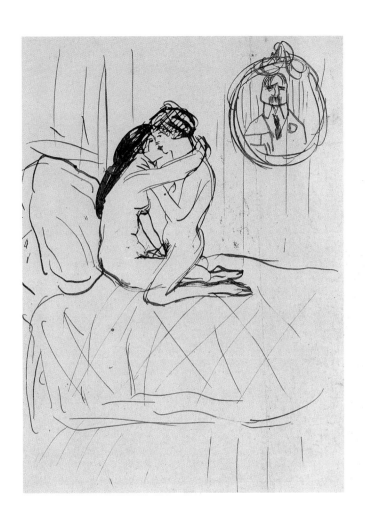

Two Women on a Bed · 1905
Private collection

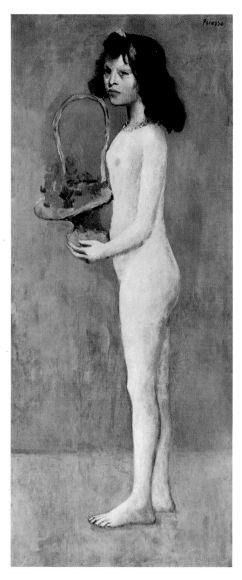

Girl with a Basket of Flowers (Flower of the Streets) · 1905
Private collection

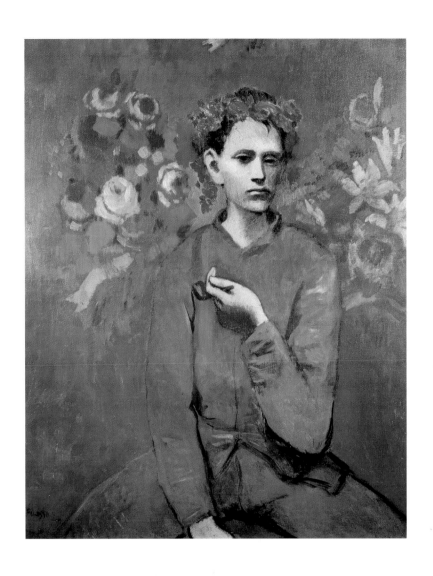

Boy with a Pipe · 1905
Mrs. John Hay Whitney Collection

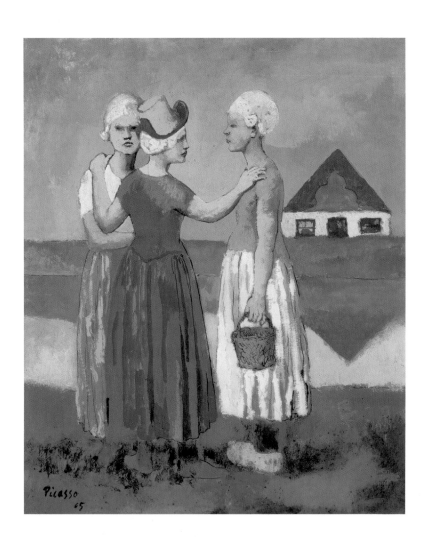

Three Dutch Girls · summer 1905
Musée National d'Art Moderne, Centre Georges Pompidou, Paris

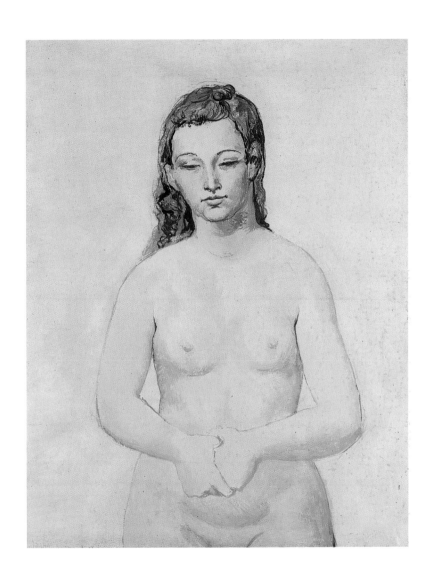

Nude with Crossed Hands · summer 1906
The Art Gallery of Ontario, Toronto, Gift of Sam and Ayala Zacks

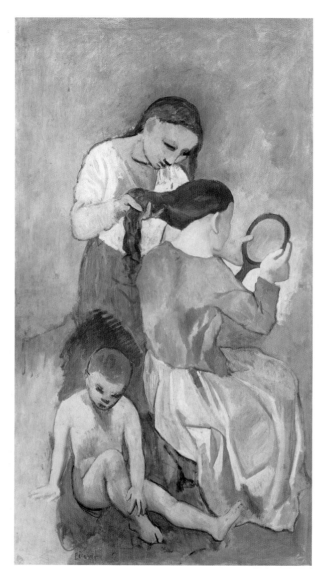

La Coiffure · spring 1906
The Metropolitan Museum of Art, New York, Catherine Lorillard Wolfe Collection

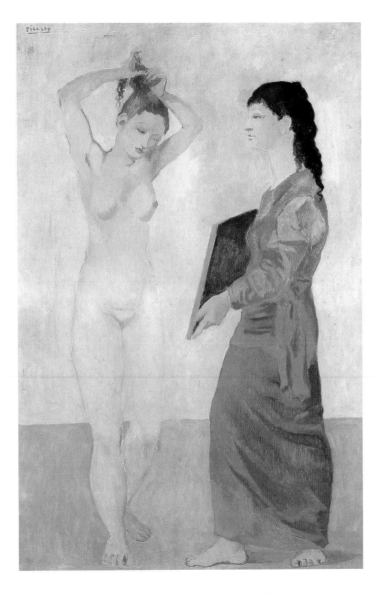

La Toilette · spring–summer 1906
Albright-Knox Art Gallery, Buffalo

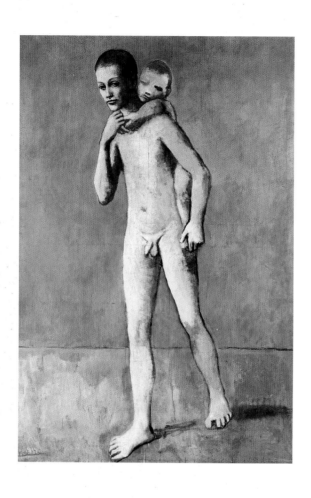

The Two Brothers · spring–summer 1906
Kunstmuseum, Basel

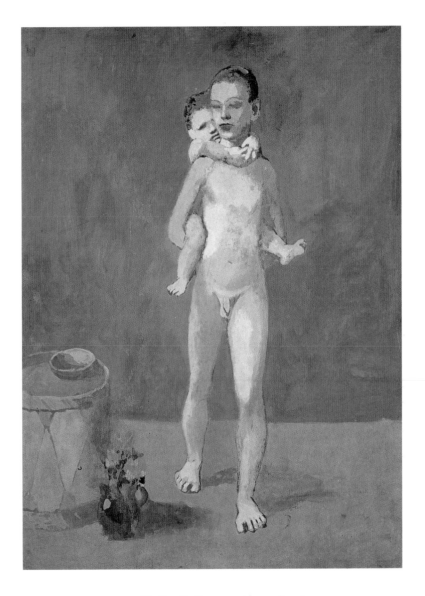

The Two Brothers · spring 1906
Musée Picasso, Paris

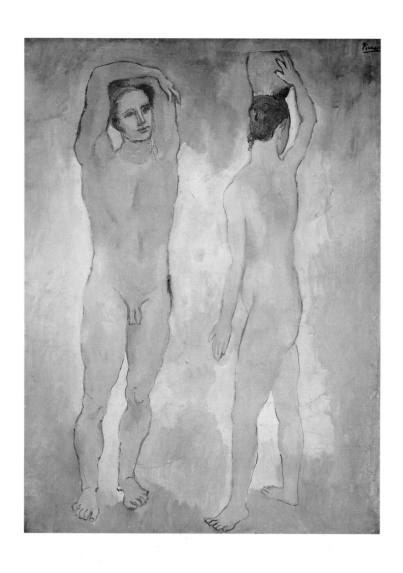

Two Youths · spring–summer 1906

Musée de l'Orangerie, Paris, Collection of Jean Walter-Paul Guillaume

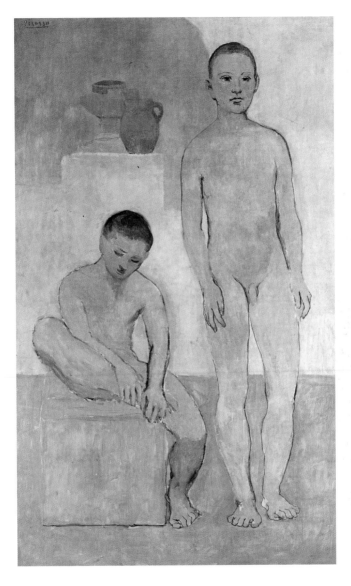

Two Youths · spring–summer 1906
The National Gallery of Art, Washington, DC, Chester Dale Collection

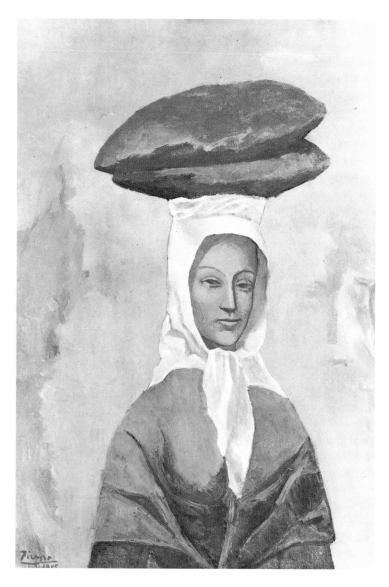

Woman with Loaves · spring–summer 1906
The Philadelphia Museum of Art

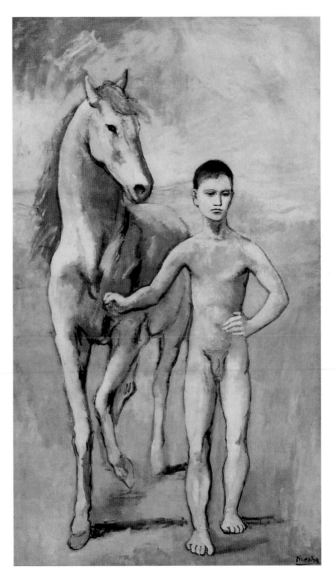

Boy Leading a Horse · 1906
The Museum of Modern Art, New York, William S. Paley Collection

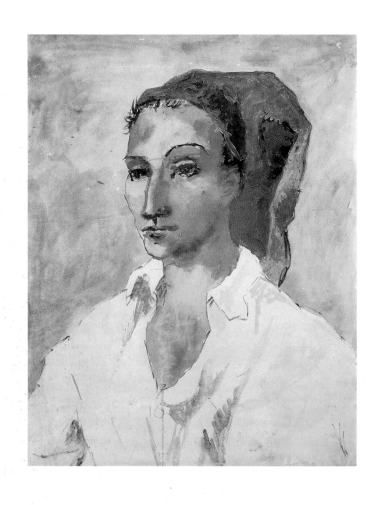

Young Gosolan Wearing a Barretina Hat · spring–summer 1906
Göteborgs Konstmuseum, Göteborg

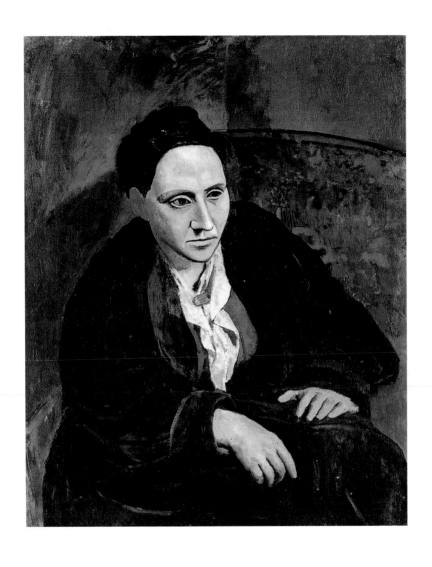

Portrait of Gertrude Stein · spring–summer 1906
The Metropolitan Museum of Art, New York

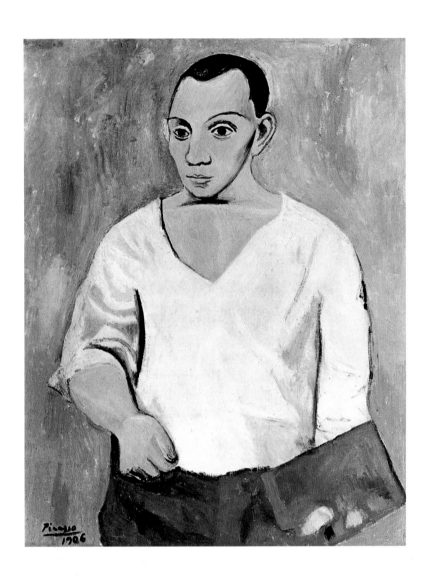

Self-Portrait with Palette · spring–summer 1906
The Philadelphia Museum of Art, E. A. Gallatin Collection

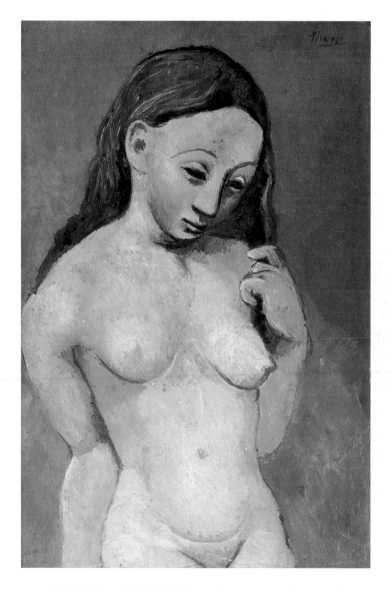

Female Nude against a Red Background · summer–autumn 1906
Musée de l'Orangerie, Paris, Collection of Jean Walter-Paul Guillaume

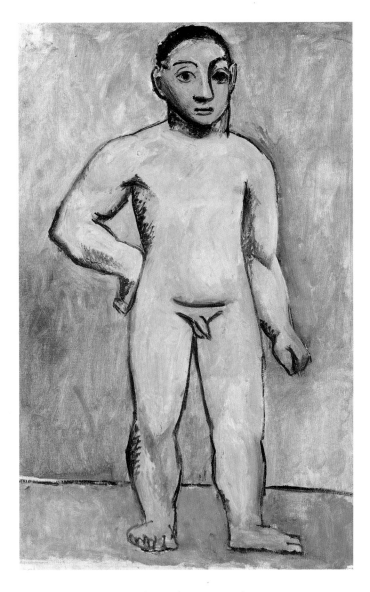

Nude Boy · autumn 1906
Musée Picasso, Paris

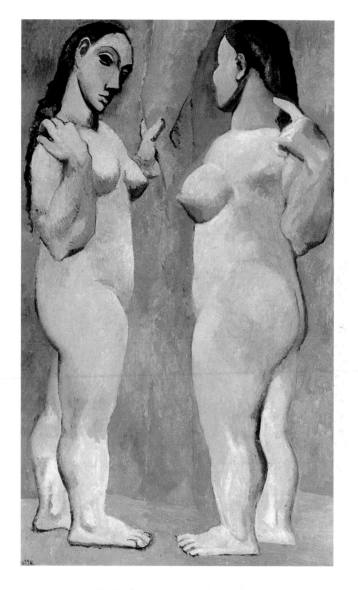

Two Nudes · autumn–winter 1906
The Museum of Modern Art, New York

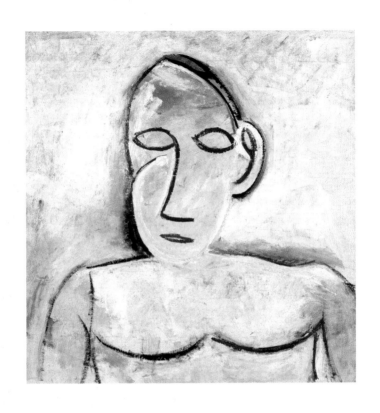

Bust · spring 1907
Musée Picasso, Paris

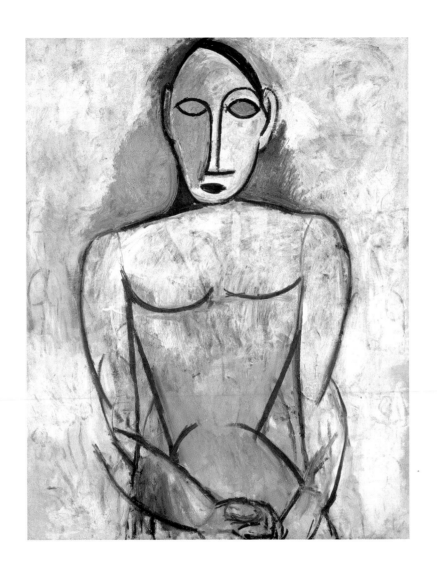

Bust of a Woman with Clasped Hands · spring 1907
Musée Picasso, Paris

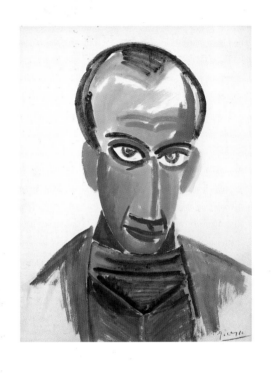

Portrait of Max Jacob · winter 1907
Museum Ludwig, Cologne, Ludwig Collection

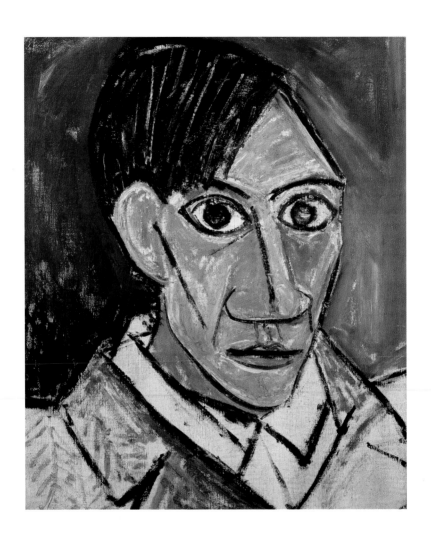

Self-Portrait · spring 1907
Národní Galerie, Prague

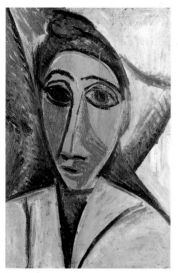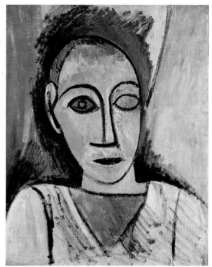

Head of a Woman or a Sailor · spring 1907
Musée Picasso, Paris
Bust of a Man · spring 1907
Musée Picasso, Paris

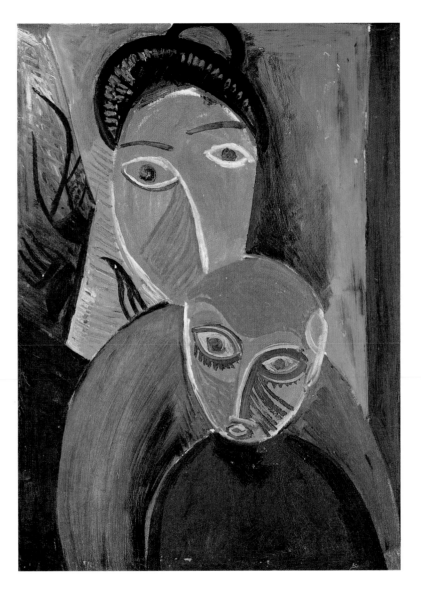

Mother and Child · summer 1907
Musée Picasso, Paris

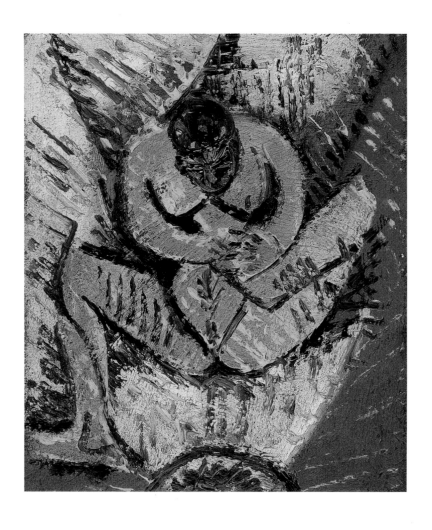

Small Seated Nude · summer 1907
Musée Picasso, Paris

Odalisque, after Ingres · summer 1907
Musée Picasso, Paris

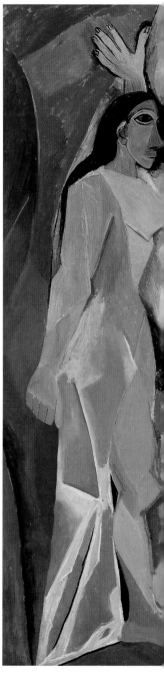

Study for "Les Demoiselles d'Avignon" · May 1907
Kunstmuseum, Basel
Les Demoiselles d'Avignon · June–July 1907
The Museum of Modern Art, New York

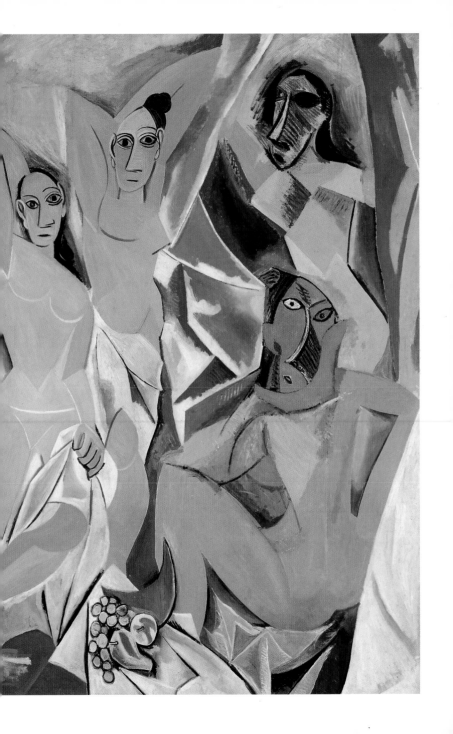

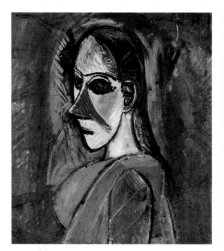 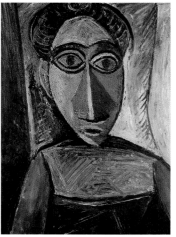

Bust of a "Demoiselle d'Avignon" · summer 1907
Musée National d'Art Moderne, Centre Georges Pompidou, Paris
Head of a Woman · spring–summer 1907
Národní Galerie, Prague

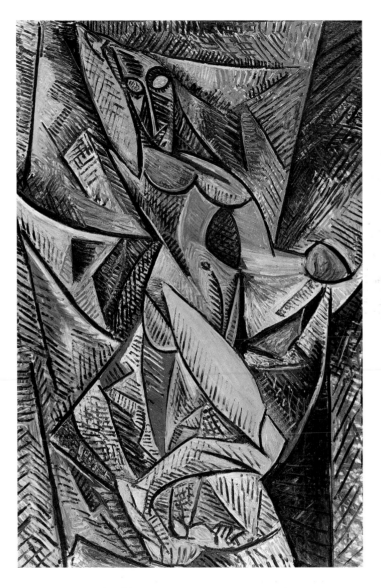

Nude with Drapery · summer–autumn 1907
State Hermitage Museum, Saint Petersburg

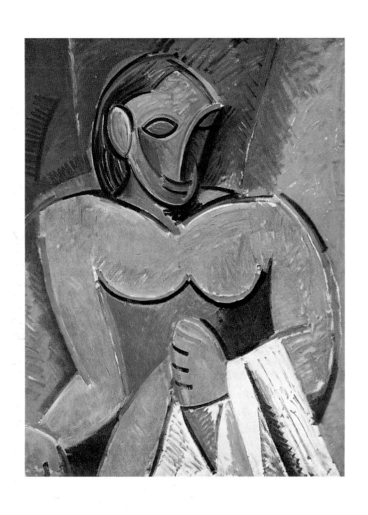

Nude with a Towel · winter 1907–8
Private collection

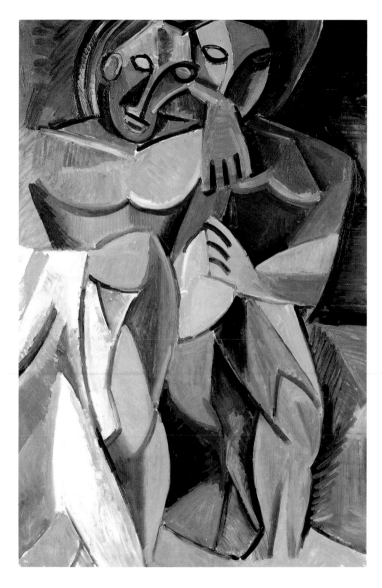

Friendship · 1907–8
State Hermitage Museum, Saint Petersburg

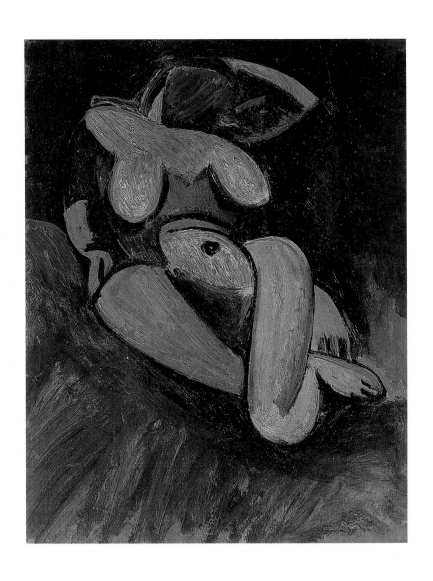

Reclining Nude · spring 1908
Musée Picasso, Paris

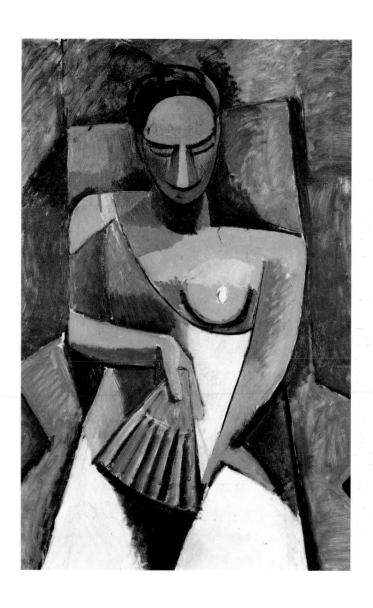

Woman with a Fan · late spring 1908
State Hermitage Museum, Saint Petersburg

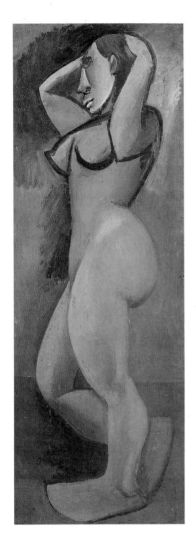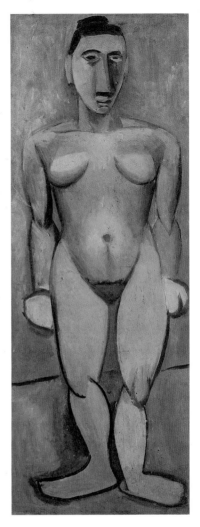

Nude with Raised Arms, Profile View · spring 1908
Private collection
Standing Nude, Front View · spring 1908
Private collection

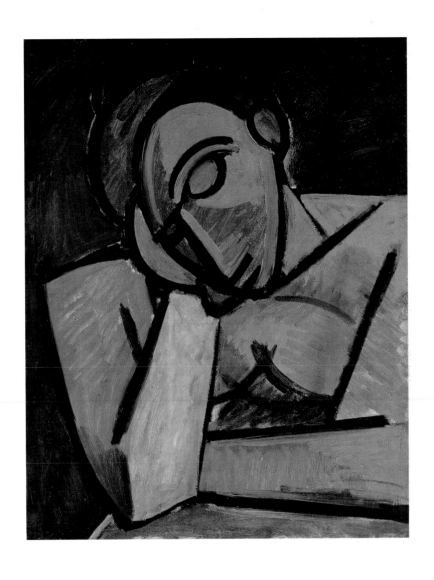

Torso of Sleeping Woman (Repose) · spring–summer 1908
The Museum of Modern Art, New York

Landscape with Two Figures · autumn 1908
Musée Picasso, Paris

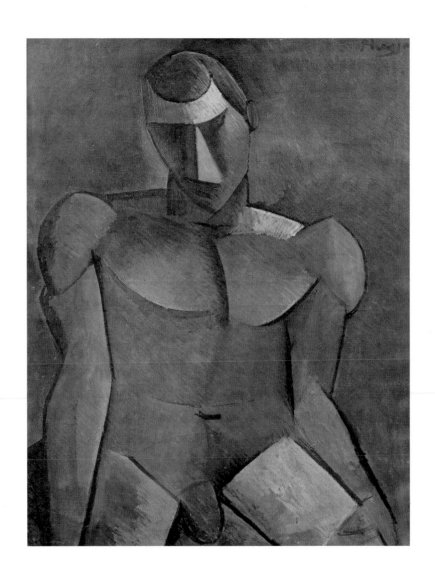

Seated Male Nude · winter 1908–9
Musée d'Art Moderne, Villeneuve-d'Ascq

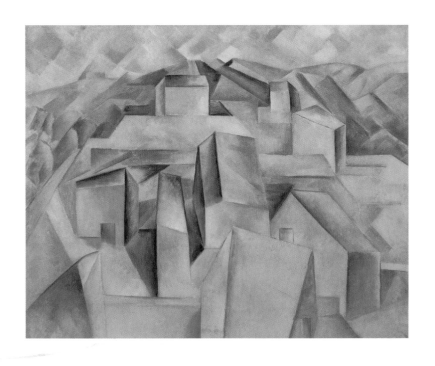

Houses on the Hill, Horta de Ebro · summer 1909
The Museum of Modern Art, New York

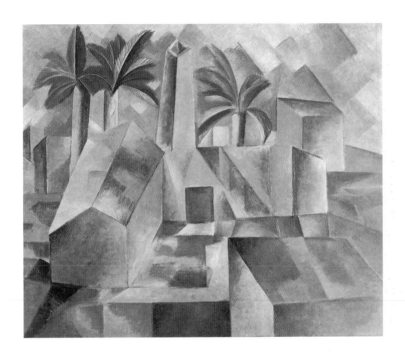

The Factory · summer 1909
State Hermitage Museum, Saint Petersburg

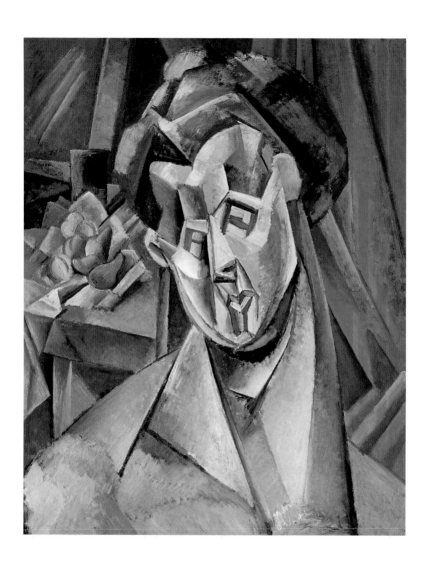

Bust of a Woman in front of a Still Life · summer 1909
Private collection

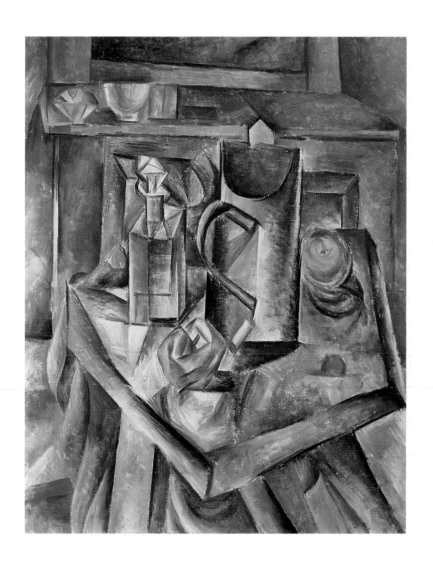

Beer · winter 1909–10
Musée d'Art Moderne, Villeneuve-d'Ascq

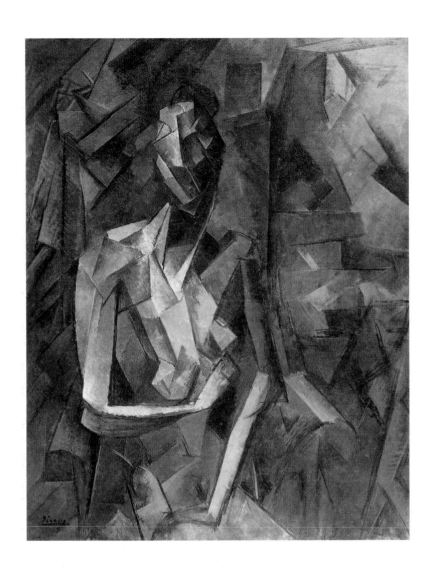

Seated Nude · winter 1909–10
The Tate Gallery, London

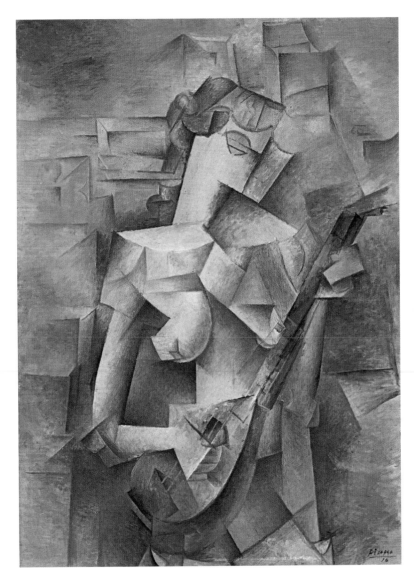

Girl with a Mandolin (Fanny Tellier) · spring 1910
The Museum of Modern Art, New York

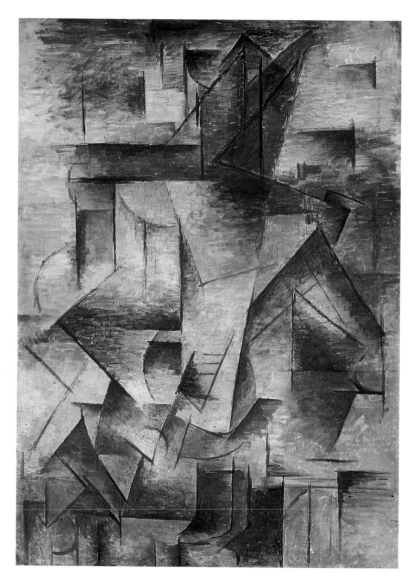

The Guitarist · summer 1910

Musée National d'Art Moderne, Centre Georges Pompidou, Paris

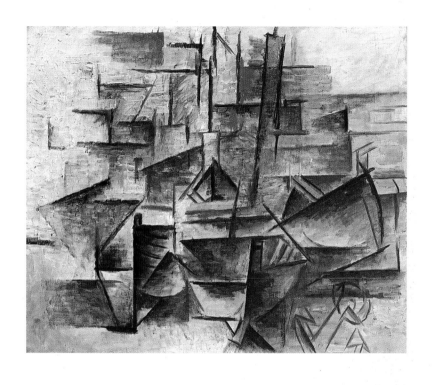

The Port of Cadaqués · summer 1910

Národní Galerie, Prague

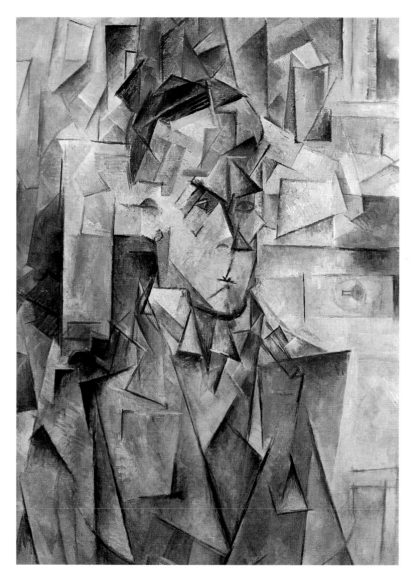

Portrait of Wilhelm Uhde · spring 1910

Private collection

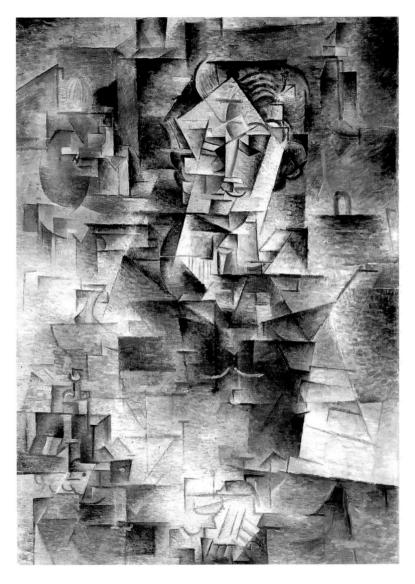

Portrait of Daniel-Henry Kahnweiler · autumn–winter 1910
The Art Institute of Chicago, Gift of Mrs. Gilbert W. Chapman, in memory of Charles R. Goodspeed

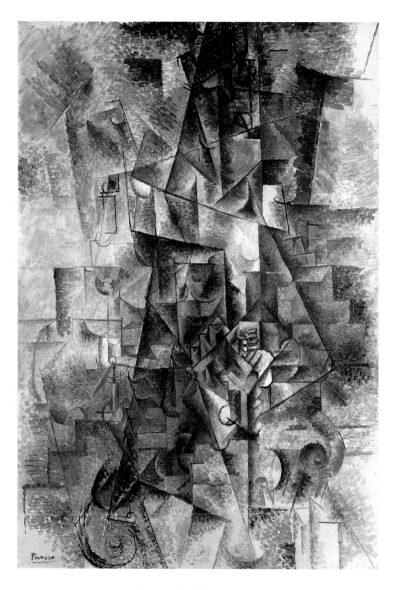

The Accordionist · summer 1911
Solomon R. Guggenheim Museum, New York

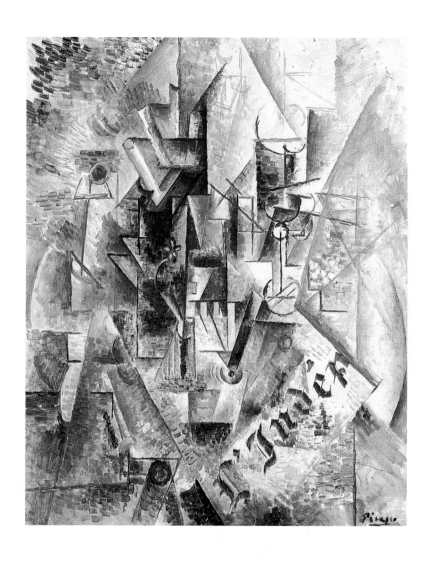

The Fan (L'Indépendant) · summer 1911
Private collection

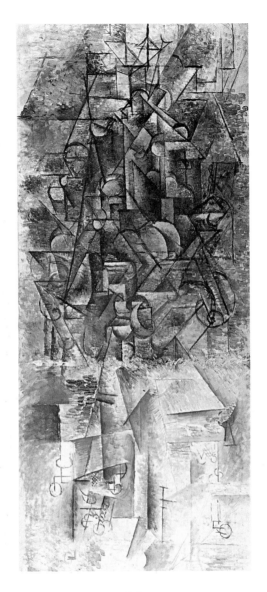

Man with a Mandolin · autumn 1911
Musée Picasso, Paris

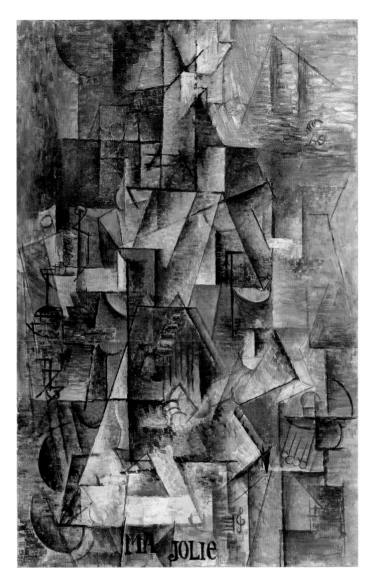

Woman with a Guitar (Ma Jolie) · winter 1911–12
The Museum of Modern Art, New York

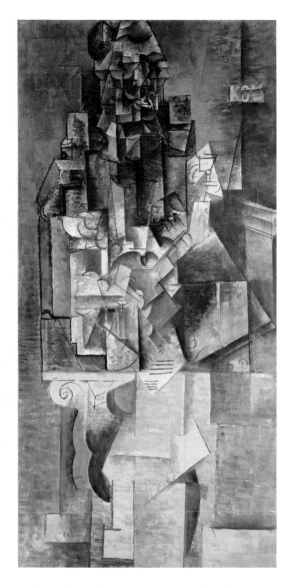

Man with a Guitar · autumn 1911 and spring 1912
Musée Picasso, Paris

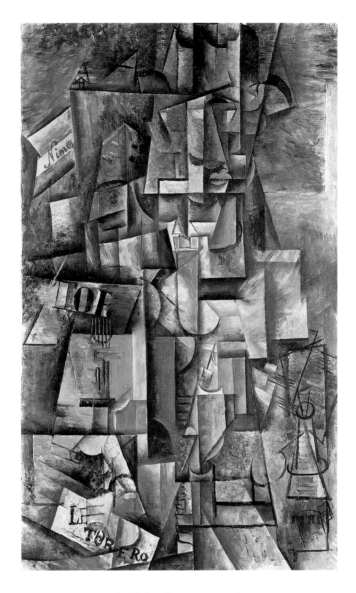

The Aficionado · summer 1912
Kunstmuseum, Basel

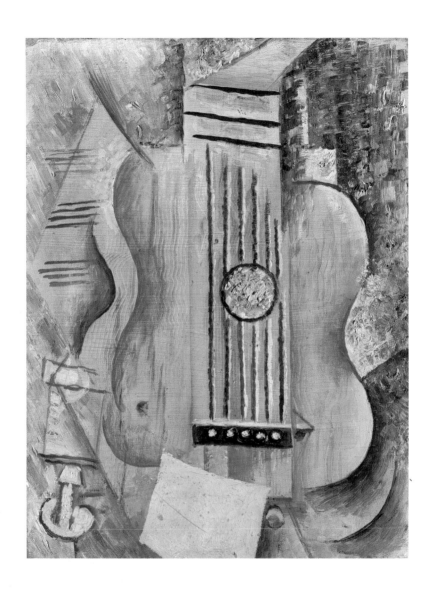

Guitar "J'aime Eva" · summer 1912
Musée Picasso, Paris

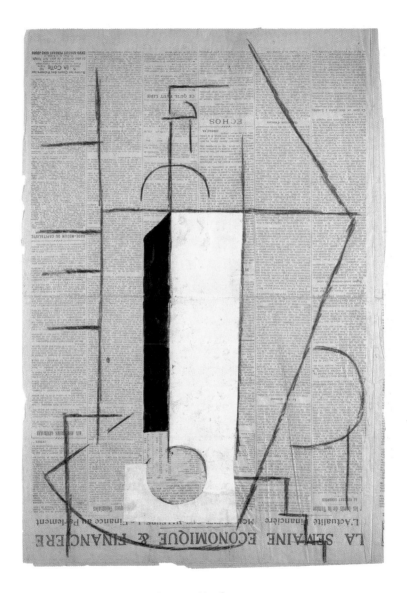

Bottle on a Table · late 1912
Musée Picasso, Paris

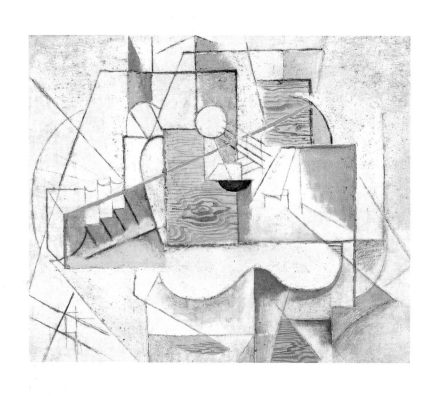

Guitar on a Table · autumn 1912
Hood Museum of Art, Dartmouth College, Hanover

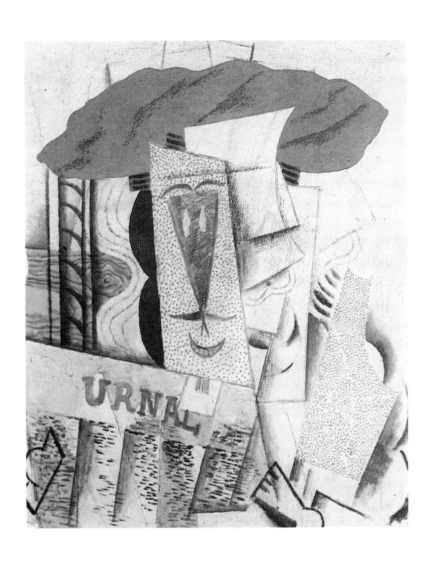

Student with a Newspaper · winter 1913–14
Private collection

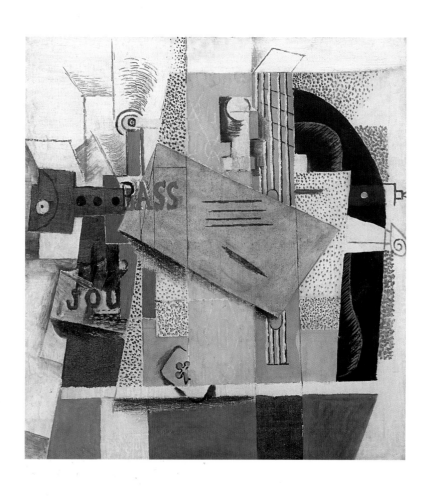

Still Life with a Violin and a Glass of Bass · 1913–14
Musée National d'Art Moderne, Centre Georges Pompidou, Paris

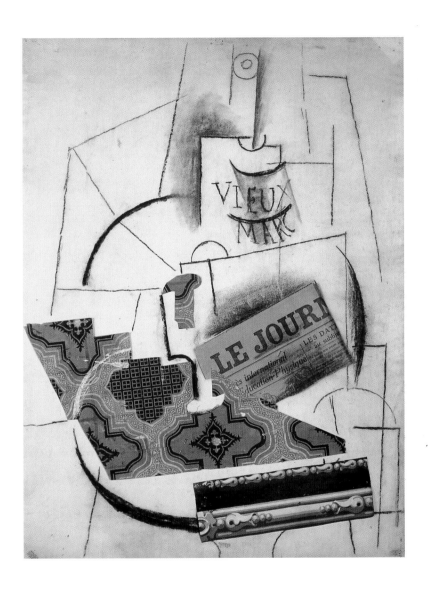

Bottle of Vieux Marc · after 15 March 1913
Musée National d'Art Moderne, Centre Georges Pompidou, Paris

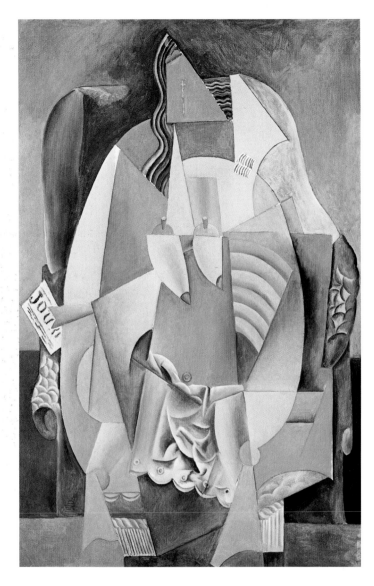

Woman in a Chemise in an Armchair · autumn 1913
Private collection

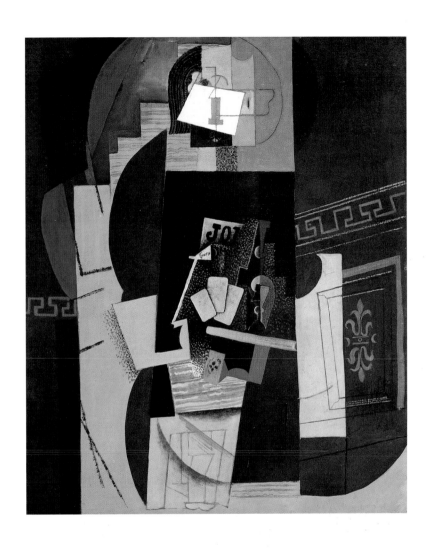

Card Player · winter 1913–14

The Museum of Modern Art, New York

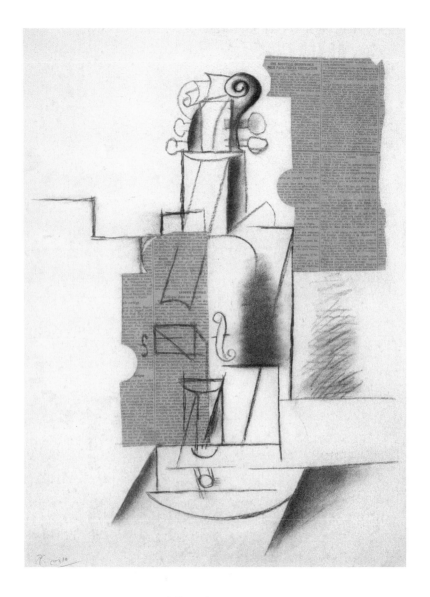

Violin · winter 1913–14

Musée National d'Art Moderne, Centre Georges Pompidou, Paris

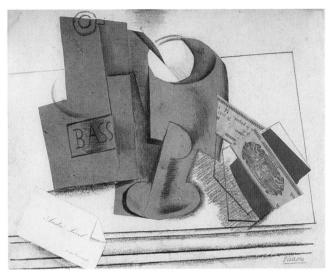

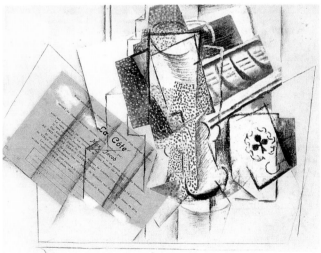

Bottle of Bass and Calling Card · spring 1914
Musée National d'Art Moderne, Centre Georges Pompidou, Paris
Still Life with Glass and Card Game (Homage to Max Jacob) · 1914
Berggruen Collection, Berlin

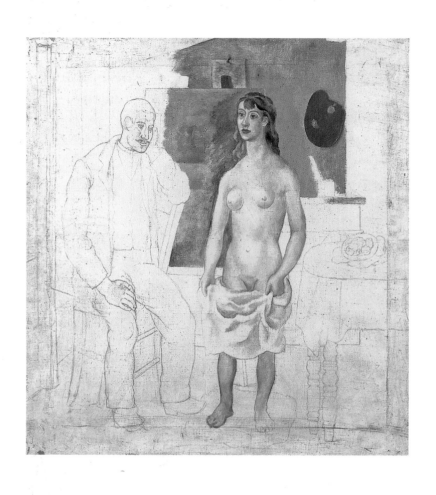

The Painter and his Model · summer 1914

Musée Picasso, Paris

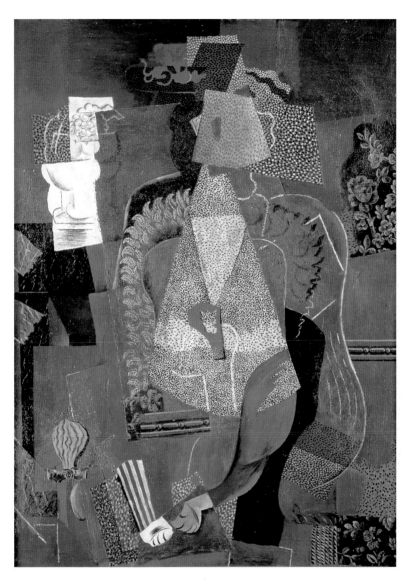

Portrait of a Girl · summer 1914

Musée National d'Art Moderne, Centre Georges Pompidou, Paris

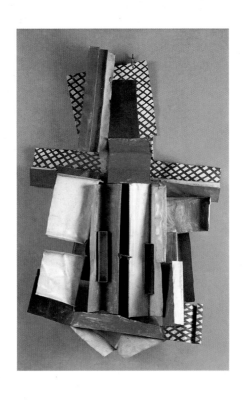

Violin · 1915
Musée Picasso, Paris

Harlequin · autumn 1915
The Museum of Modern Art, New York

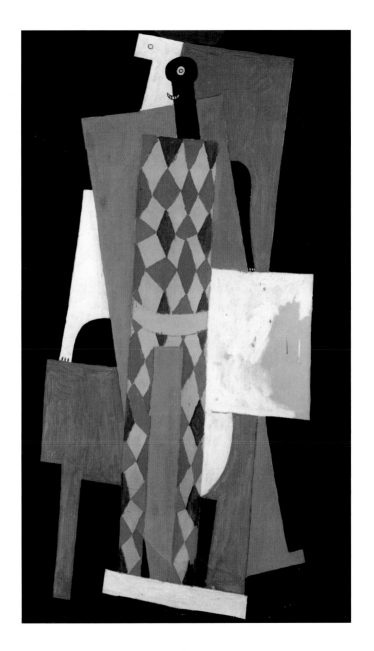

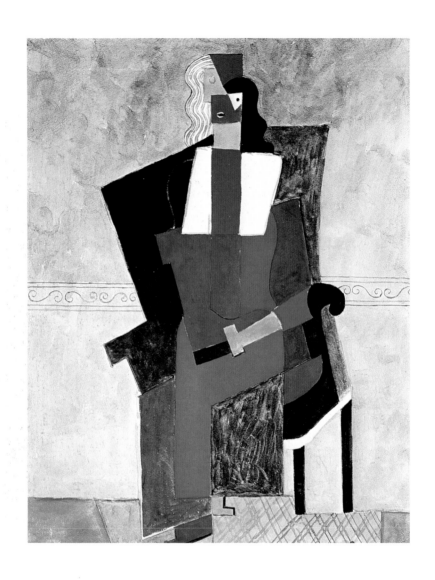

Woman in an Armchair · early 1916

Private collection

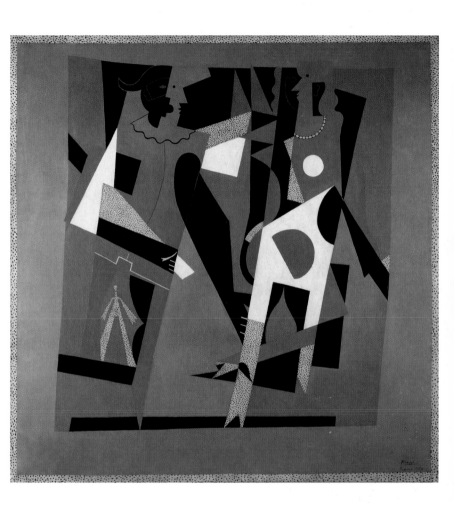

Harlequin and Woman with Necklace · 1917
Musée National d'Art Moderne, Centre Georges Pompidou, Paris

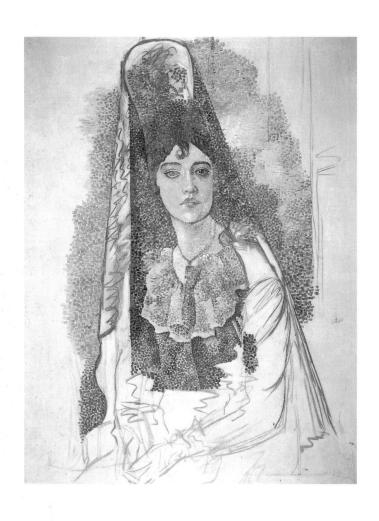

Woman in a Mantilla (La Salchichona) · 1917
Museu Picasso, Barcelona

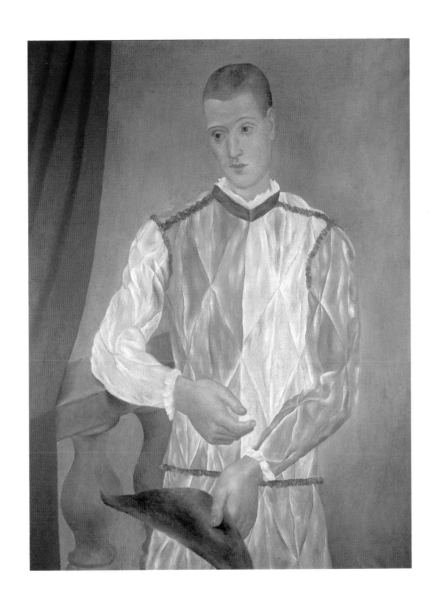

Harlequin · 1917
Museu Picasso, Barcelona

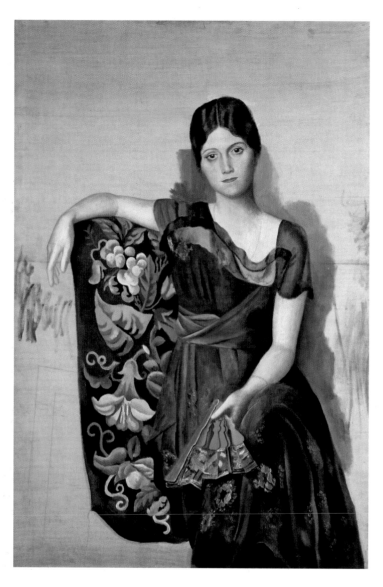

Portrait of Olga in an Armchair · autumn 1917
Musée Picasso, Paris

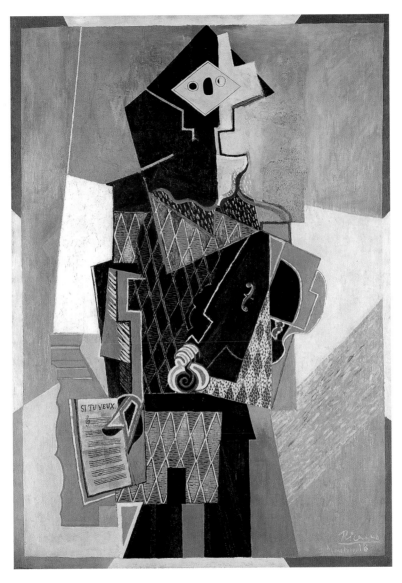

Harlequin with a Violin ("Si tu veux") · 1918

The Cleveland Museum of Art

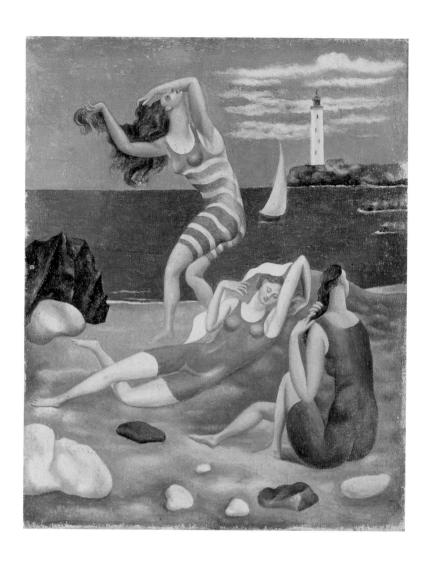

The Bathers · summer 1918
Musée Picasso, Paris

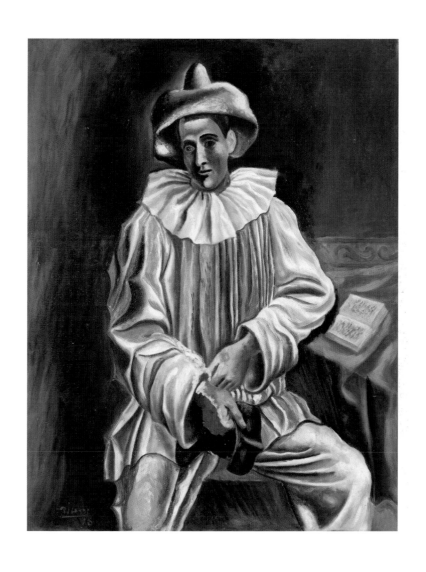

Pierrot · 1918
The Museum of Modern Art, New York

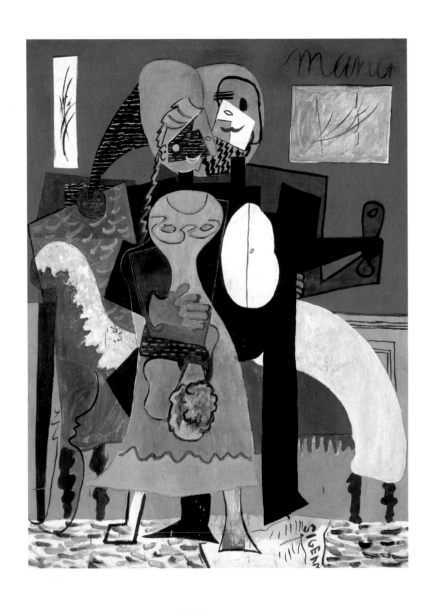

The Lovers · 1919
Musée Picasso, Paris

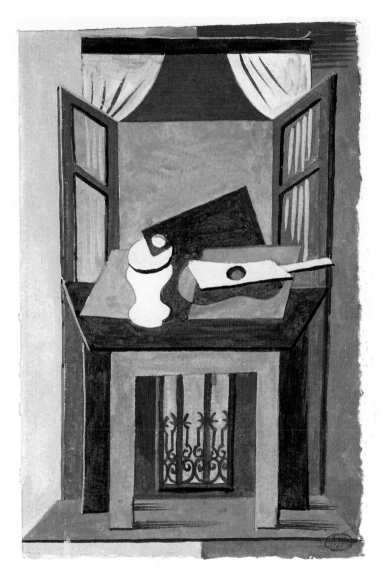

Still Life on a Table in front of an Open Window · 26 October 1919
Musée Picasso, Paris

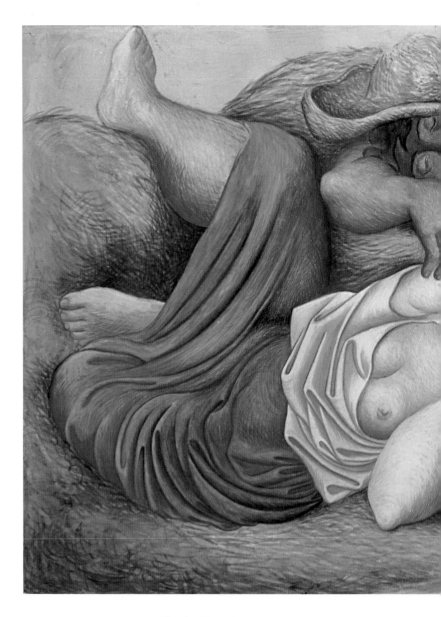

Sleeping Peasants · 1919
The Museum of Modern Art, New York

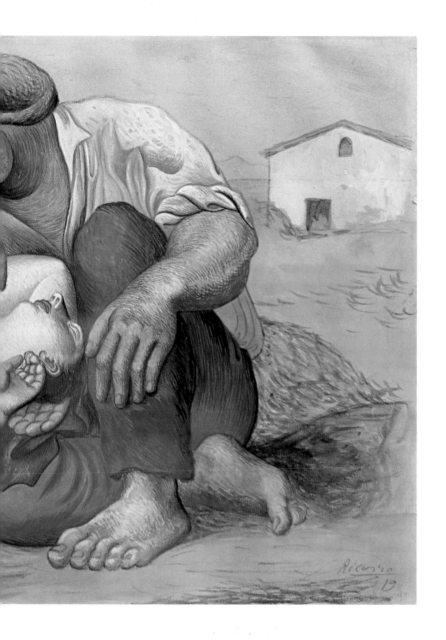

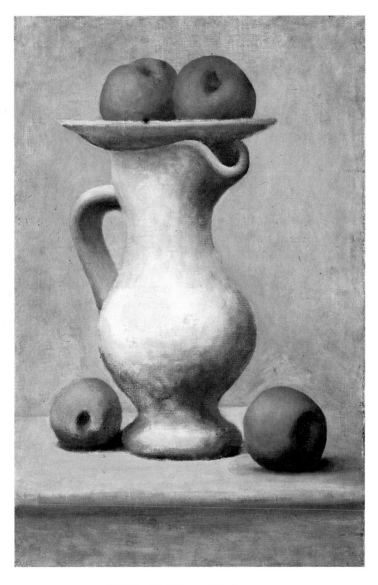

Still Life with Pitcher and Apples · 1919

Musée Picasso, Paris

 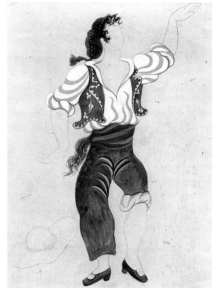

Costume designs for the ballet "Tricorne": a Woman and the Miller · 1919
Musée Picasso, Paris

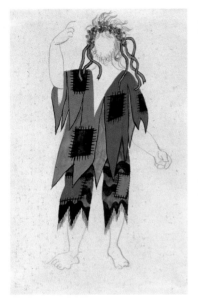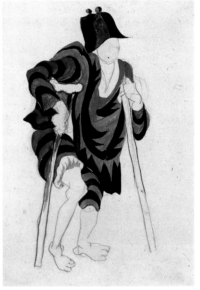

Costume designs for the ballet "Tricorne":
the Madman and the Old Man with Crutches · 1919
Musée Picasso, Paris

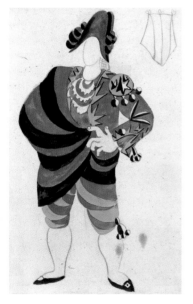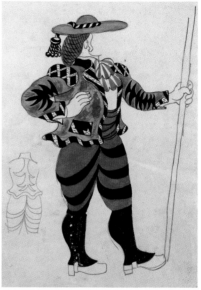

**Costume designs for the ballet "Tricorne":
the Partner of the Woman from Seville and a Picador** · 1919
Musée Picasso, Paris

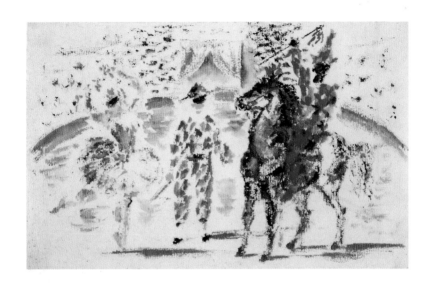

Design for a drop curtain for the ballet "Pulcinella":
Harlequin on the Stage with Dancer and Rider · 1920
Musée Picasso, Paris

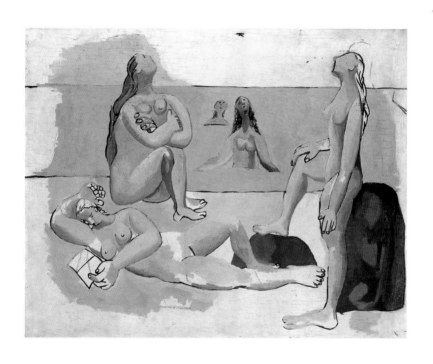

Bathers Watching an Airplane · 1920
Musée Picasso, Paris
> **The Abduction** · 1920
The Museum of Modern Art, New York, The Philip L. Goodwin Collection

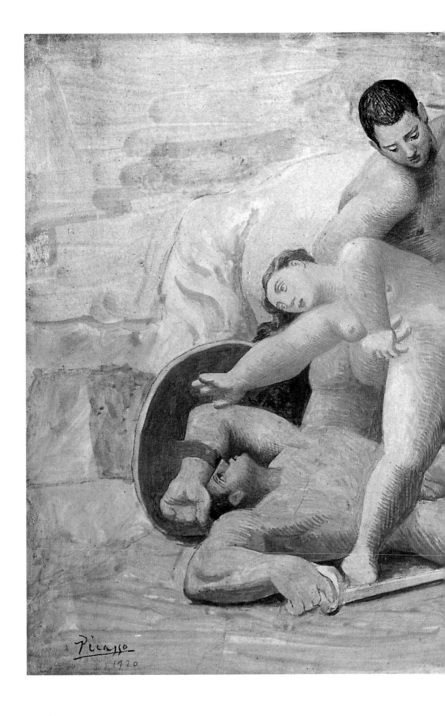

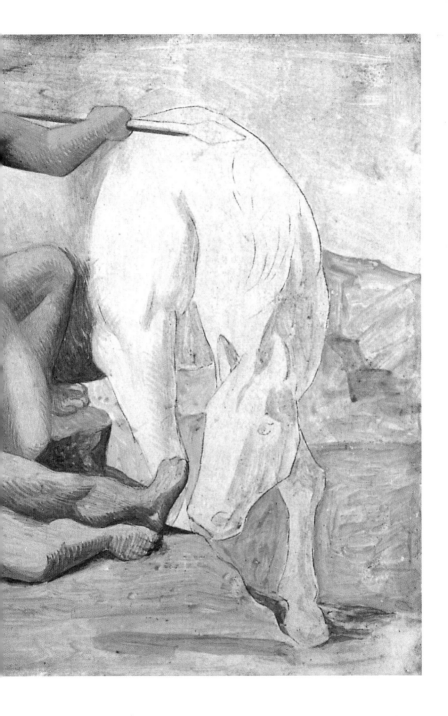

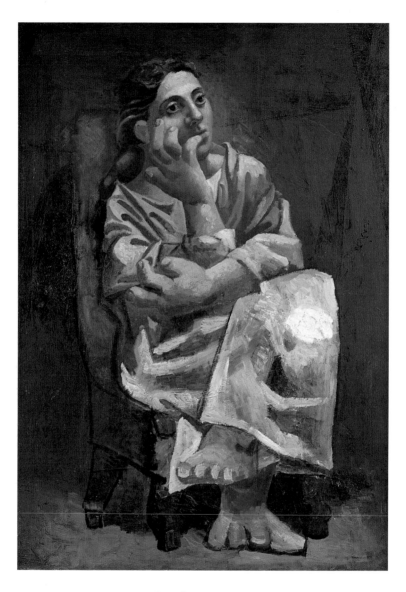

Seated Woman · 1920

Musée Picasso, Paris

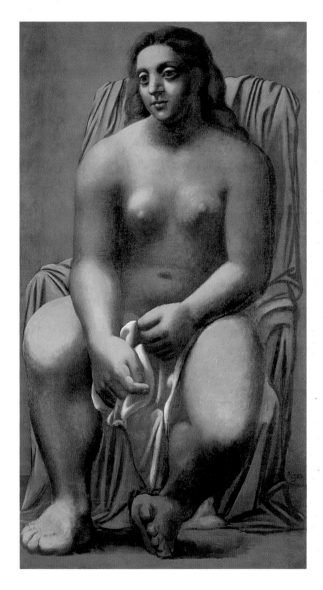

Large Bather · 1921–2

Musée de l'Orangerie, Paris, Collection of Jean Walter-Paul Guillaume

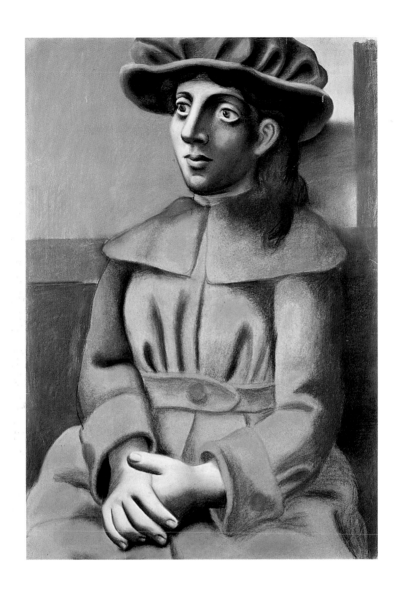

Girl in a Hat with her Hands Crossed · 1920–21
Musée Picasso, Paris

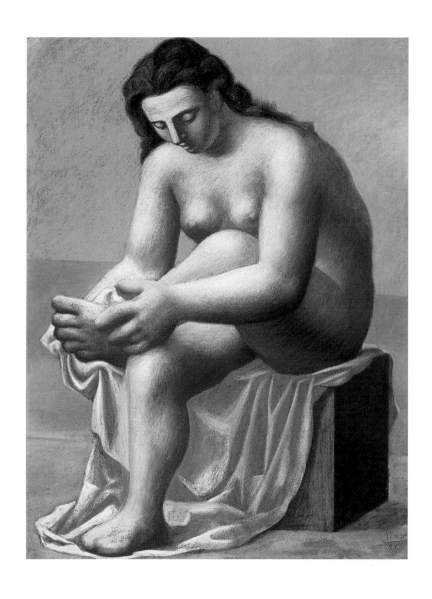

Seated Bather Drying her Feet · summer 1921
Berggruen Collection, Berlin

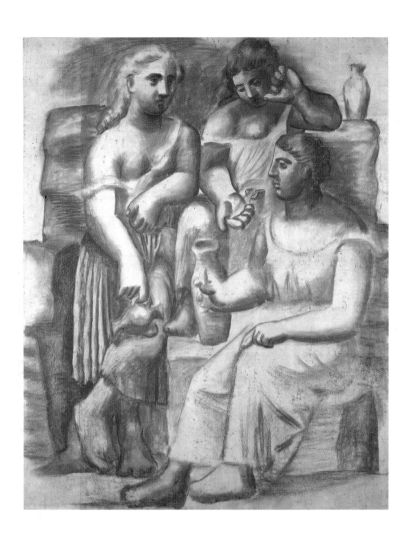

Three Women at the Well · 1921
Musée Picasso, Paris

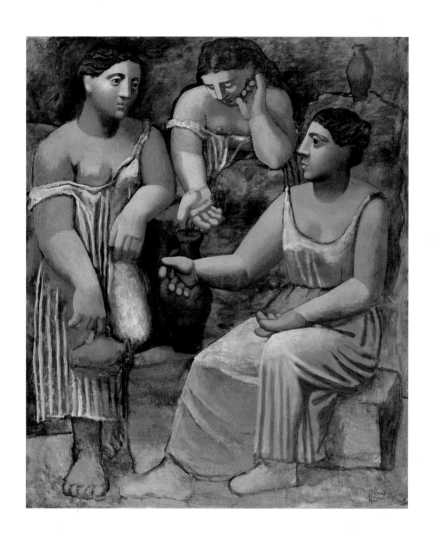

Three Women at the Well · 1921
The Museum of Modern Art, New York

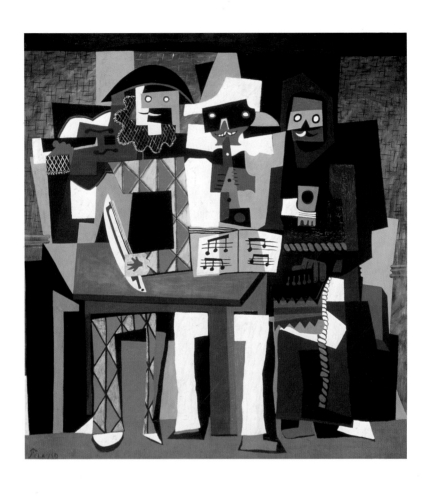

Three Musicians · summer 1921
The Philadelphia Museum of Art, E. A. Gallatin Collection

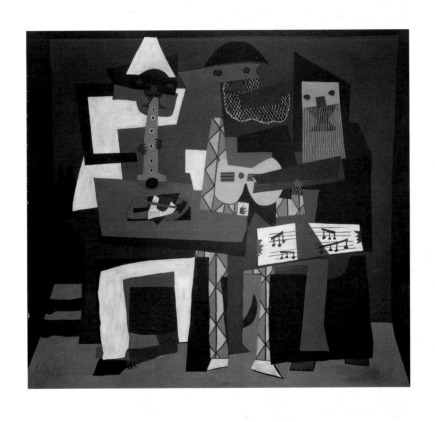

Three Musicians · summer 1921

The Museum of Modern Art, New York, Mrs. Simon Guggenheim Collection

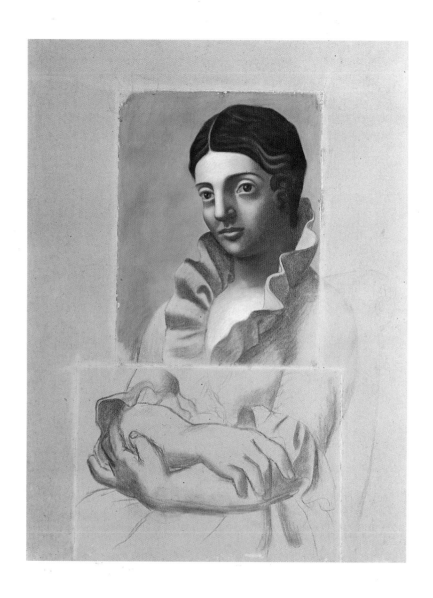

Portrait of Olga · 1921

Musée Picasso, Paris (on deposit at the Musée de Peinture et de Sculpture de Grenoble)

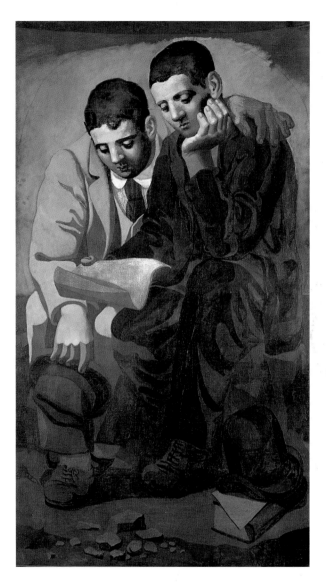

Reading the Letter · 1921
Musée Picasso, Paris

Mother and Child · 1922
Musée Picasso, Paris

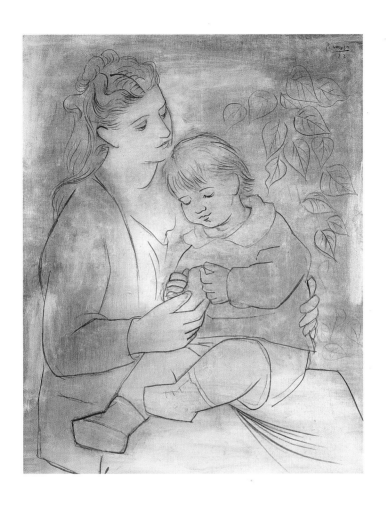

Mother and Child · summer 1922
Baltimore Museum of Art, The Cone Collection
> **Two Women Running on the Beach (The Race)** · summer 1922
Musée Picasso, Paris

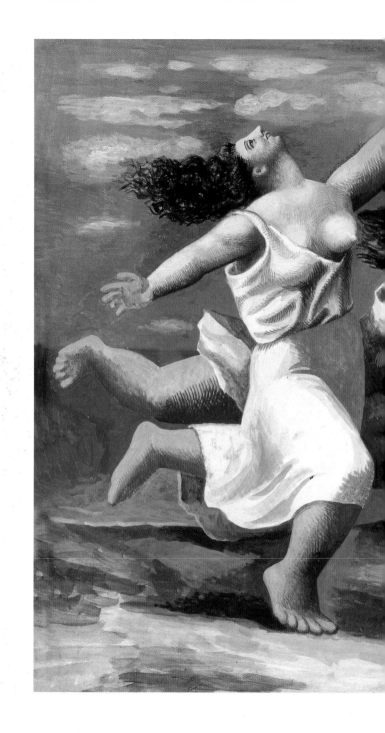

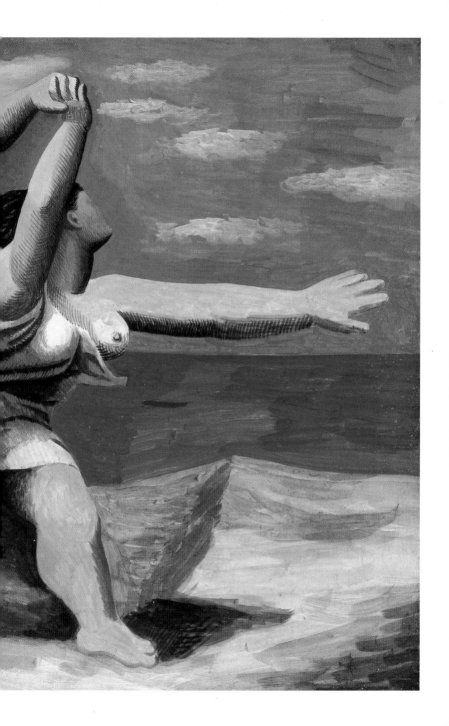

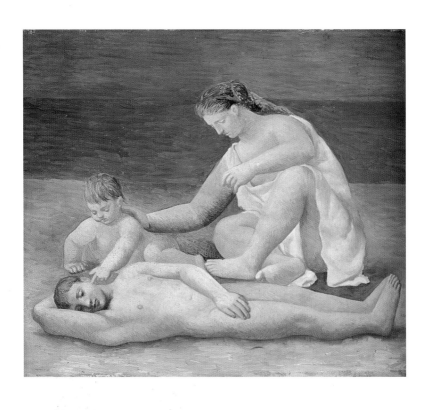

Family by the Sea · summer 1922
Musée Picasso, Paris

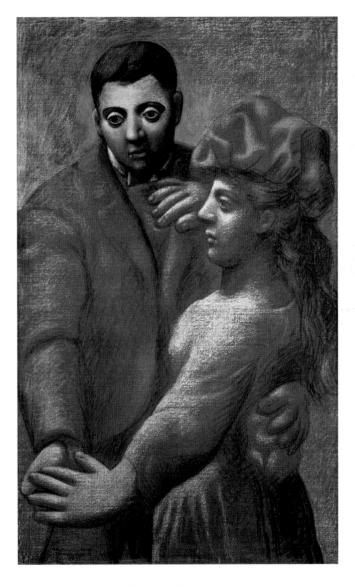

The Village Dance · 1922
Musée Picasso, Paris

Bust of a Woman Leaning on an Elbow (Sketchbook, fol. 9r) · 1922

Musée Picasso, Paris

Nude Seen from Behind (Sketchbook, fol. 11r) · 1922
Musée Picasso, Paris

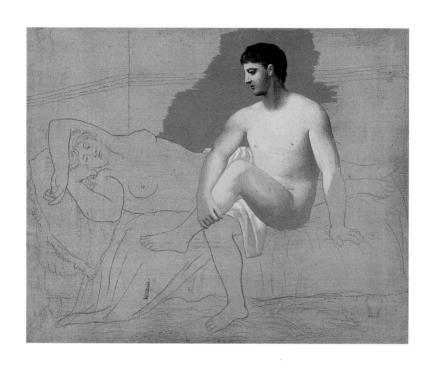

Man Watching a Sleeping Woman · 1922
Private collection

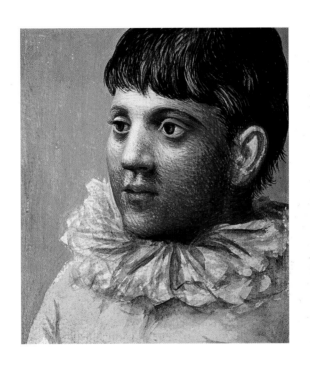

Young Man Dressed as Pierrot · 27 December 1922
Musée Picasso, Paris

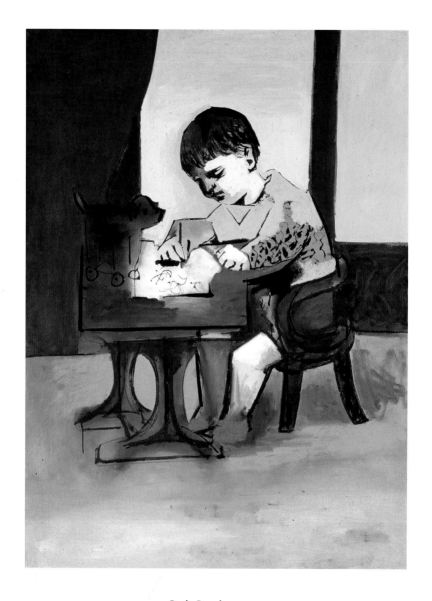

Paulo Drawing · 1923
Musée Picasso, Paris

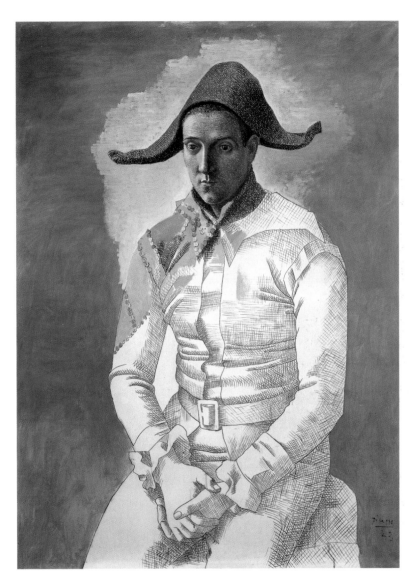

Seated Harlequin (Portrait of the Painter Jacint Salvadó) · 1923
Musée National d'Art Moderne, Centre Georges Pompidou, Paris

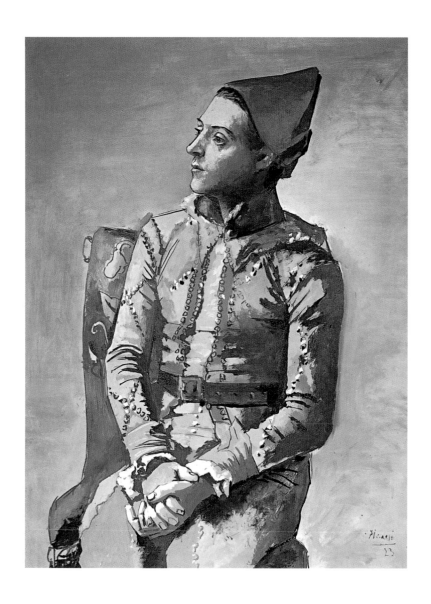

Harlequin (Portrait of the Painter Jacint Salvadó) · 1923
Kunstmuseum, Basel

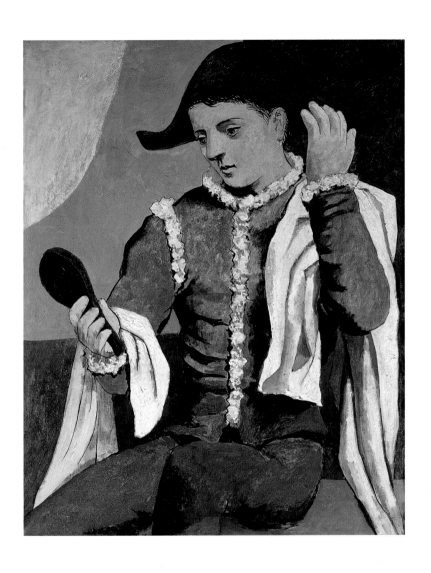

Seated Harlequin with Mirror · 1923
Museo Thyssen-Bornemisza, Madrid

The Pan-Pipes · summer 1923
Musée Picasso, Paris

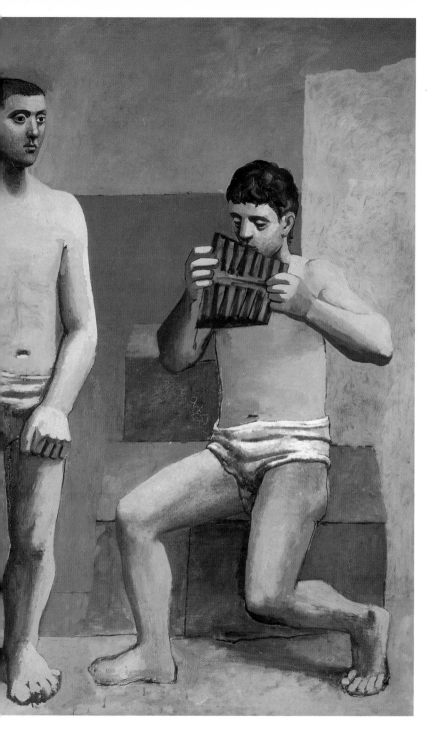

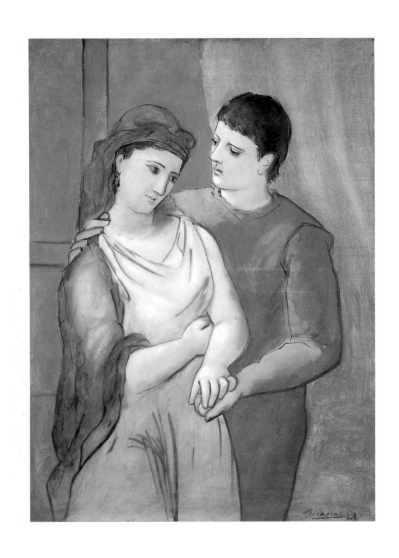

The Lovers · 1923
The National Gallery of Art, Washington, DC, Chester Dale Collection

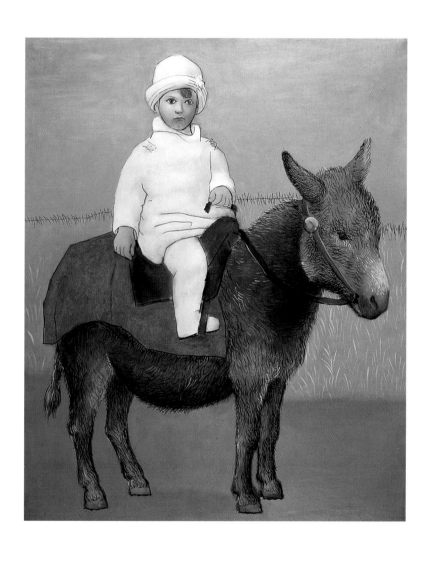

Paulo, the Artist's Son, at Age Two · 1923
Private collection

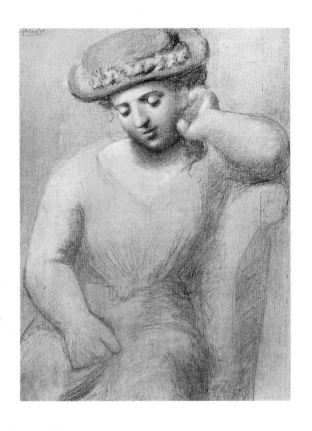

Seated Woman in a Hat · 1923
Private collection

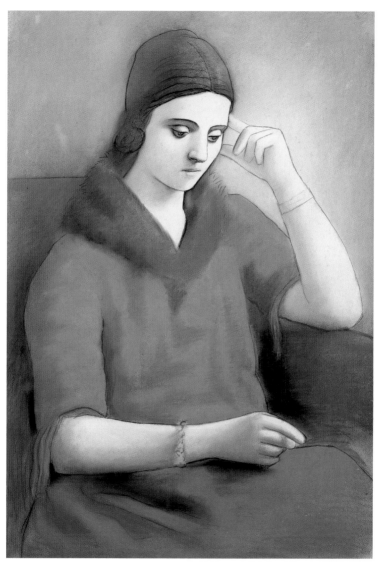

Olga in a Pensive Mood · 1923
Musée Picasso, Paris

> **The Red Carpet** · 1924
Private collection

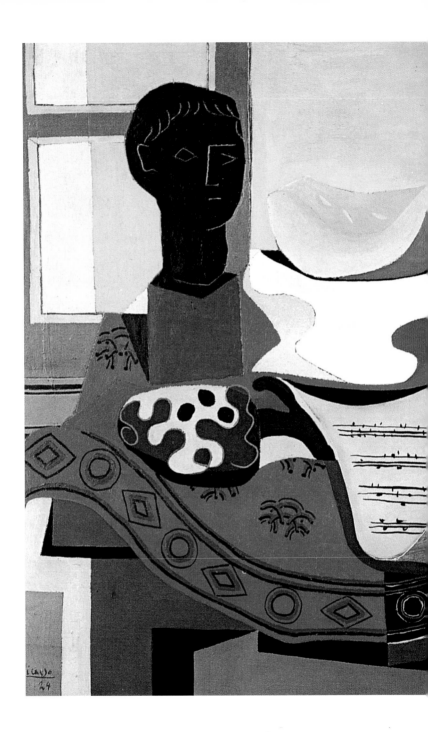

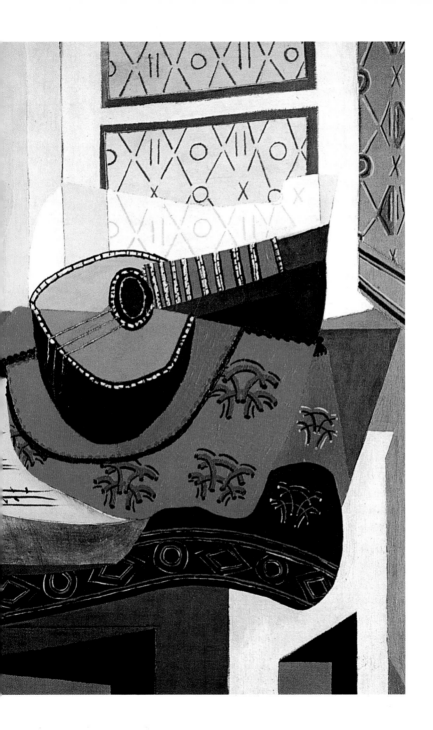

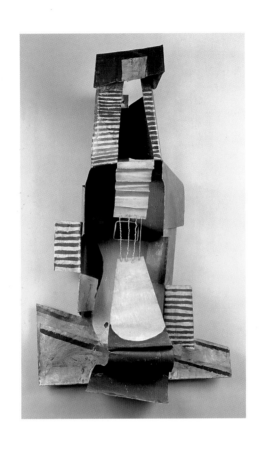

Guitar · 1924
Musée Picasso, Paris

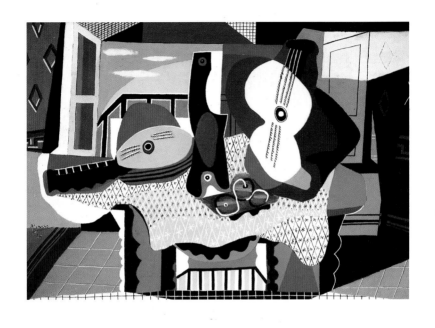

Mandolin and Guitar · summer 1924
Solomon R. Guggenheim Museum, New York

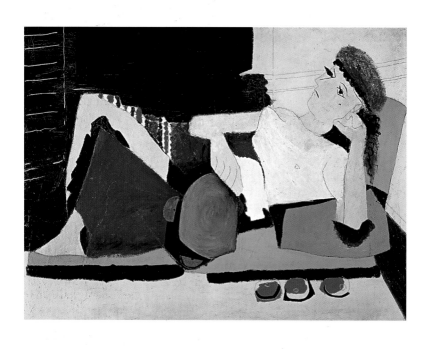

The Woman with a Tambourine · 1925

Musée de l'Orangerie, Paris, Collection of Jean Walter-Paul Guillaume

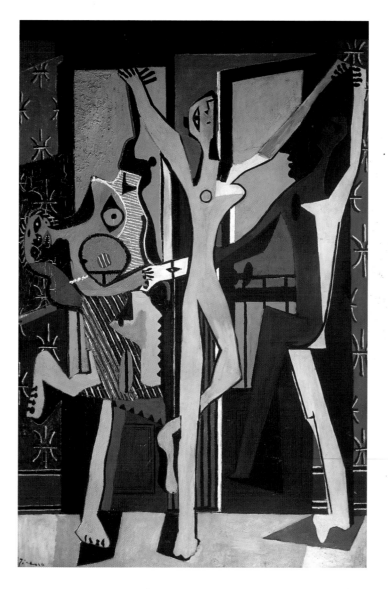

The Dance · June 1925
The Tate Gallery, London

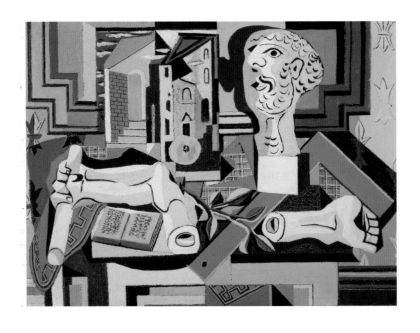

Studio with Plaster Head · summer 1925
The Museum of Modern Art, New York

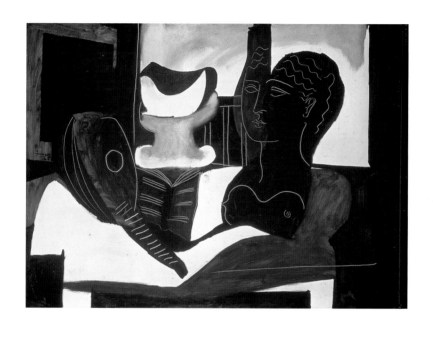

Still Life with an Antique Bust · summer 1925
Musée National d'Art Moderne, Centre Georges Pompidou, Paris

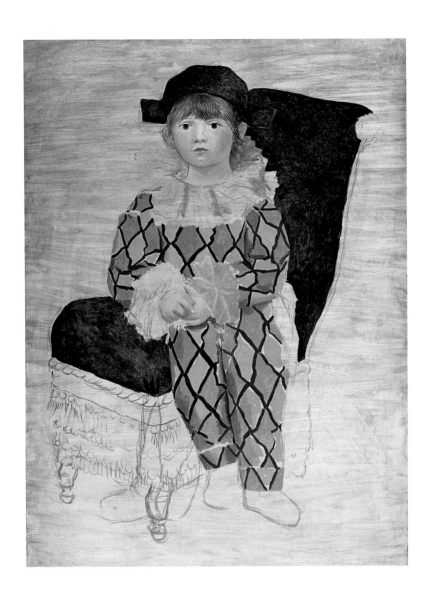

Paulo as Harlequin · 1925
Musée Picasso, Paris

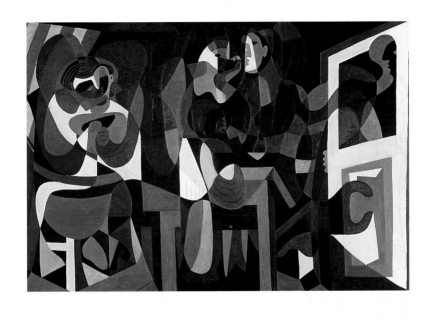

The Dress Designer's Workshop · January 1926
Musée National d'Art Moderne, Centre Georges Pompidou, Paris

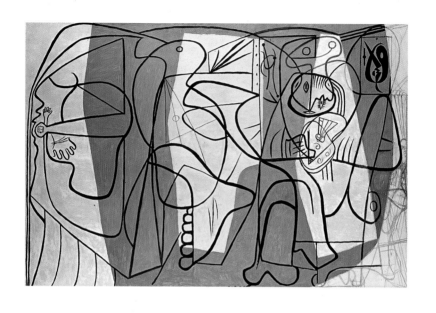

The Painter and his Model · 1926
Musée Picasso, Paris

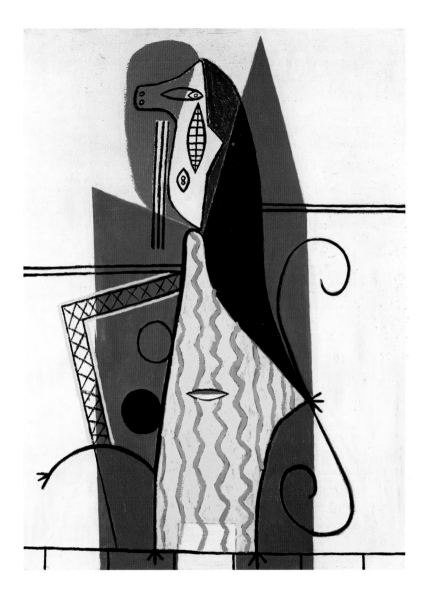

Woman in an Armchair · summer 1927
Musée Picasso, Paris

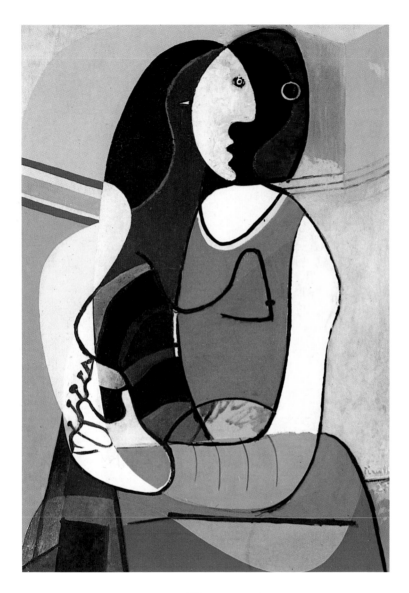

Seated Woman · 1927

The Museum of Modern Art, New York

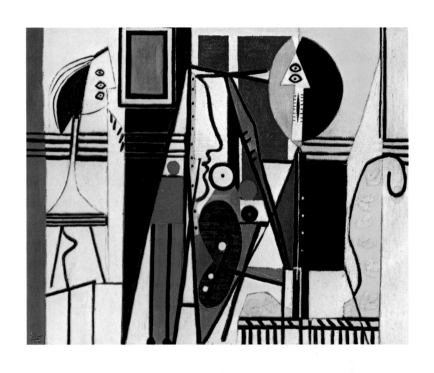

Painter and Model · 1928
The Museum of Modern Art, New York

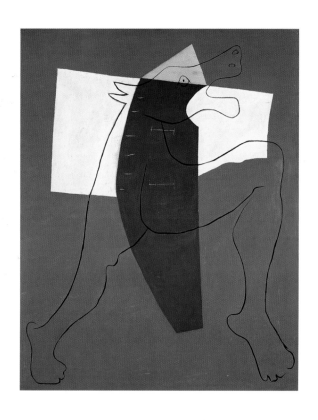

Running Minotaur · 1 January 1928
Musée Picasso, Paris

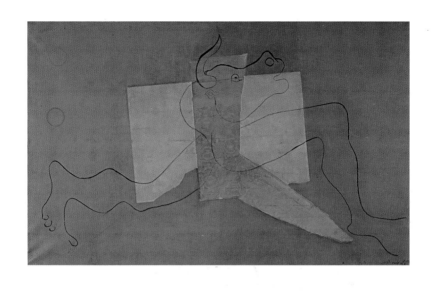

Minotaur · 1 January 1928

Musée National d'Art Moderne, Centre Georges Pompidou, Paris

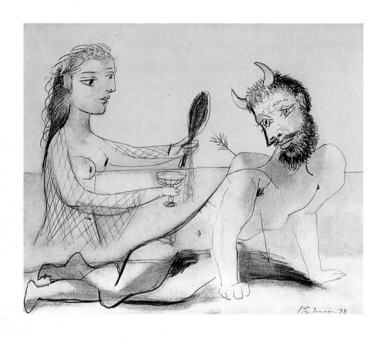

Wounded Faun and Woman · 1 January 1928

Private collection

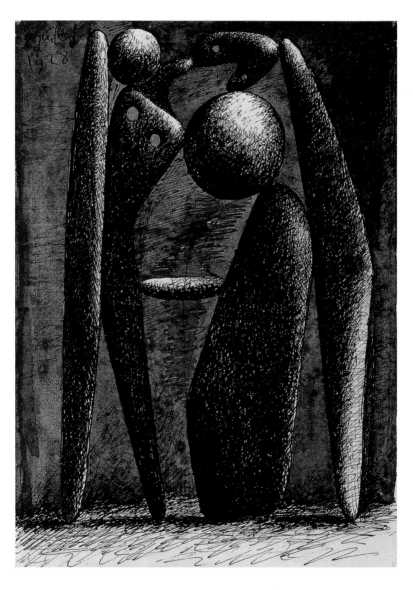

Bathers (design for a monument) · 8 July 1928
Musée Picasso, Paris

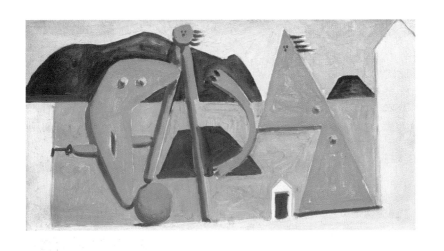

Bathers on the Beach · 12 August 1928
Musée Picasso, Paris

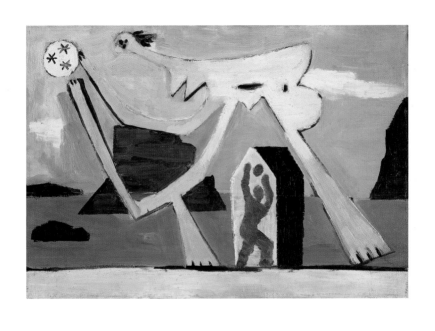

Playing Ball on the Beach · 15 August 1928
Musée Picasso, Paris

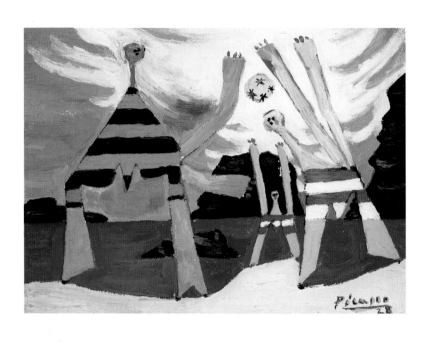

Bathers with a Ball · 21 August 1928
Private collection

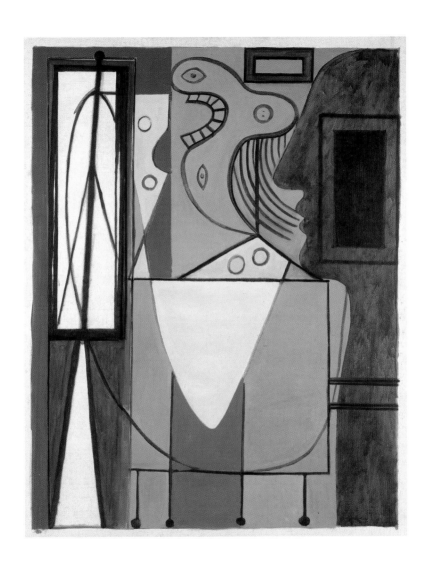

The Studio · 1928–9

Musée Picasso, Paris

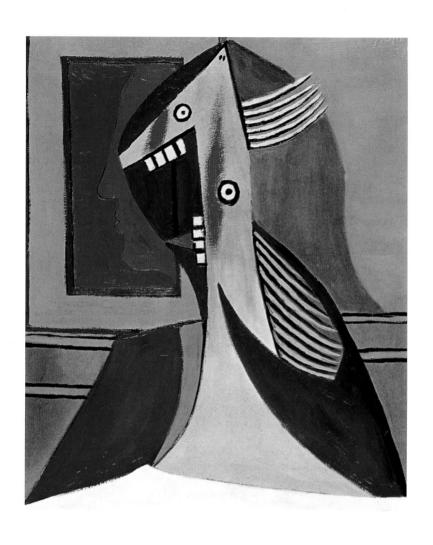

Head of a Woman with Self-Portrait · February 1929
Private collection

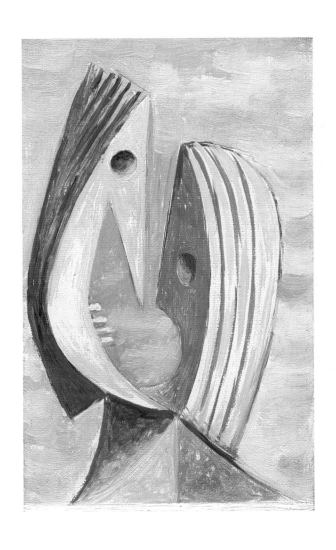

The Kiss · 25 August 1929
Musée Picasso, Paris

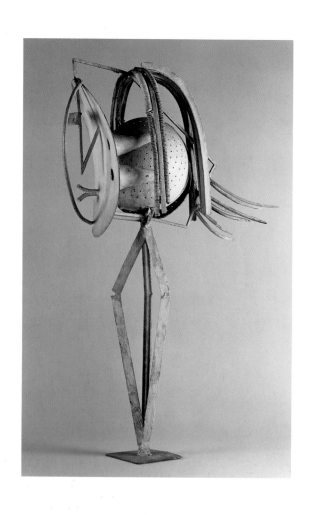

Head of a Woman · 1929–30

Musée Picasso, Paris

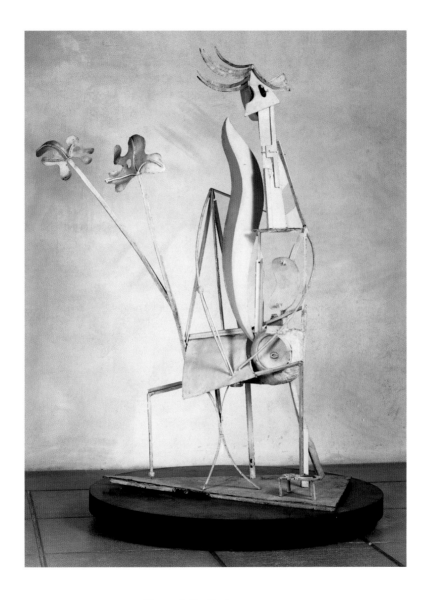

Woman in the Garden · 1929–30

Musée Picasso, Paris

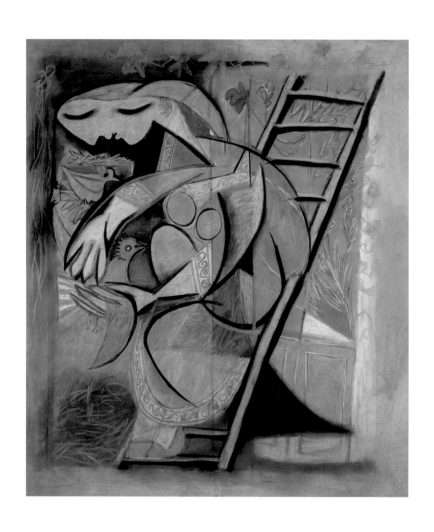

Woman with Pigeons · 1930
Musée National d'Art Moderne, Centre Georges Pompidou, Paris

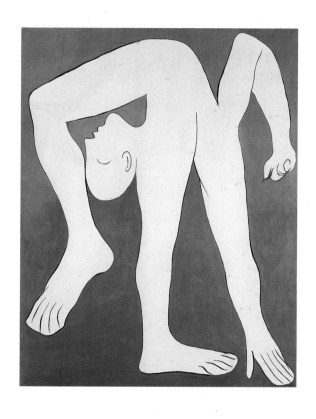

The Acrobat · 18 January 1930
Musée Picasso, Paris
> **The Crucifixion** · 7 February 1930
Musée Picasso, Paris

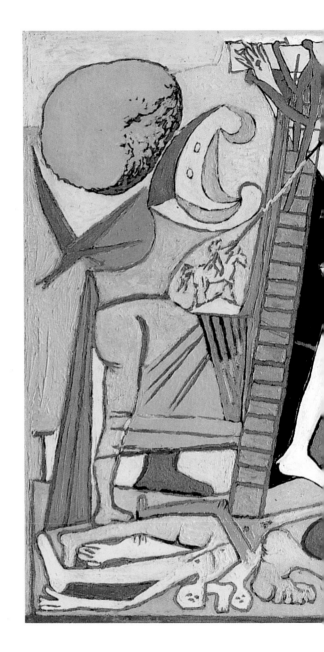

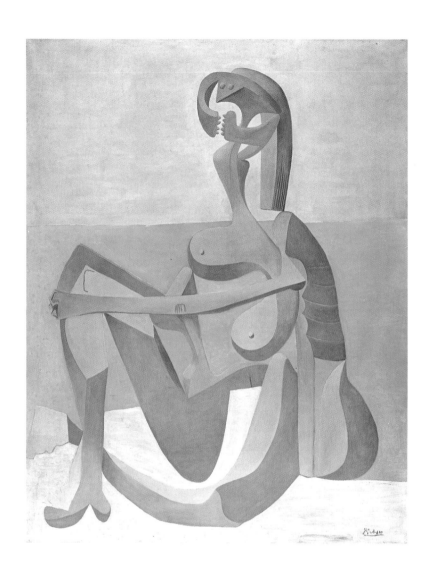

Seated Bather by the Sea · early 1930
The Museum of Modern Art, New York, Mrs. Simon Guggenheim Collection

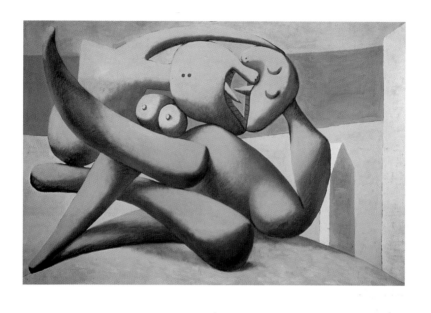

Figures by the Sea · 12 January 1931
Musée Picasso, Paris

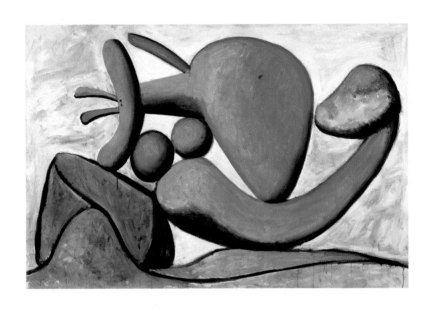

Woman Throwing a Stone · 8 March 1931
Musée Picasso, Paris

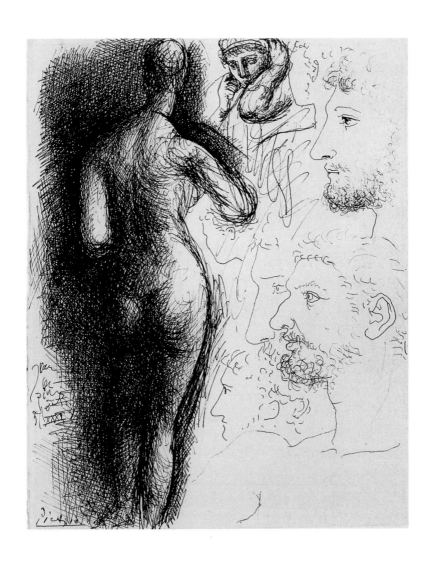

Nude (page from a sketchbook) · 31 August 1931
The Museum of Fine Arts, Boston, Arthur Mason Knopp Fund

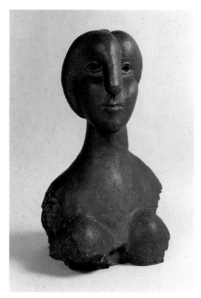
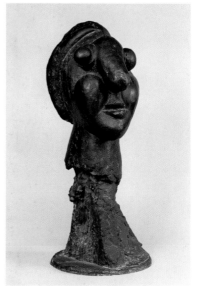

Bust of a Woman · 1931
Musée Picasso, Paris
Head of a Woman · 1931
Musée Picasso, Paris

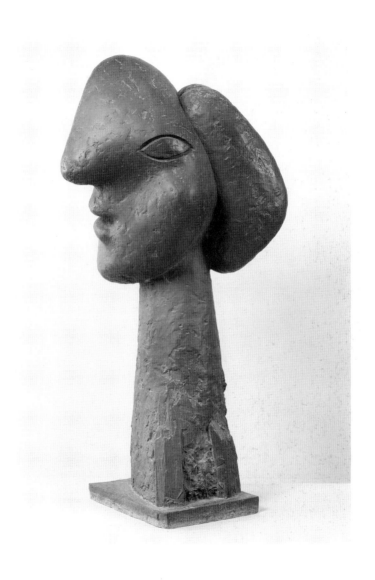

Head of a Woman · 1931
Musée Picasso, Paris

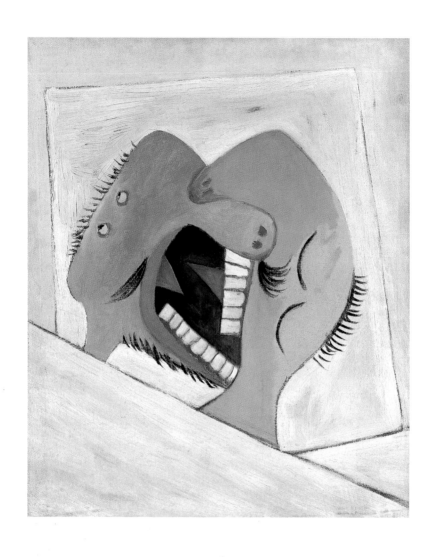

The Kiss · 12 January 1931

Musée Picasso, Paris

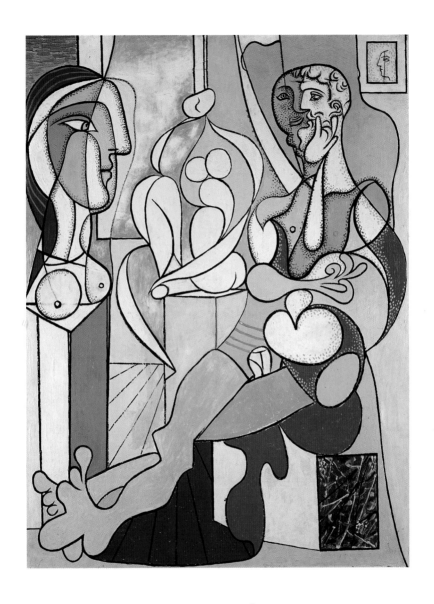

The Sculptor · 7 December 1931

Musée Picasso, Paris

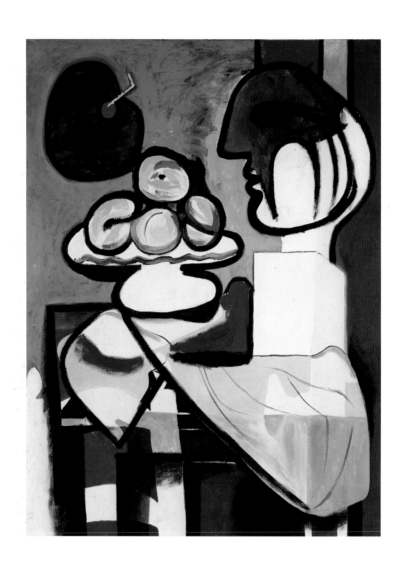

Still Life with Bust, Bowl and Palette · 3 March 1932
Musée Picasso, Paris

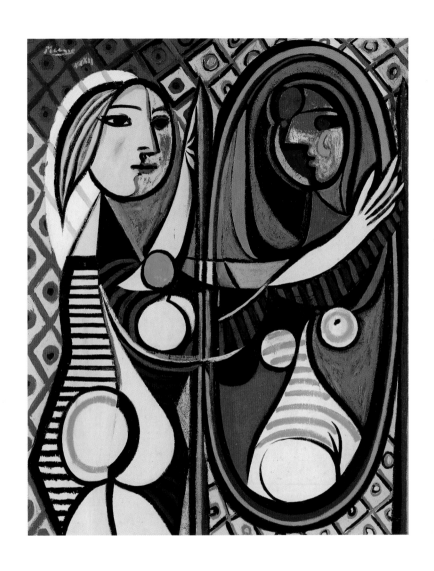

Woman at the Mirror · 14 March 1932
The Museum of Modern Art, New York
> **Reclining Nude** · 4 April 1932
Musée Picasso, Paris

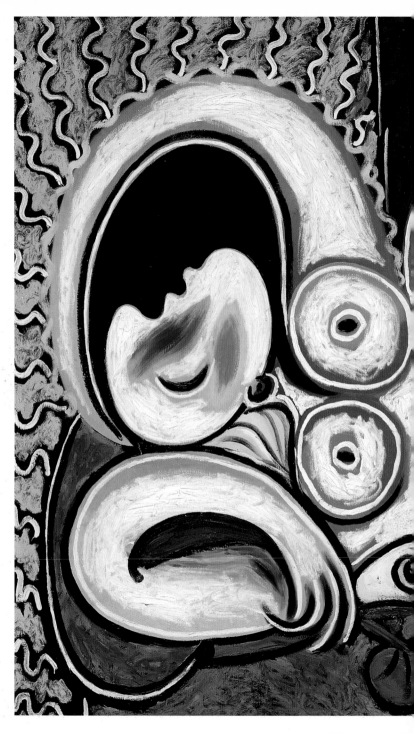

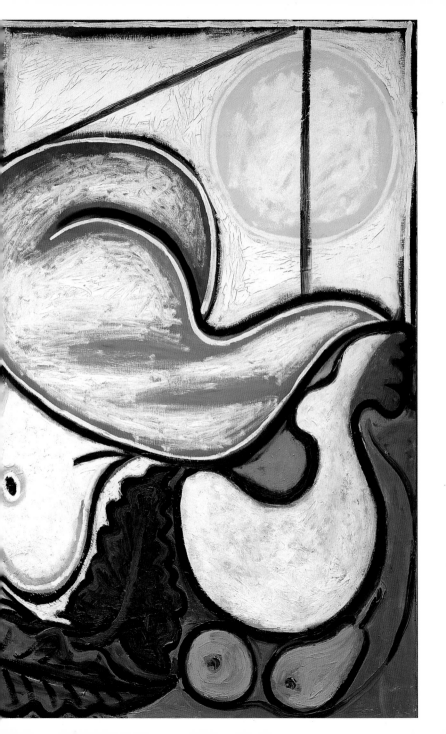

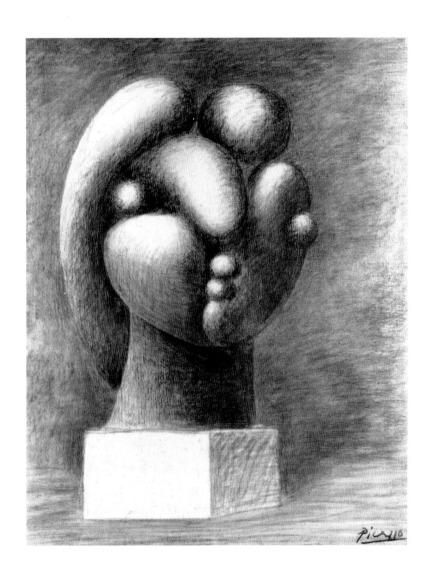

Sculptural Head · 1932
Galerie Beyeler, Basel

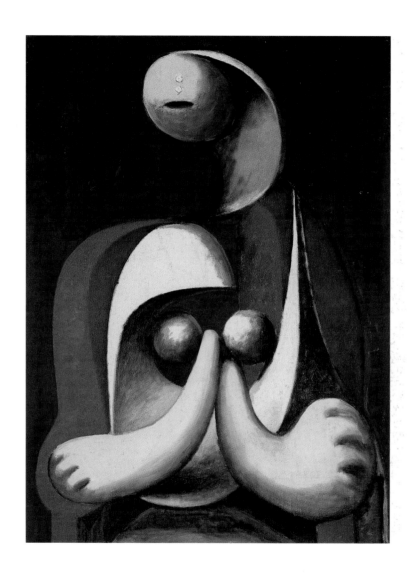

Nude Woman Seated in a Red Armchair · 1932
Musée Picasso, Paris

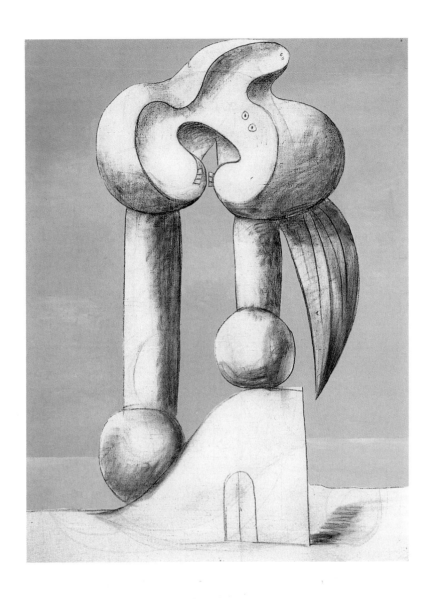

Figures by the Sea · 1932
Museo Nacional Centro de Arte Reina Sofía, Madrid

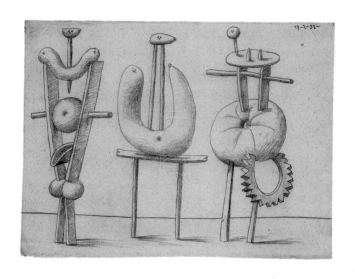

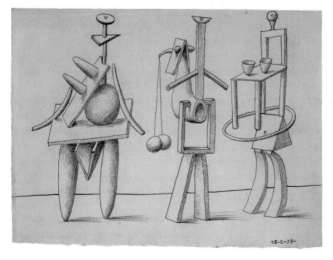

Anatomical Study: Three Women · 27 February 1933
Musée Picasso, Paris
Anatomical Study: Three Women · 28 February 1933
Musée Picasso, Paris

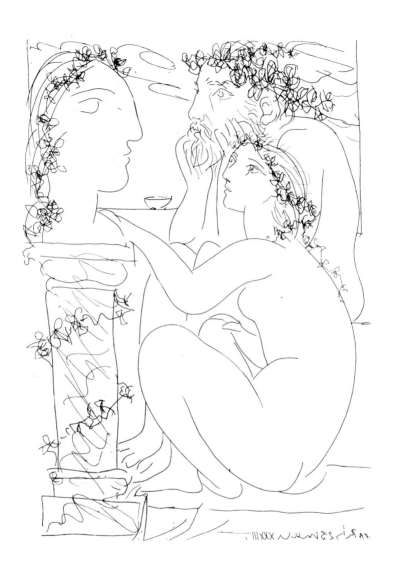

**Sculptor and Seated Model before a Sculptured Head
(Vollard Suite no. 45)** · 23 March 1933

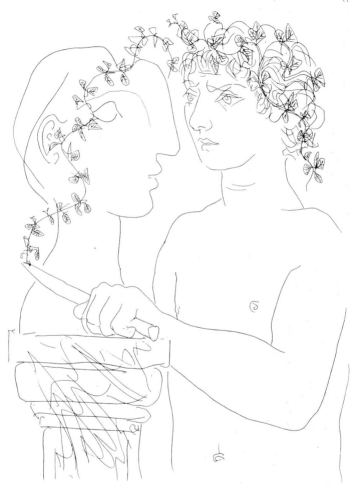

Young Sculptor at Work (Vollard Suite no. 46) · 25 March 1933
> **Sculptor and Reclining Model at Window Viewing a Sculptured Torso
(Vollard Suite no. 53)** · 30 March 1933

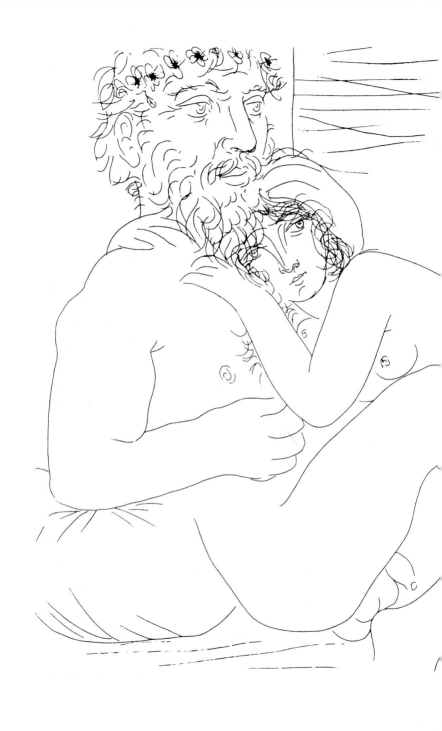

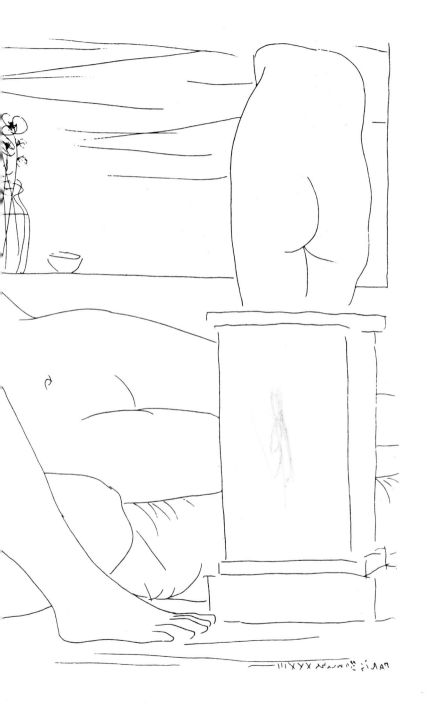

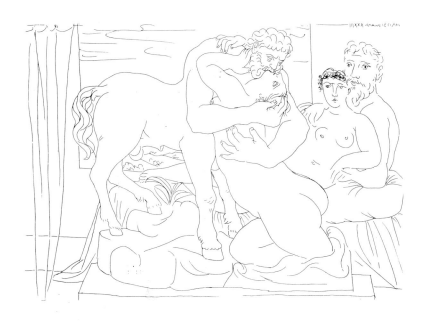

**Sculptor and Model with Statue of Centaur Kissing a Girl
(Vollard Suite no. 58)** · 31 March 1933

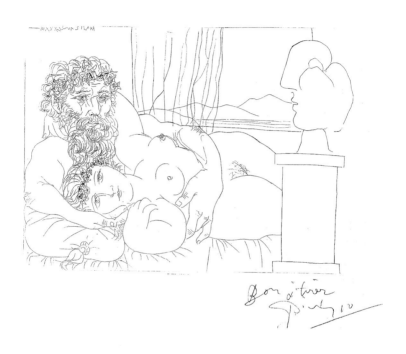

The Sculptor and his Model · 2 April 1933
Musée Picasso, Paris

Design for the cover of "Minotaure" · May 1933

The Museum of Modern Art, New York

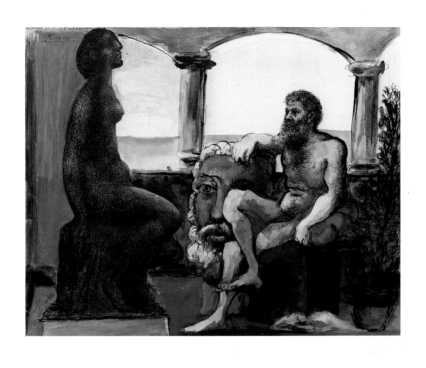

The Sculptor and the Statue · 20 July 1933

Private collection

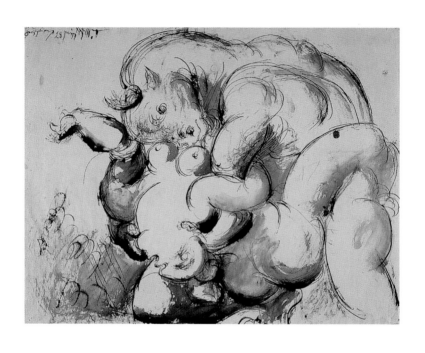

Minotaur Abducting a Woman · 28 June 1933
Musée Picasso, Paris

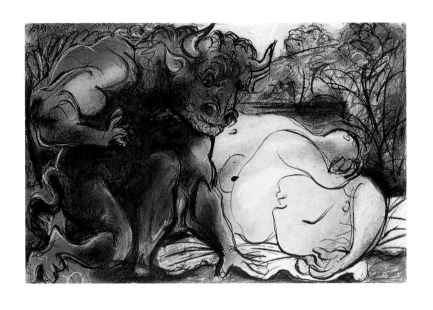

Minotaur · 12 November 1933
Musée des Beaux-Arts, Dijon

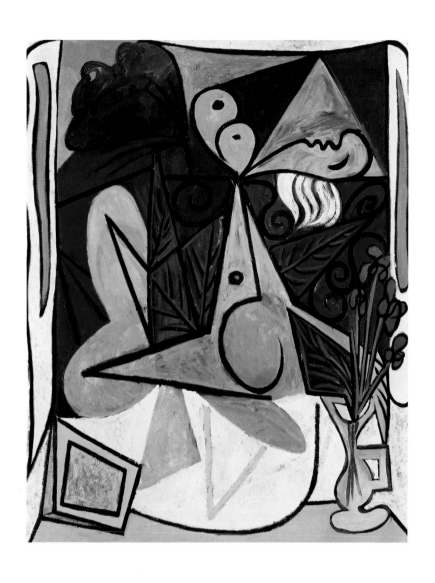

Nude with a Bouquet of Irises and a Mirror · 22 May 1934
Musée Picasso, Paris

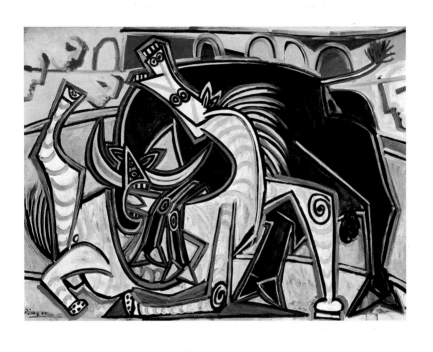

Bullfight · 2 July 1934
Private collection

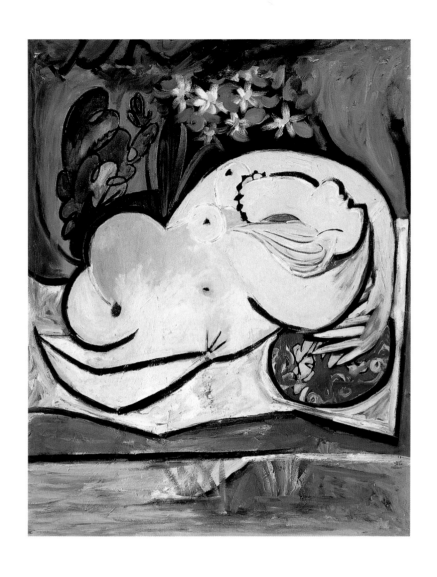

Nude in the Garden · 4 August 1934
Musée Picasso, Paris

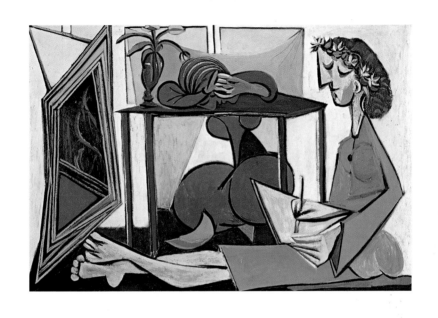

Two Women in an Interior · 12 February 1935
The Museum of Modern Art, New York
> The Muse · 1935
Musée National d'Art Moderne, Centre Georges Pompidou, Paris

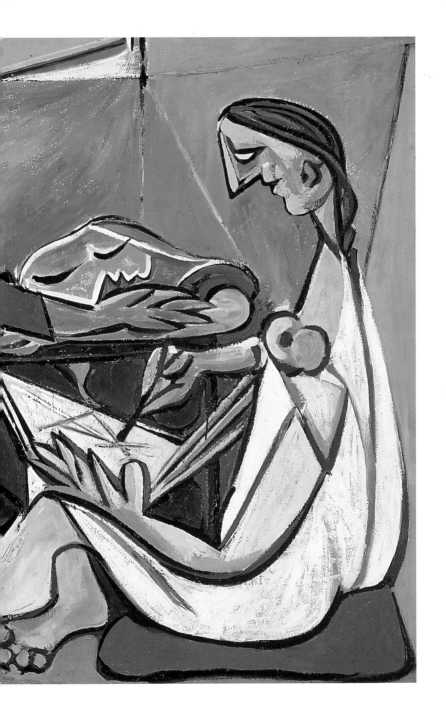

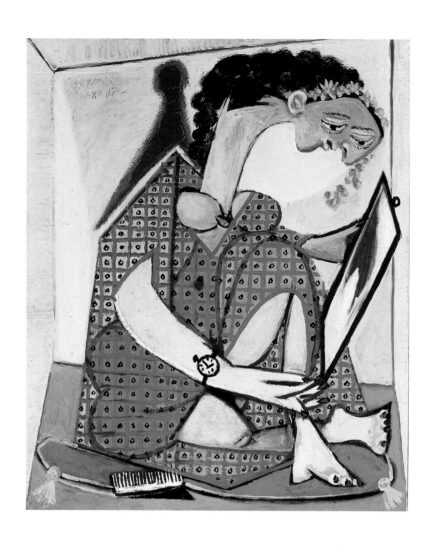

Woman with a Watch · 30 April 1936

Musée Picasso, Paris

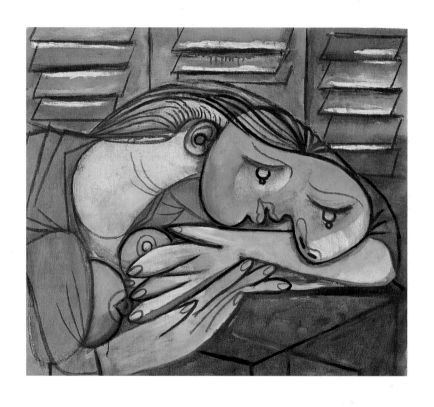

Sleeping Woman with Shutters · 25 April 1936
Musée Picasso, Paris

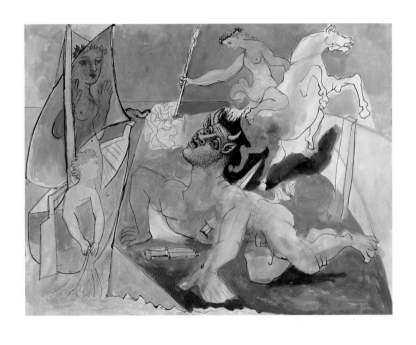

Composition with Minotaur · 9 May 1936
Private collection

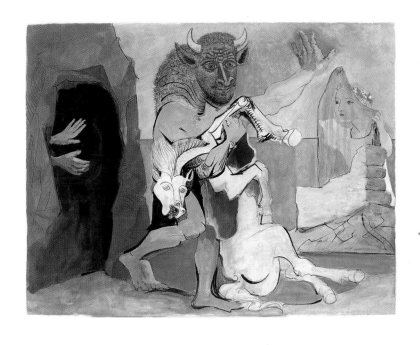

Minotaur and Dead Mare before a Cave Facing a Girl in a Veil · 9 May 1936
Musée Picasso, Paris

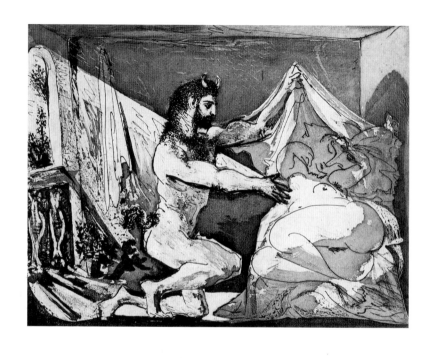

Faun Unveiling a Woman · 12 June 1936
The Museum of Modern Art, New York

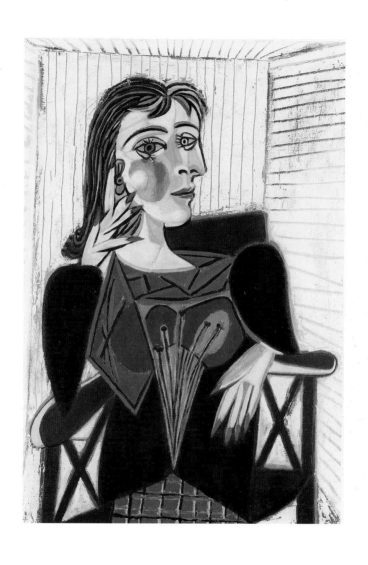

Portrait of Dora Maar · 1937
Musée Picasso, Paris

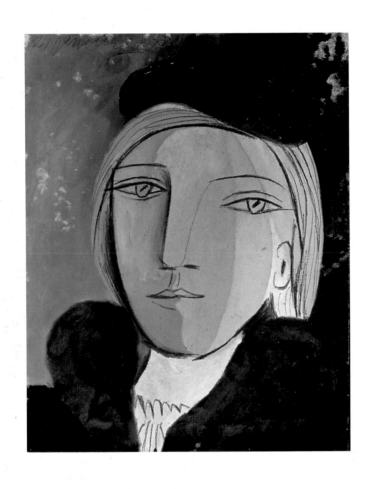

Portrait of Marie-Thérèse · 21 January 1937
Private collection

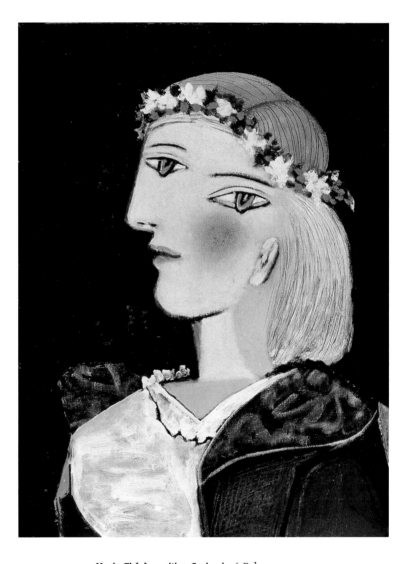

Marie-Thérèse with a Garland · 6 February 1937
Private collection
> **Woman at the Mirror** · 16 February 1937
Kunstsammlung Nordrhein-Westfalen, Düsseldorf

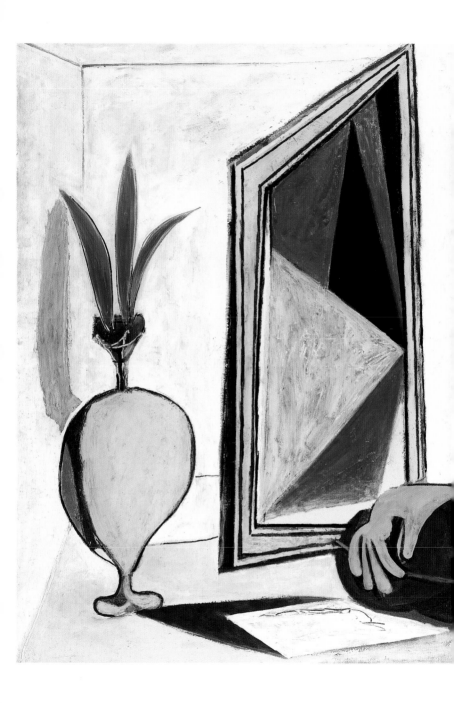

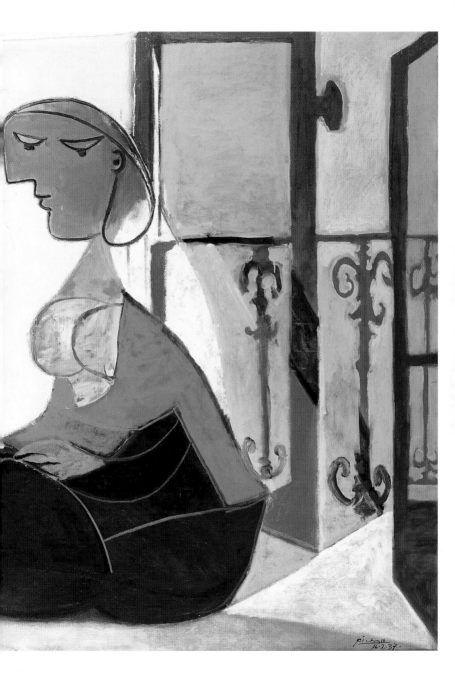

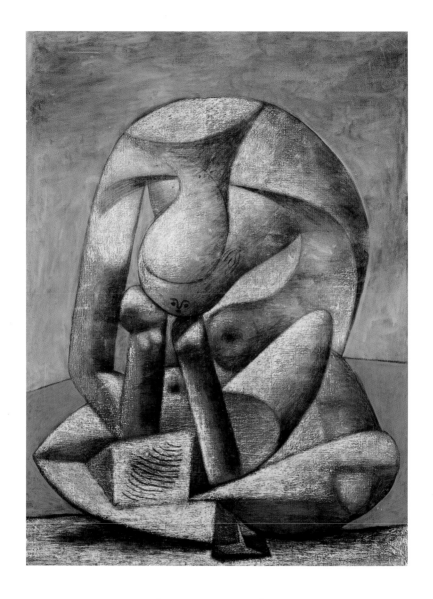

Large Bather with a Book · 18 February 1937
Musée Picasso, Paris

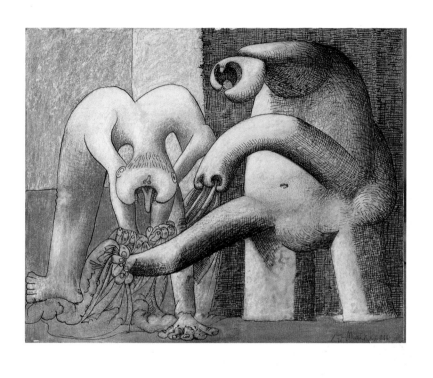

Two Nudes on the Beach · 1 May 1937
Musée Picasso, Paris

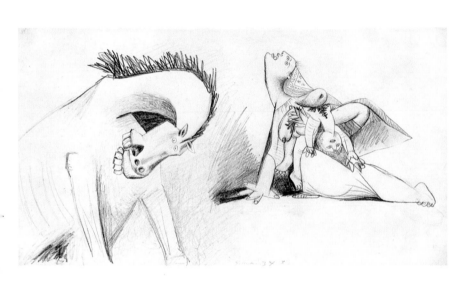

Study for "Guernica": Horse and Mother with Dead Child · 8 May 1937
Museo Nacional Centro de Arte Reina Sofía, Madrid
Studies for "Guernica": Hooves and Heads of a Horse · 10 May 1937
Museo Nacional Centro de Arte Reina Sofía, Madrid

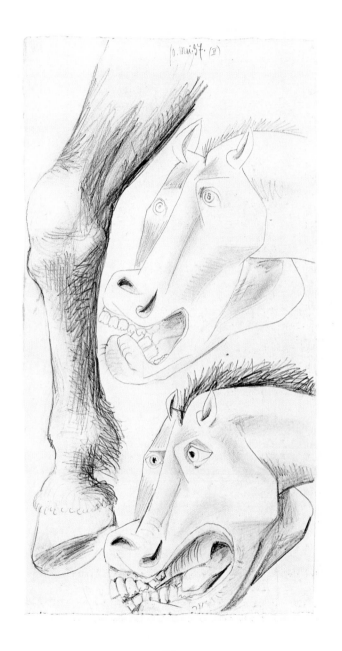

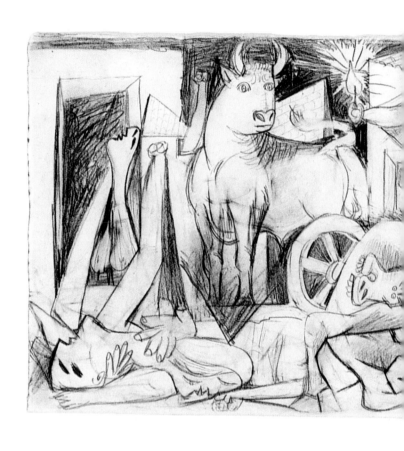

Study for "Guernica" · 9 May 1937
Museo Nacional Centro de Arte Reina Sofía, Madrid

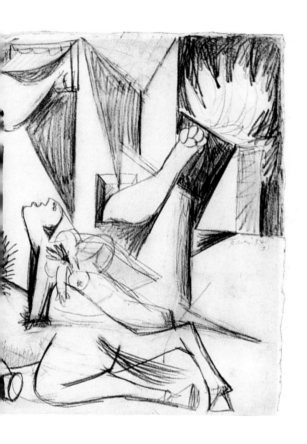

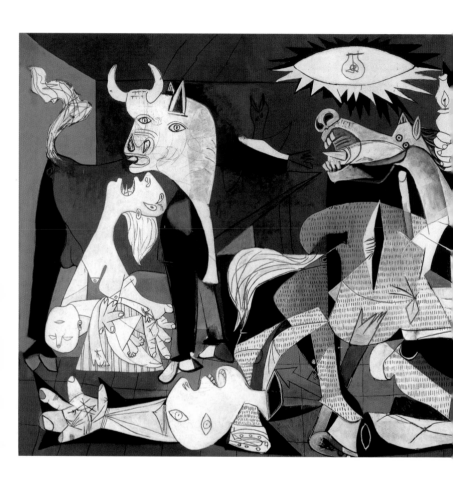

Guernica · 1 May–4 June 1937
Museo Nacional Centro de Arte Reina Sofía, Madrid

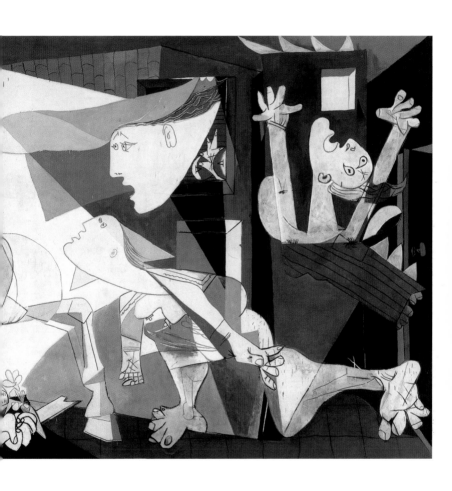

Horse before a Landscape · 23 October 1937
Private collection

Man Holding a Horse · 23 October 1937
Private collection

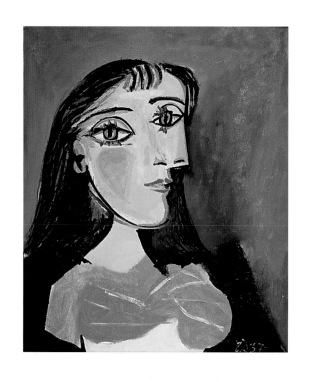

Portrait of a Woman · 8 December 1937
Private collection

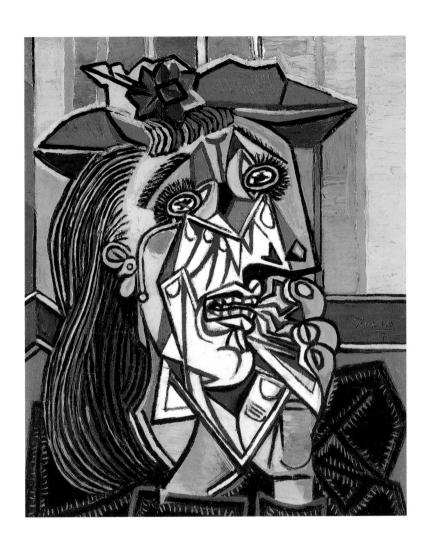

Woman in Tears · 26 October 1937
Private collection

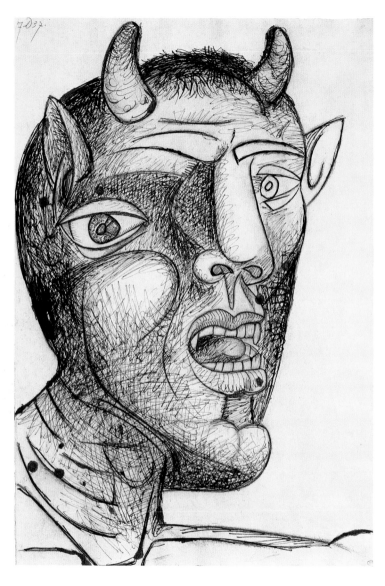

Minotaur · 7 December 1937

Musée Picasso, Paris

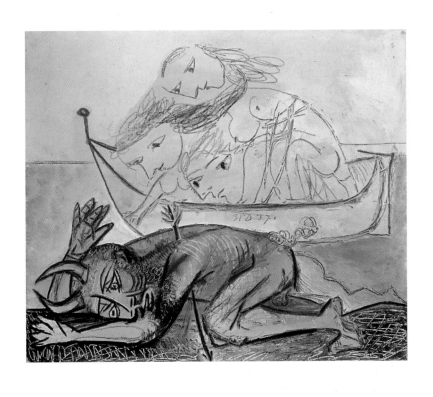

Wounded Faun · 31 December 1937
Private collection

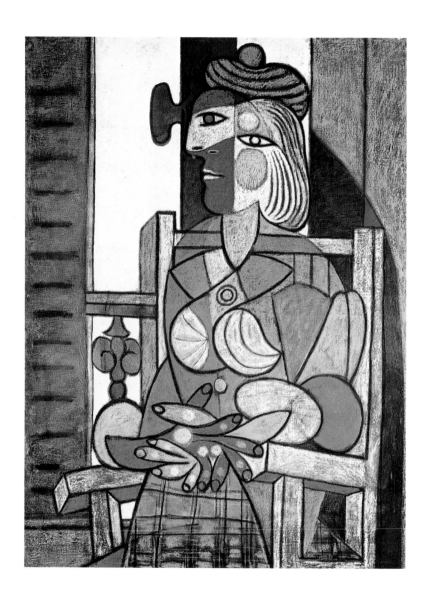

Woman Seated before the Window · 11 March 1937
Musée Picasso, Paris

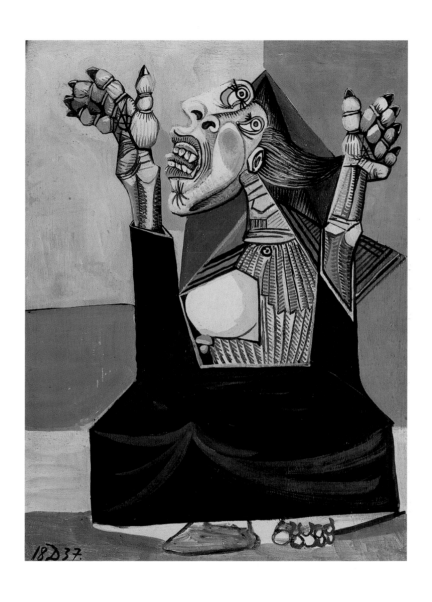

La Suppliante · 18 December 1937

Musée Picasso, Paris

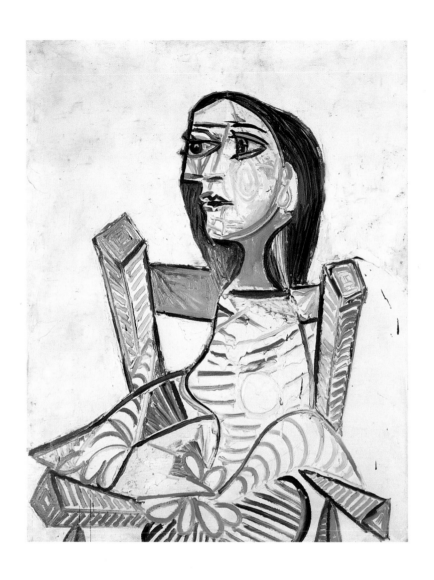

Seated Woman · 1938
Musée National d'Art Moderne, Centre Georges Pompidou, Paris

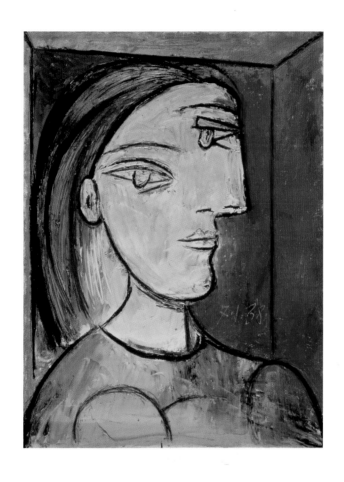

Marie-Thérèse · 7 January 1938

Private collection

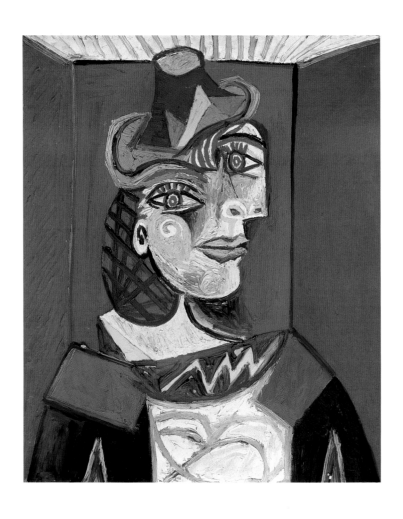

Woman in a Hairnet · 12 January 1938
Private collection

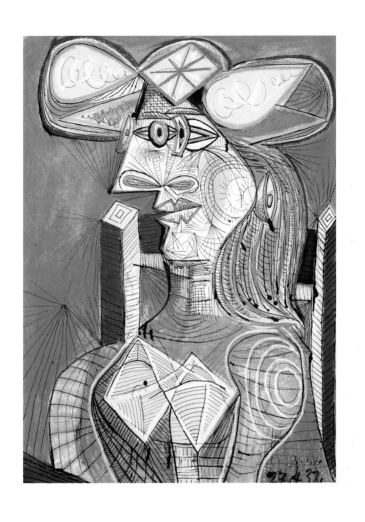

Seated Woman · 27 April 1938
Galerie Beyeler, Basel

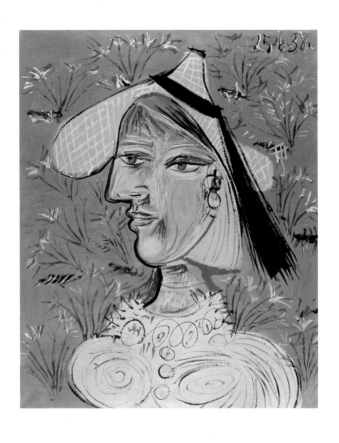

Woman in a Straw Hat against a Flowered Background · 25 June 1938

Rosengart Collection, Lucerne

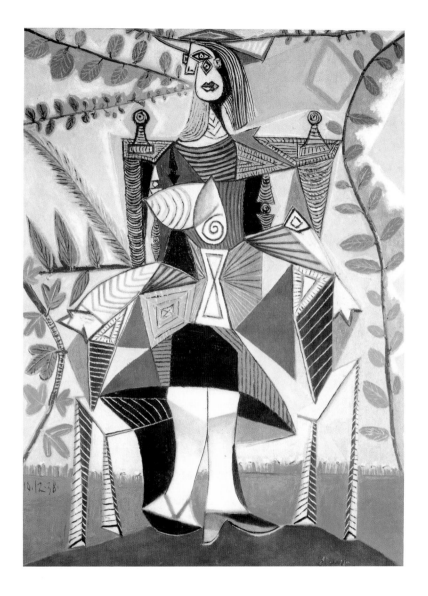

Seated Woman in a Garden · 10 December 1938
Private collection

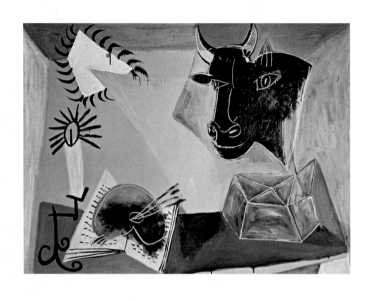

Still Life with a Black Bull, Book, Palette and Chandelier · 19 November 1938
Private collection

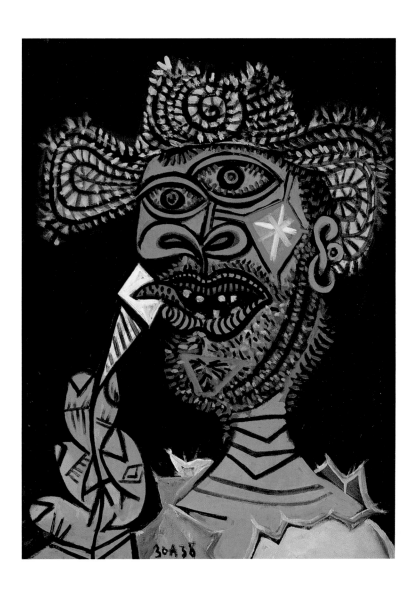

Man in a Straw Hat with Ice Cream Cone · 30 August 1938
Musée Picasso, Paris

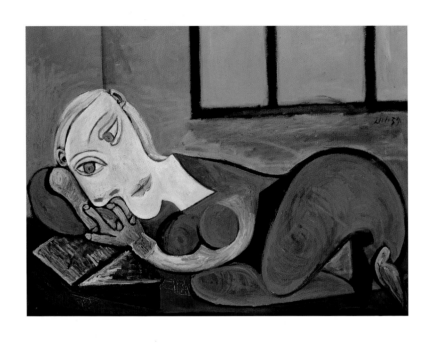

Reclining Woman Reading · 21 January 1939

Musée Picasso, Paris

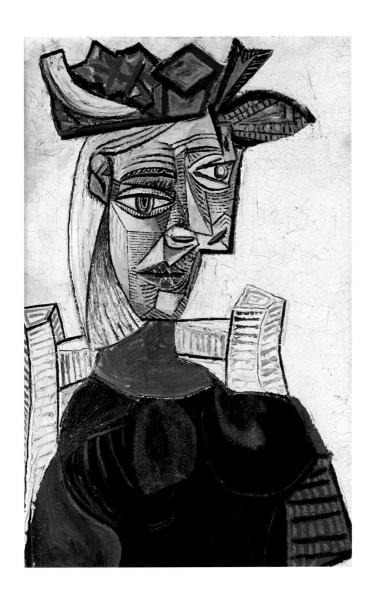

Seated Woman in a Hat · 27 May 1939
Musée Picasso, Paris

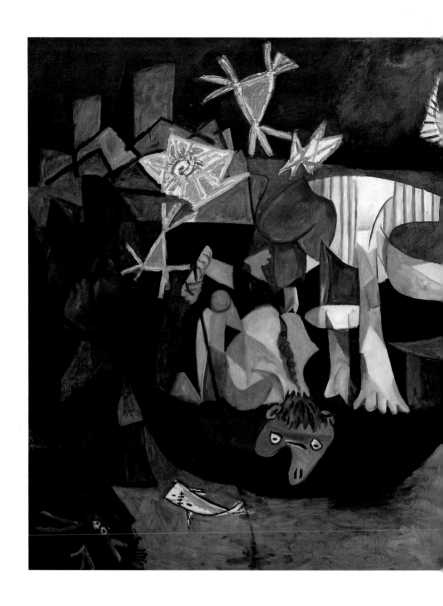

Night Fishing at Antibes · August 1939

The Museum of Modern Art, New York, Mrs. Simon Guggenheim Collection

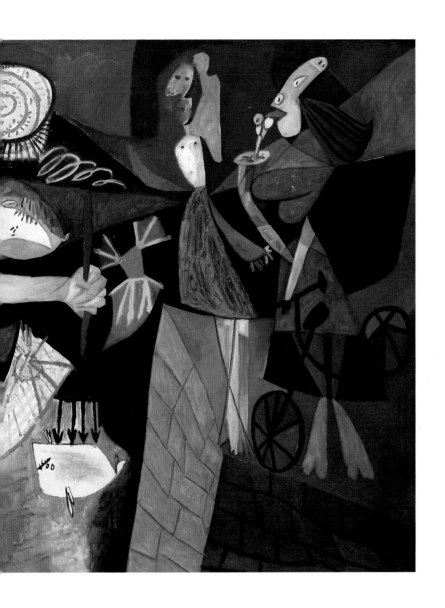

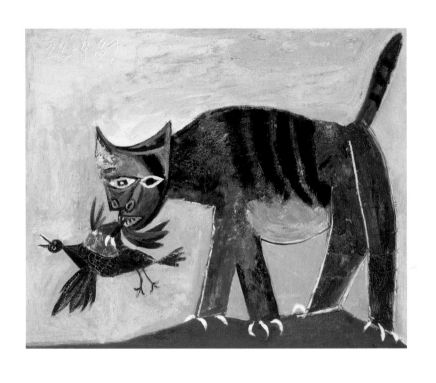

Cat Catching a Bird · 22 April 1939
Musée Picasso, Paris

Café in Royan · 15 August 1940
Musée Picasso, Paris

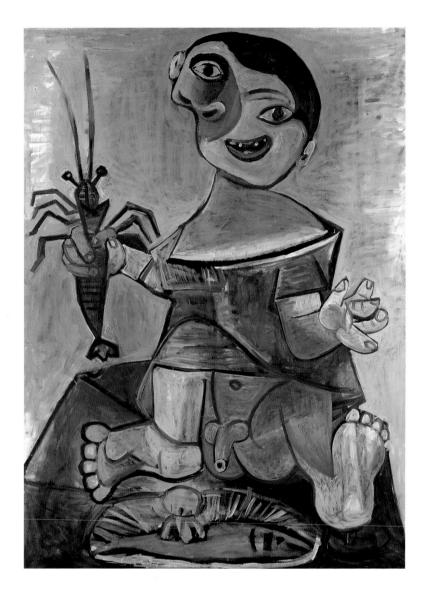

Young Boy with a Crayfish · 21 June 1941

Musée Picasso, Paris

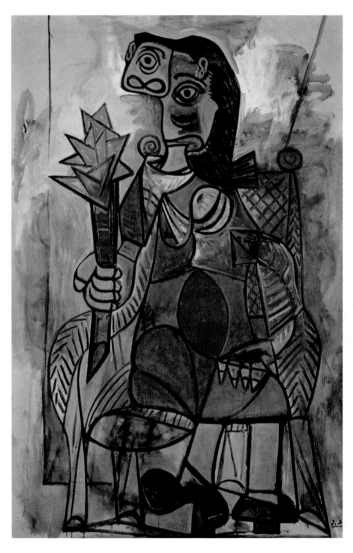

Woman with an Artichoke · summer 1941
Museum Ludwig, Cologne
> **L'Aubade** · 4 May 1942
Musée National d'Art Moderne, Centre Georges Pompidou, Paris

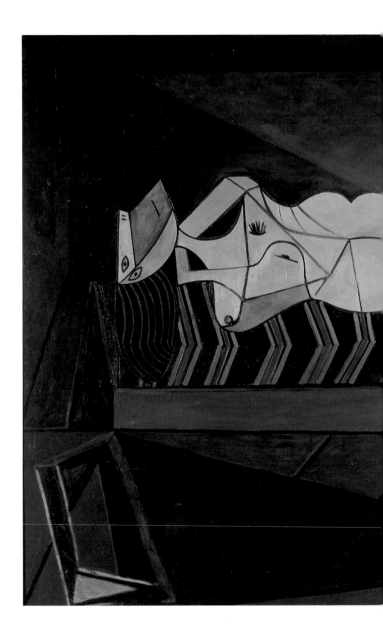

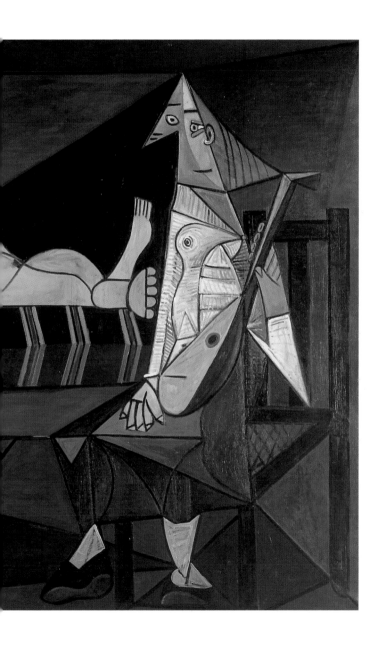

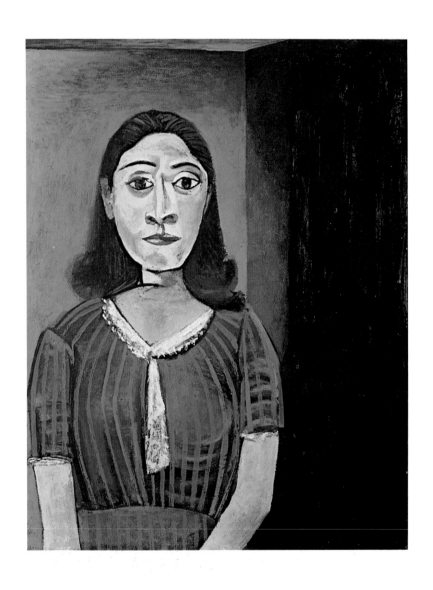

Portrait of Dora Maar · 9 October 1942
Private collection

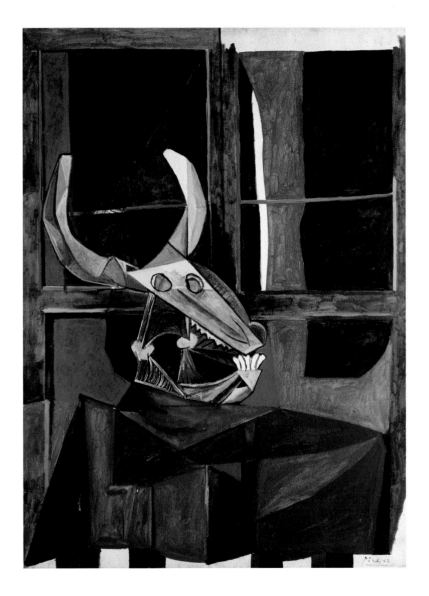

Still Life with Steer's Skull · 5 April 1942
Kunstsammlung Nordrhein-Westfalen, Düsseldorf

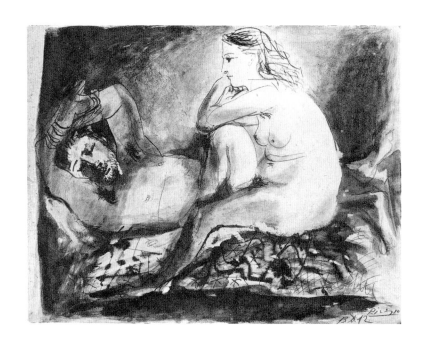

Reclining Man and Seated Woman · 13 December 1942
Private collection

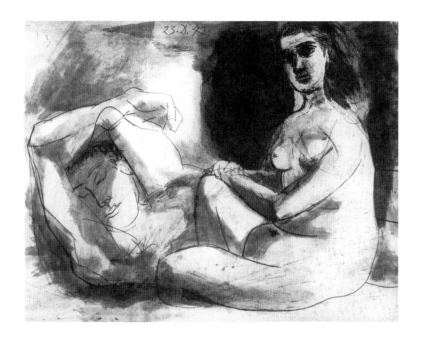

Reclining Man and Seated Woman · 1942
Private collection

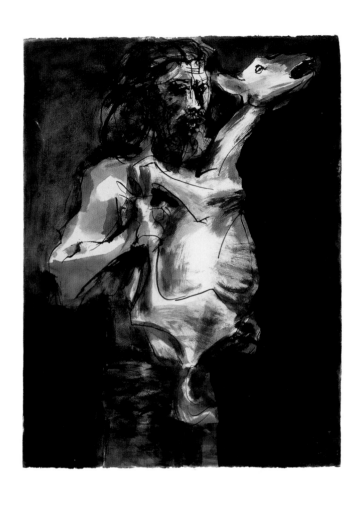

Study for "Man with a Sheep" · 19 February 1943
Musée Picasso, Paris

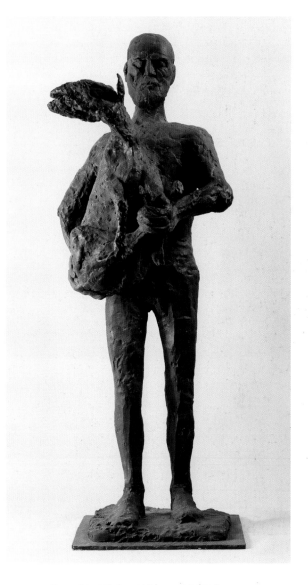

Man with a Sheep · February–March 1943
Musée Picasso, Paris

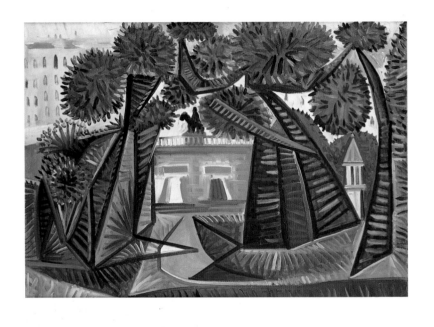

Le Vert-Galant · 25 June 1943

Musée Picasso, Paris

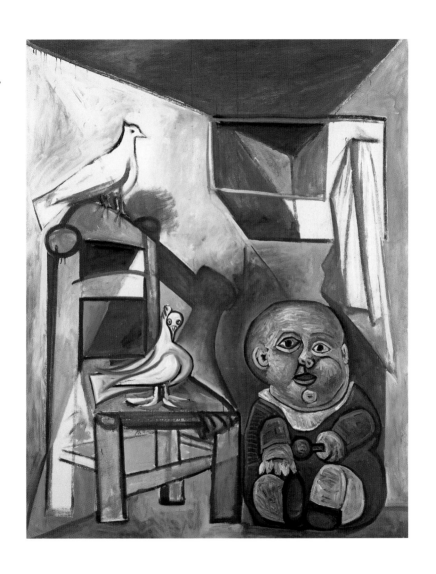

Child with Doves · 24 August 1943
Musée Picasso, Paris

> **The Charnel House** · 1945
The Museum of Modern Art, New York

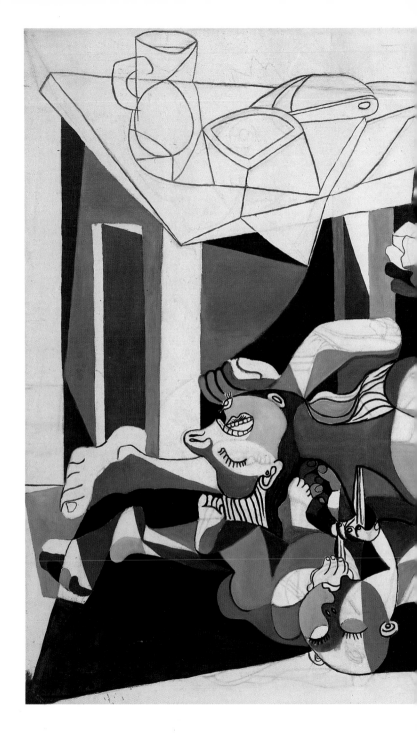

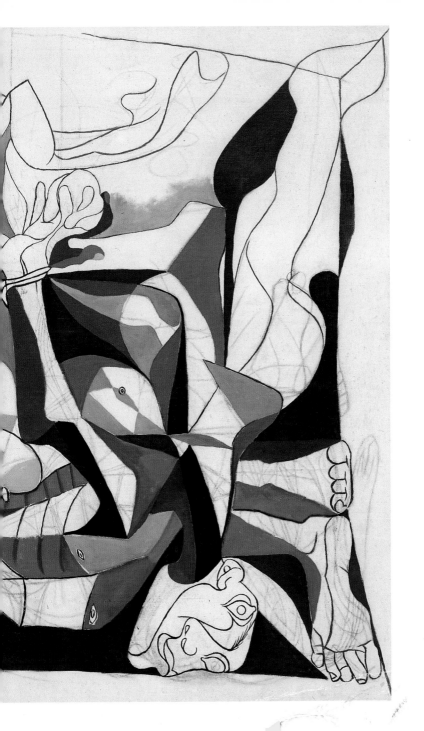

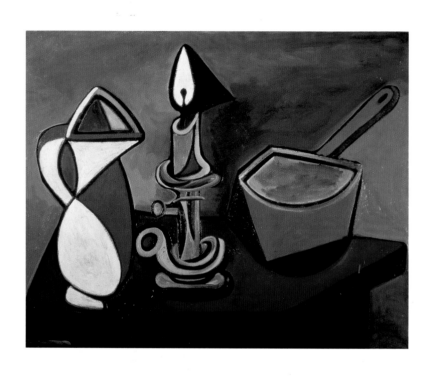

The Enamel Saucepan · 16 February 1945
Musée National d'Art Moderne, Centre Georges Pompidou, Paris

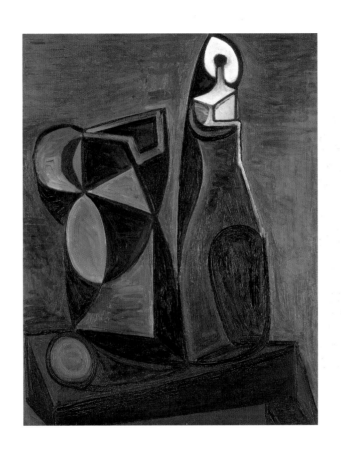

Still Life with Candle · 21 February 1945
Musée Picasso, Paris

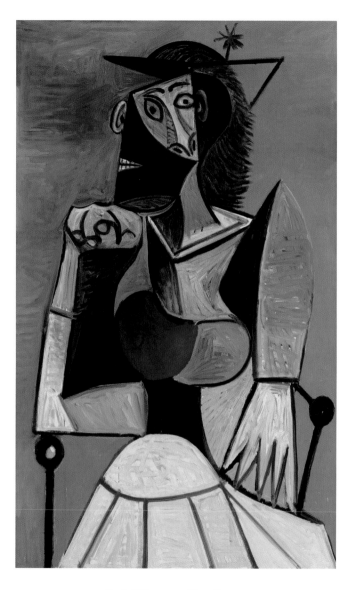

Seated Woman · 5 March 1945
Musée Picasso, Paris

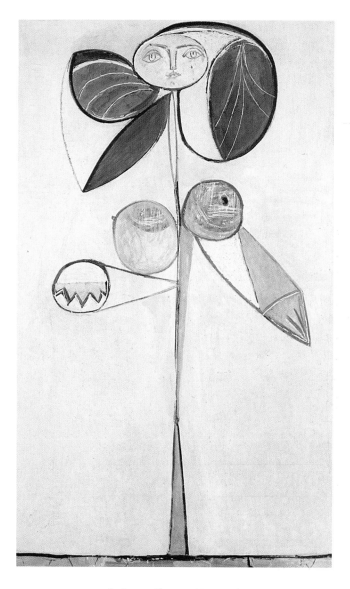

La Femme Fleur · 5 May 1946

Private collection

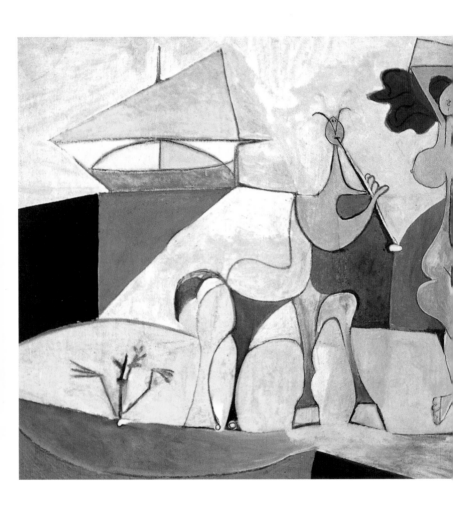

La Joie de Vivre (Antipolis) · 1946
Musée Picasso, Antibes

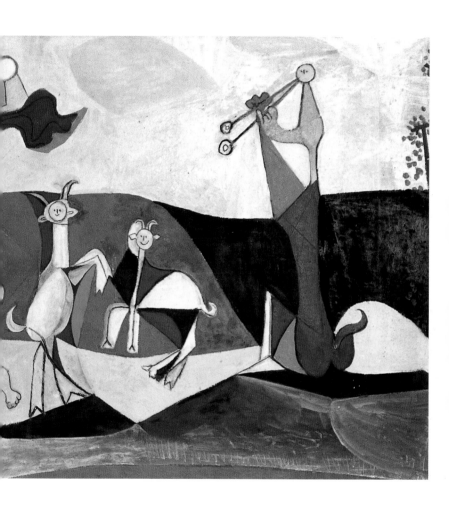

319

Standing Nude · 28 June 1946
Musée Picasso, Paris

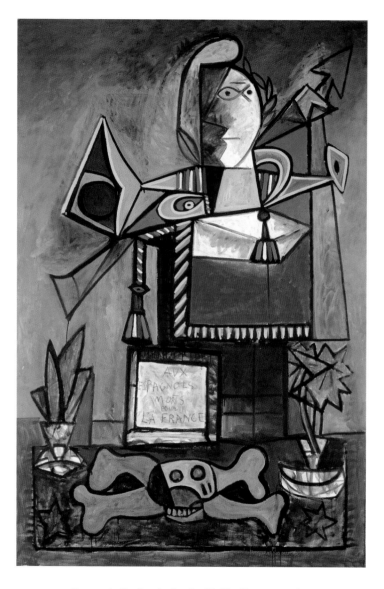

Homage to the Spaniards who Died for France · 1946–7

Museo Nacional Centro de Arte Reina Sofía, Madrid

Three Heads · 1 November 1947
Galerie Louise Leiris, Paris

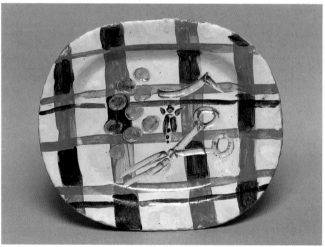

Rectangular Plate decorated with the Head of a Faun · 20 October 1947
Musée Picasso, Paris
Rectangular Plate decorated with a Bunch of Grapes and Scissors · 1948
Musée Picasso, Paris

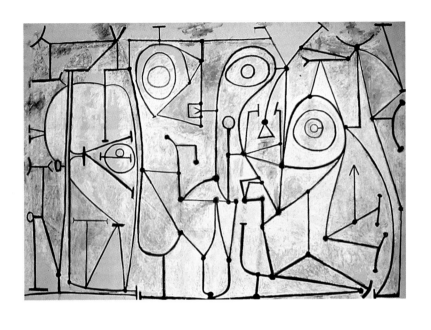

The Kitchen · 9 November 1948

The Museum of Modern Art, New York

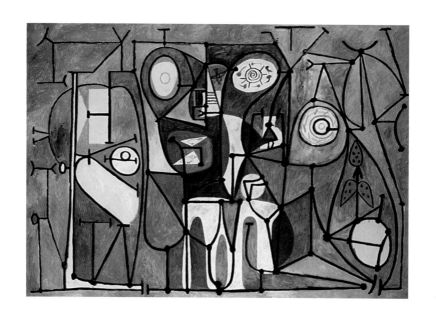

The Kitchen · November 1948
Musée Picasso, Paris

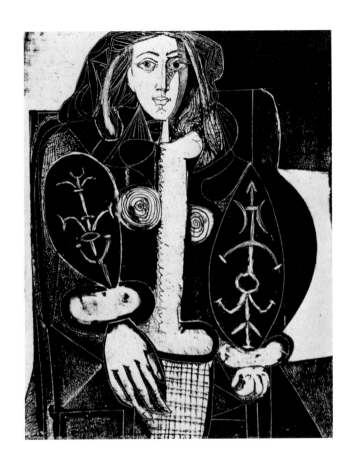

Woman in an Armchair I · 17 December 1948
Musée Picasso, Paris

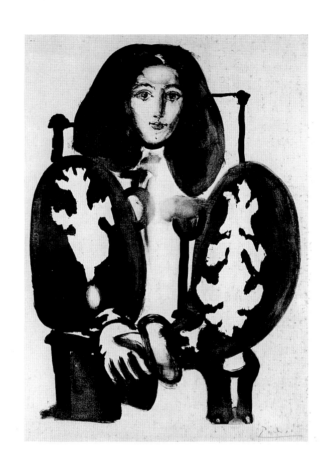

Woman in an Armchair I (The Polish Coat) · 1949
Musée Picasso, Paris

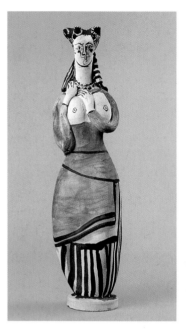 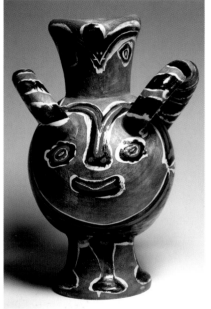

Vase: Woman in a Mantilla · 1949
Musée Picasso, Paris
Owl-Shaped Vase · 1949
Musée Picasso, Antibes

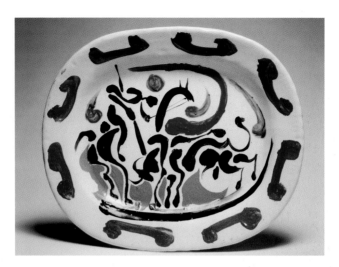

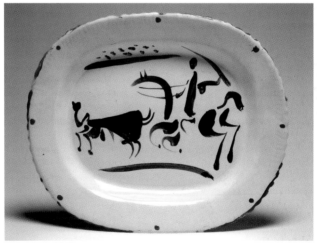

Rectangular Plate decorated with Corrida · 1949
Musée Picasso, Antibes
Rectangular Plate decorated with Corrida · 1949
Musée Picasso, Antibes

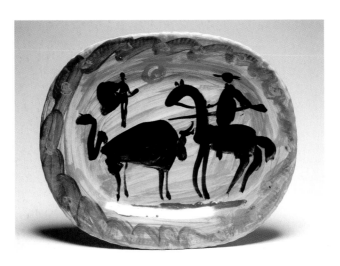

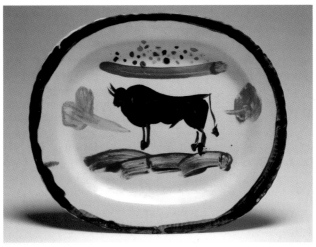

Rectangular Plate decorated with Corrida · 1949
Musée Picasso, Antibes
Rectangular Plate decorated with Corrida · 1949
Musée Picasso, Antibes

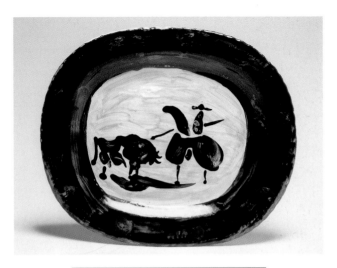

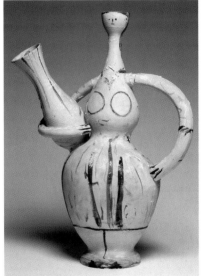

Rectangular Plate decorated with Corrida · 1949
Musée Picasso, Antibes
Tanagra with Amphora · 1949
Musée Picasso, Antibes

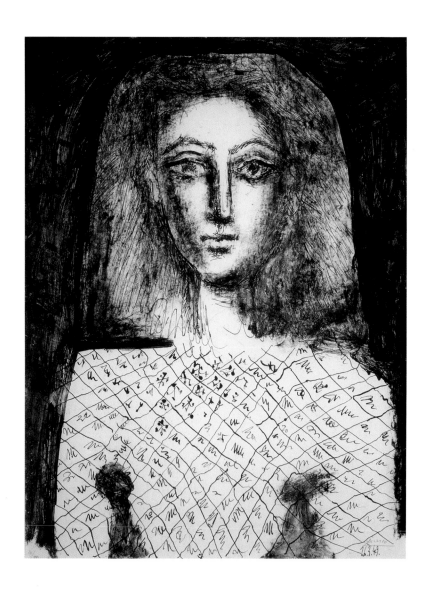

The Checked Blouse · 26 March 1949

Musée Picasso, Antibes

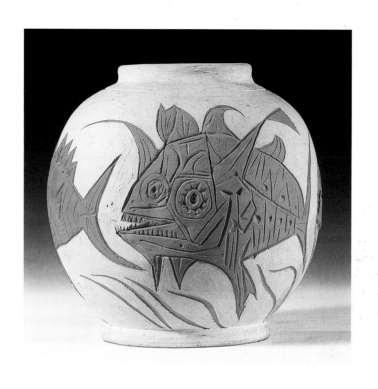

Bulbous Vase: "Four Fish" · 1 July 1950
Galerie Beyeler, Basel

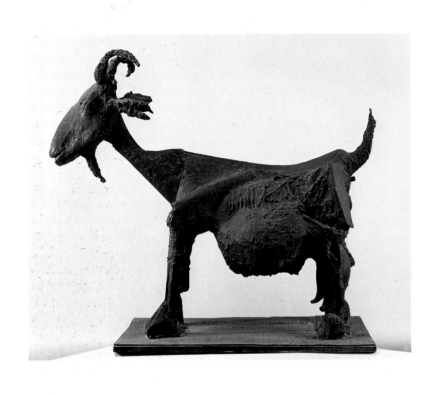

The Goat · 1950
Musée Picasso, Paris

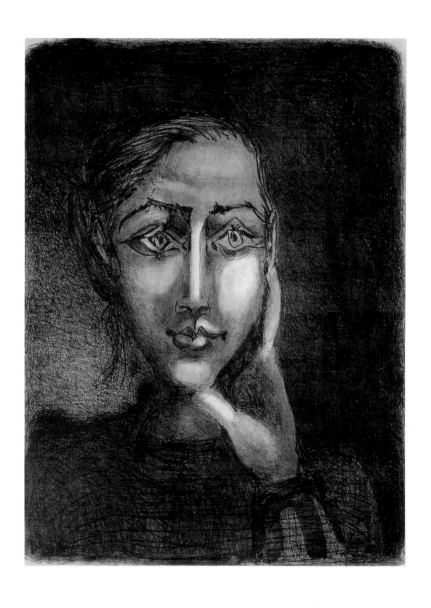

Françoise Gilot against a Gray Background · 19 November 1950
Musée Picasso, Antibes

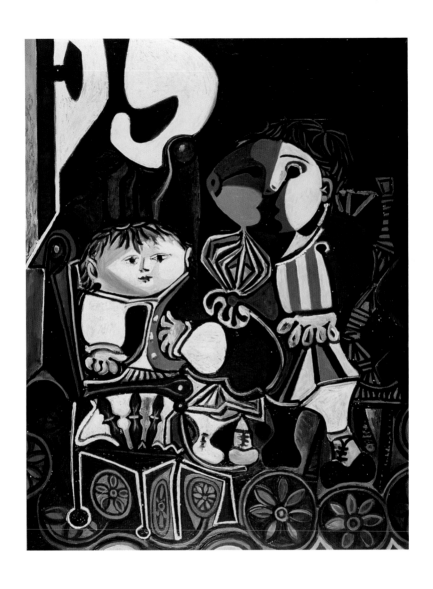

Claude and Paloma · 20 January 1950
Private collection

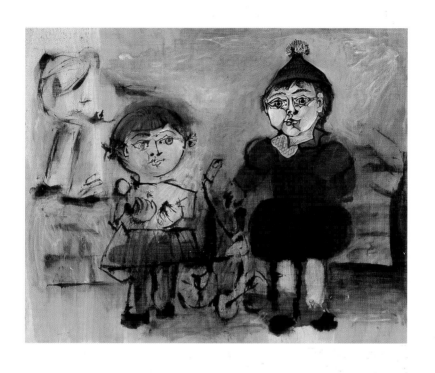

Reclining Woman · 1951
Private collection

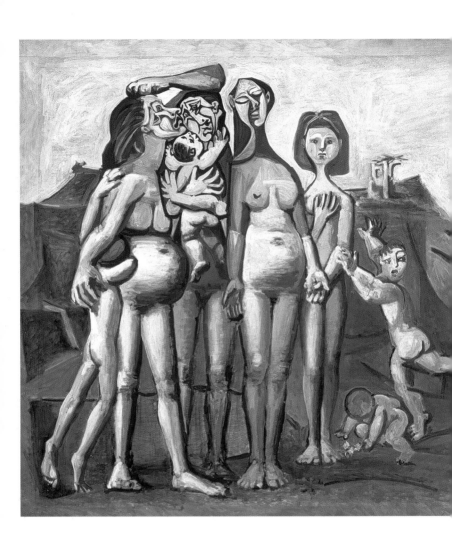

Massacres in Korea · 18 January 1951

Musée Picasso, Paris

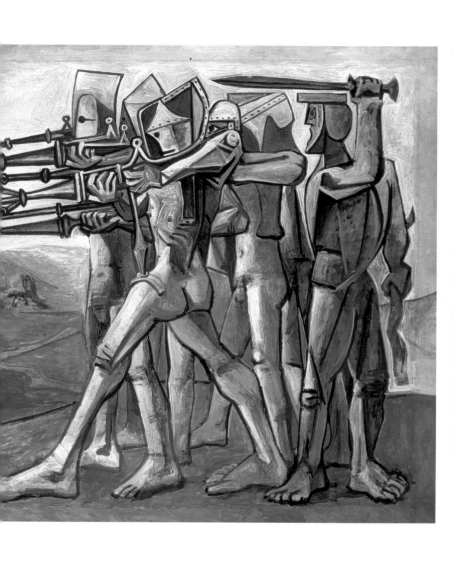

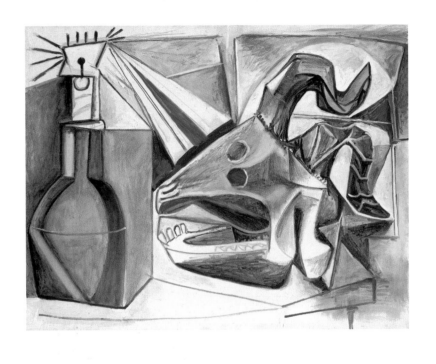

Goat's Skull, Bottle and Candle · 25 March 1952

Musée Picasso, Paris

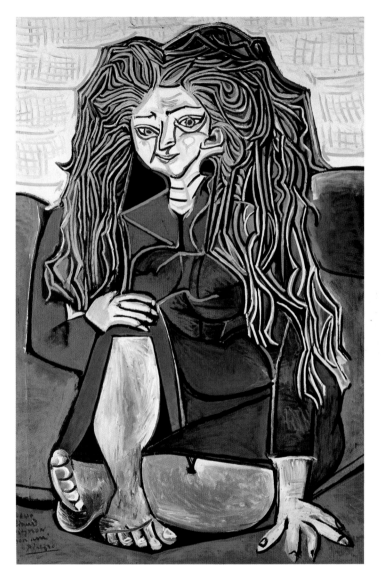

Portrait of Madame P. (Hélène Parmelin) · 1952
Private collection

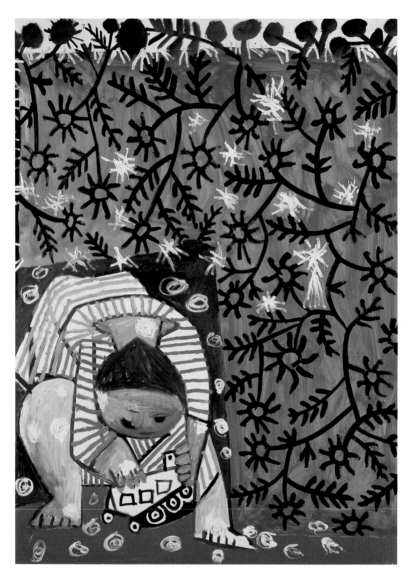

Child Playing with a Toy Truck · 27 December 1953
Musée Picasso, Paris

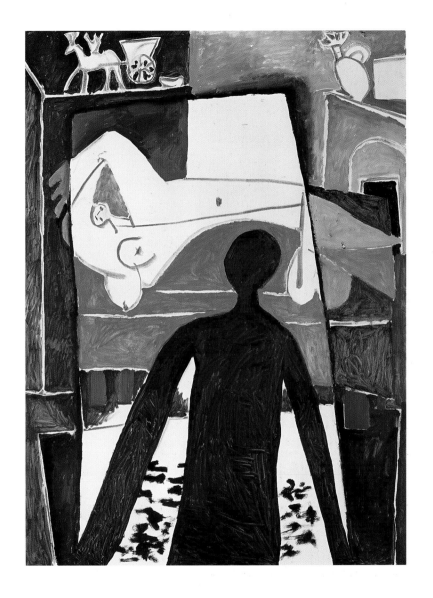

The Shadow · 29 December 1953
Musée Picasso, Paris

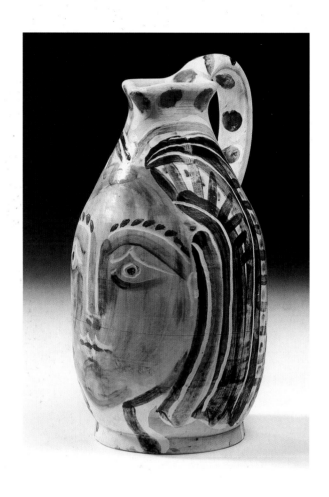

Jug: Face of a Woman · 10 July 1953
Galerie Beyeler, Basel

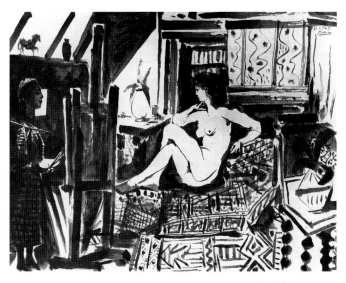

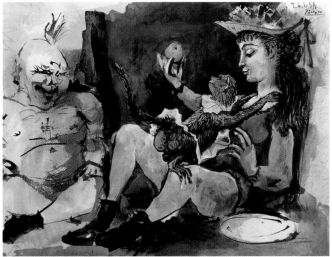

Interior (Woman Painter and Nude in the Studio) · 21 January 1954
Mr. and Mrs. Daniel Saidenberg Collection, New York
Seated Man, Girl with Monkey and Apple · 26 January 1954
Private collection

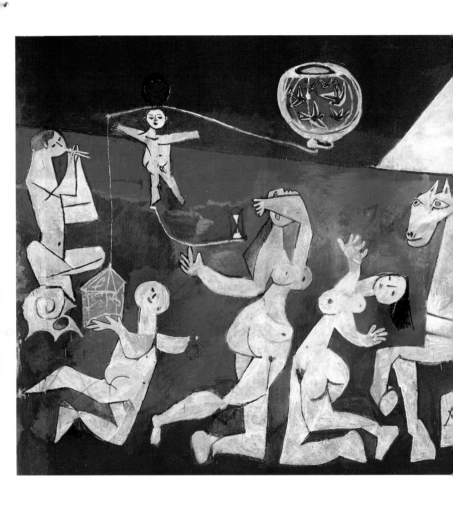

Peace · 1954
Chapel of the Château, Temple de la Paix, Vallauris

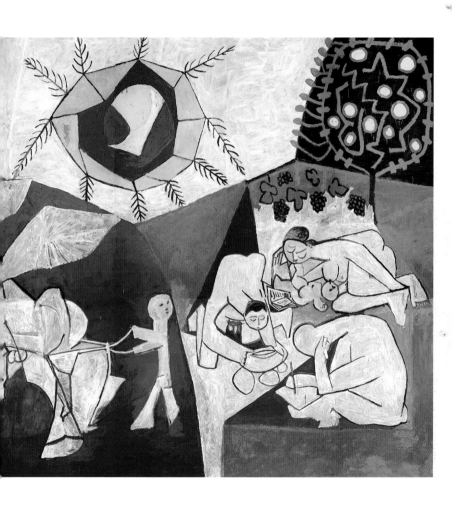

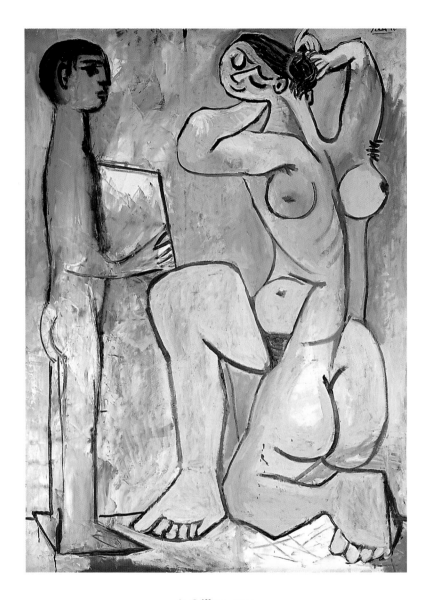

La Coiffure · 1954
Picasso Museum, Lucerne

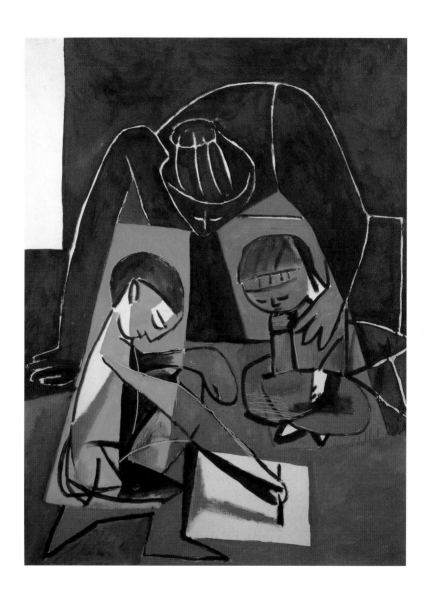

Claude Drawing, Françoise, and Paloma · 17 May 1954
Musée Picasso, Paris

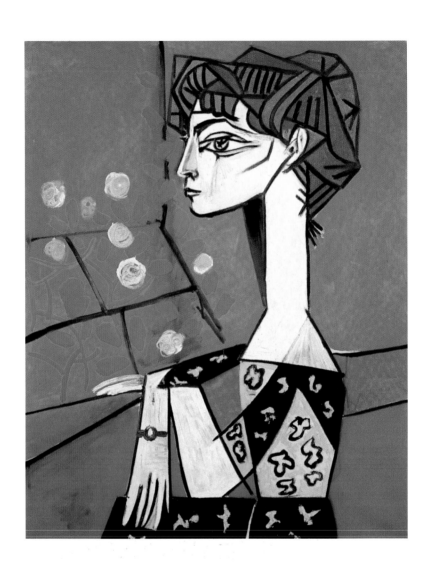

Jacqueline with Flowers · 2 June 1954

Private collection

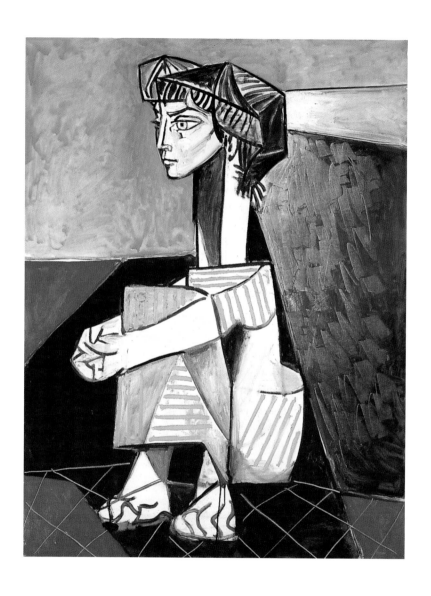

Jacqueline with Crossed Hands · 3 June 1954
Private collection

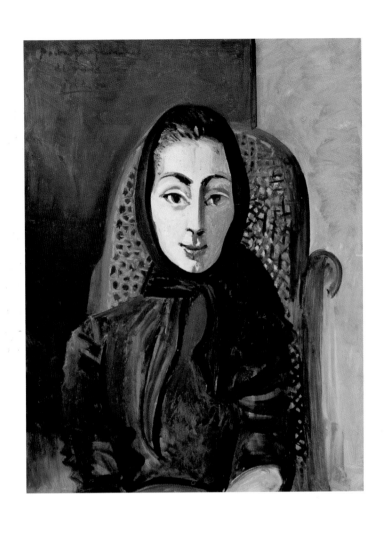

Jacqueline with a Black Shawl · 11 October 1954
Private collection

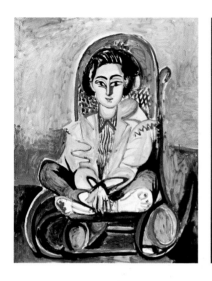 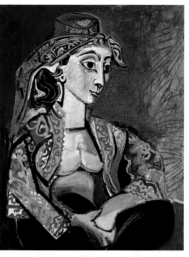

Jacqueline in a Rocking Chair · 9 October 1954
Private collection
Woman in a Turkish Jacket · 20 November 1955
Private collection
> **The Women of Algiers, after Delacroix** · 14 February 1955
Private collection

353

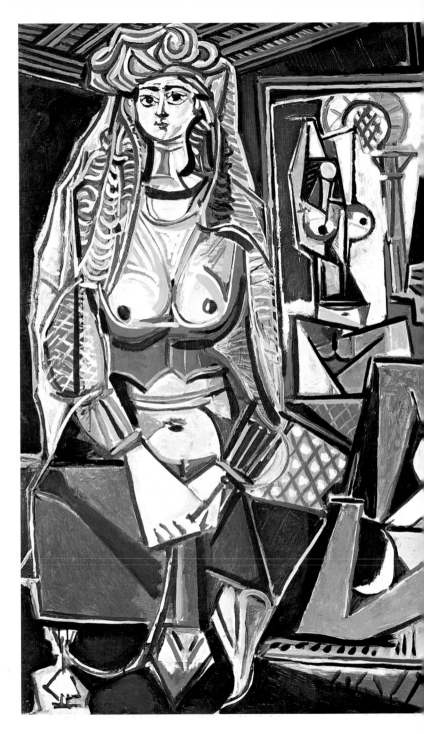

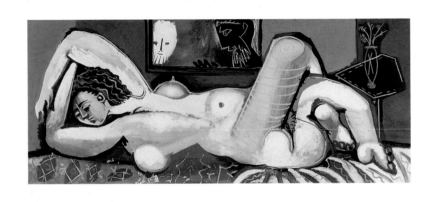

Susanna and the Elders · 1955
Private collection

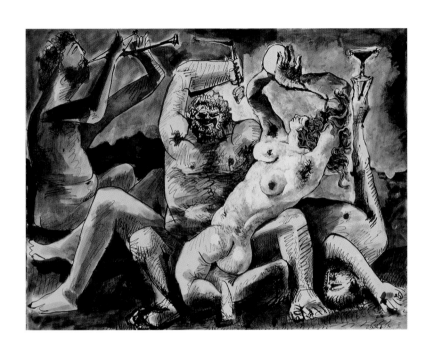

Bacchanale · 22–3 September 1955
Private collection

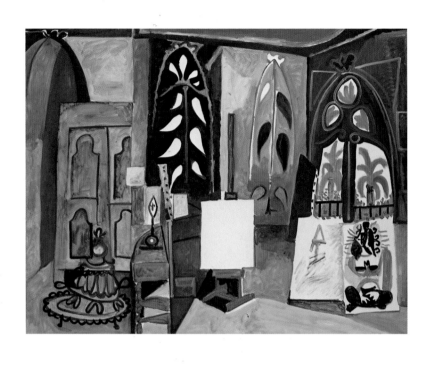

The Studio at La Californie, Cannes · 29 October 1955
Musée Picasso, Paris

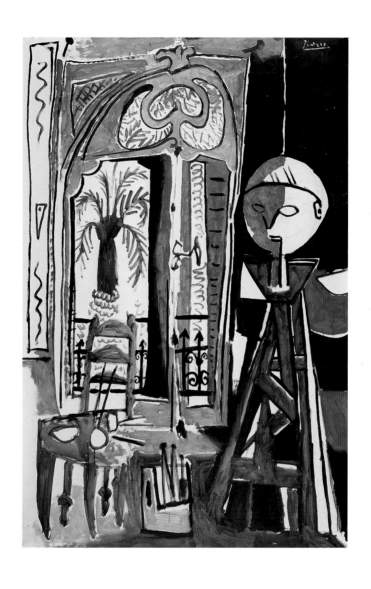

The Studio · 23 October 1955
Picasso Museum, Lucerne

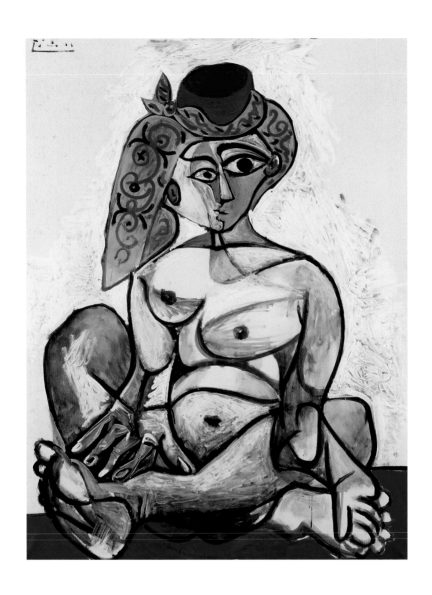

Nude in a Turkish Hat · 1 December 1955
Musée National d'Art Moderne, Centre Georges Pompidou, Paris

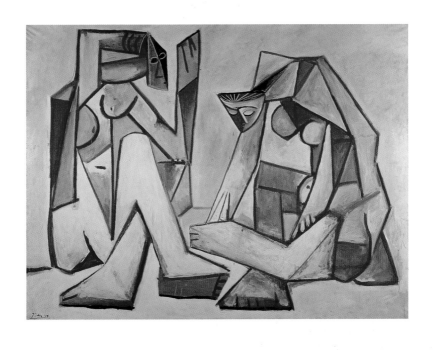

Two Women on the Beach · 6 February–26 March 1956
Musée National d'Art Moderne, Centre Georges Pompidou, Paris

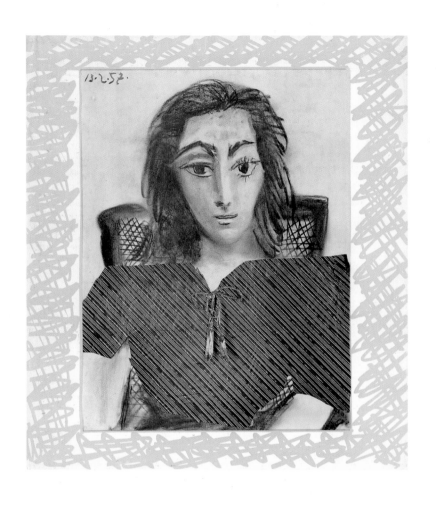

Portrait of Jacqueline · 13 February 1957
Private collection

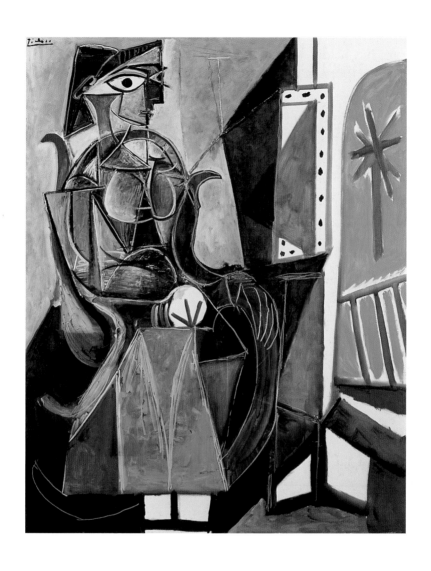

Woman Seated near the Window (Jacqueline) · 11 June 1956
The Museum of Modern Art, New York

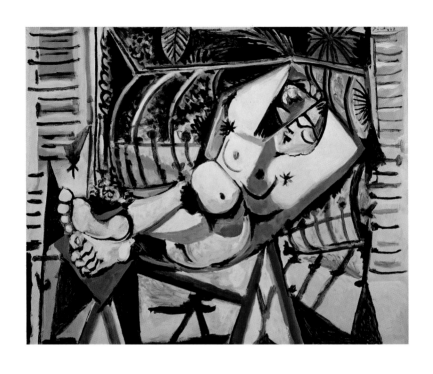

Reclining Nude before a Window · 29–31 August 1956
Stedelijk Museum, Amsterdam

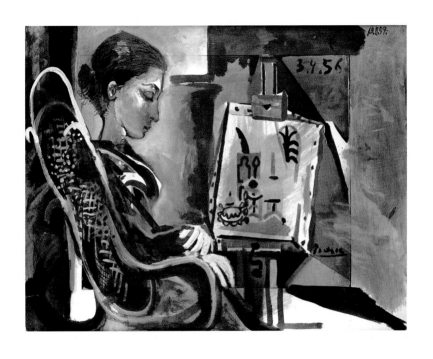

Jacqueline in the Studio · 13 November 1956
Musée Picasso, Paris
> **Las Meninas** · 17 August 1957
Museu Picasso, Barcelona

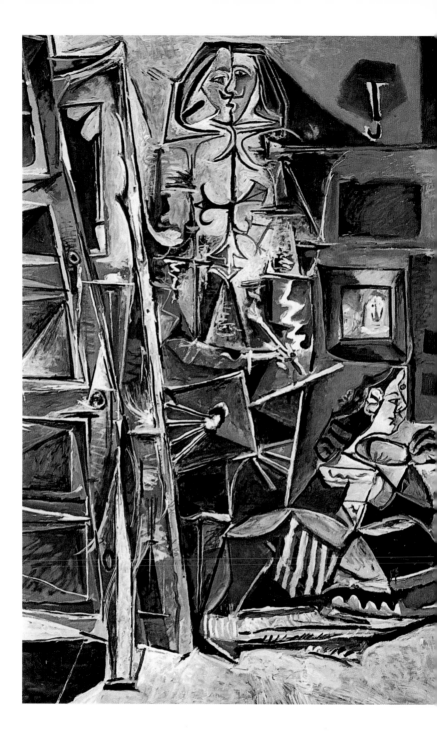

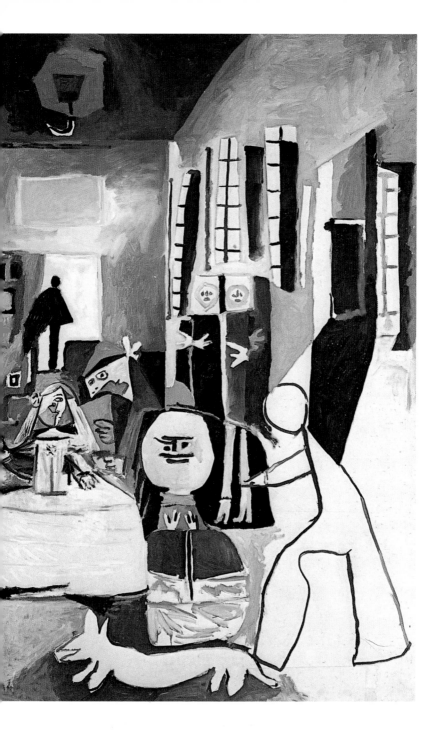

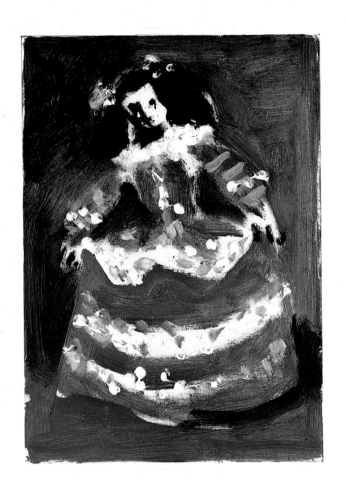

Las Meninas (Isabel de Velasco) · 30 December 1957
Museu Picasso, Barcelona

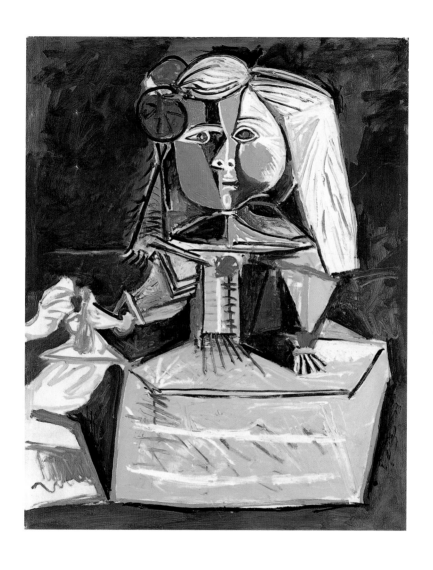

Las Meninas (Infanta Margarita María) · 14 September 1957
Museu Picasso, Barcelona
> **The Bay of Cannes** · 19 April–9 June 1958
Musée Picasso, Paris

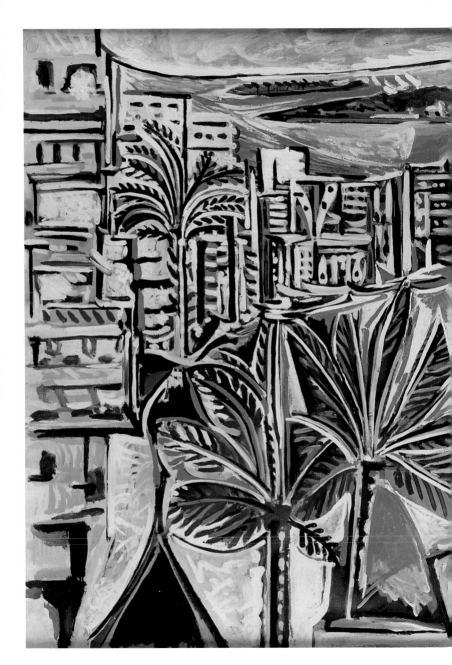

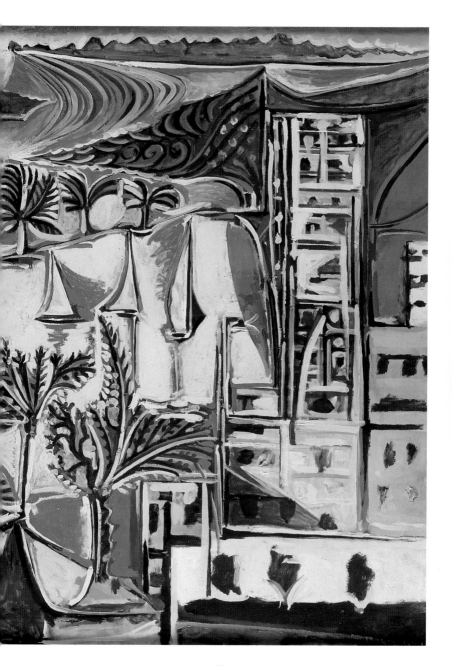

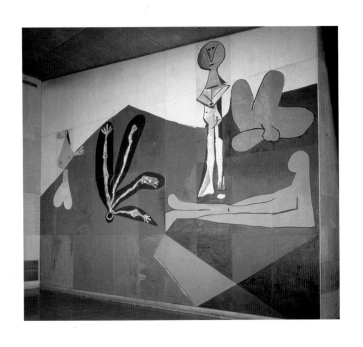

The Fall of Icarus · 1958
Lobby of the Hall of the Delegates, UNESCO headquarters, Paris

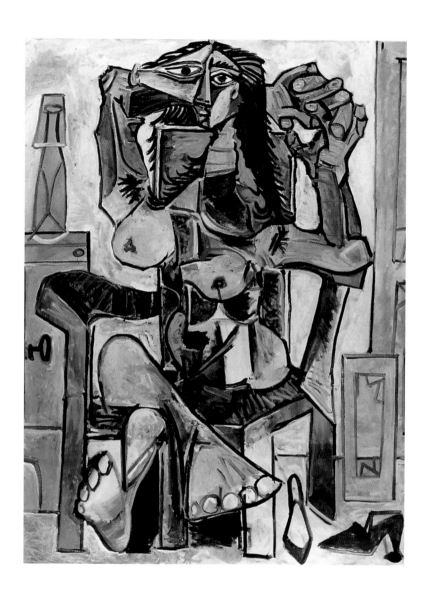

Seated Nude · 1959
Private collection

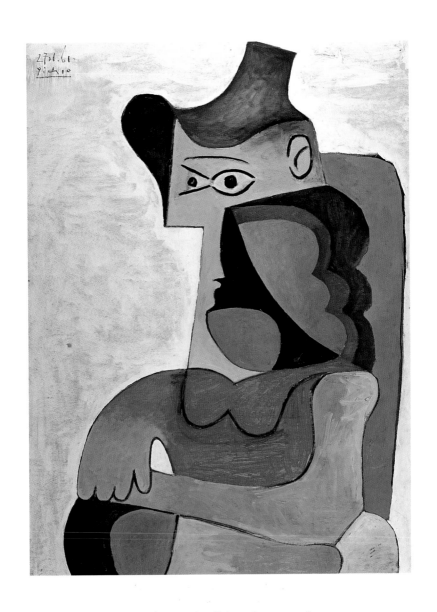

Seated Woman in a Hat · 27 January 1961
Rosengart Collection, Lucerne

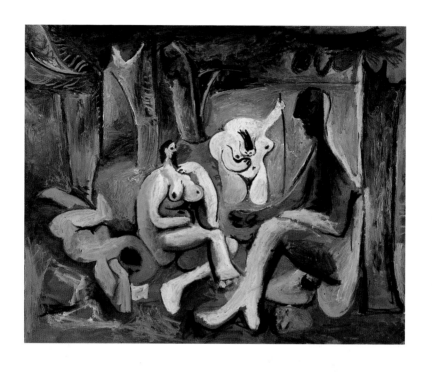

Le Déjeuner sur l'Herbe, after Manet · 12 July 1961
Musée Picasso, Paris
> **Le Déjeuner sur l'Herbe, after Manet** · 17 June 1961
Private collection

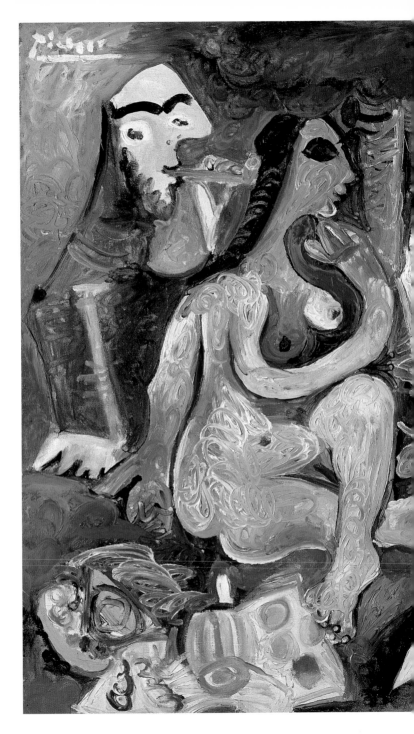

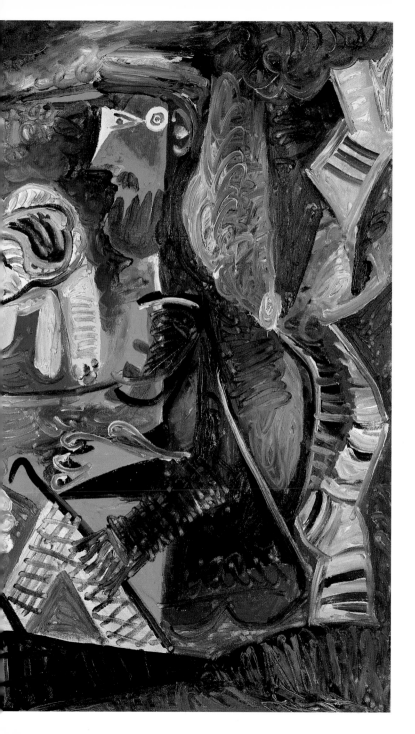

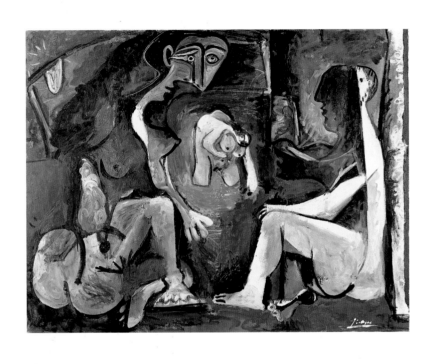

Le Déjeuner sur l'Herbe, after Manet · 16 July 1961

Picasso Museum, Lucerne

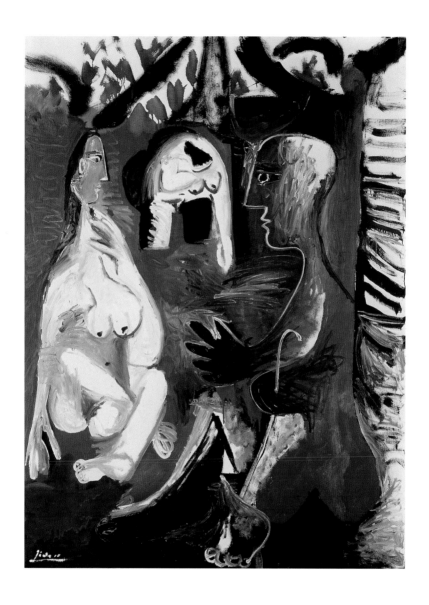

Le Déjeuner sur l'Herbe, after Manet · 30 July 1961

Louisiana Museum of Modern Art, Humlebæk, Denmark

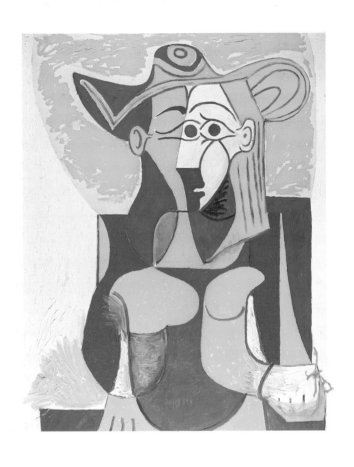

Seated Woman in a Yellow and Green Hat · 2 January 1962
Private collection

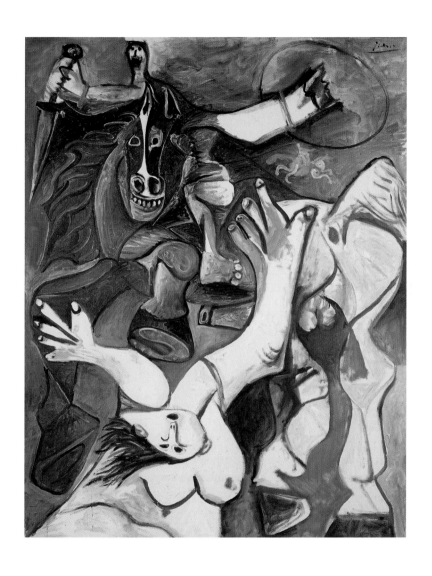

The Abduction of the Sabine Women · 2 and 4 November 1962
Norman Granz Collection, Beverly Hills

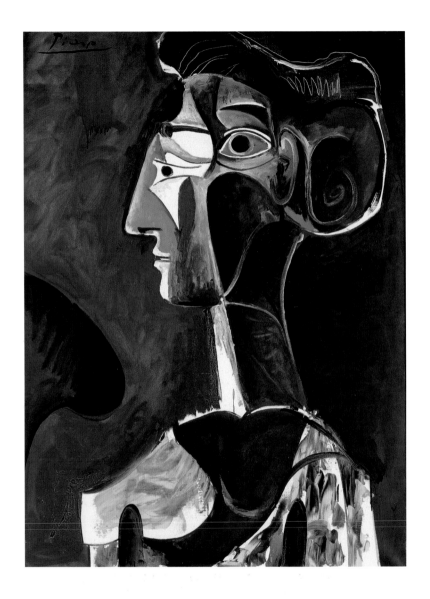

Large Profile · 7 January 1963
Kunstsammlung Nordrhein-Westfalen, Düsseldorf

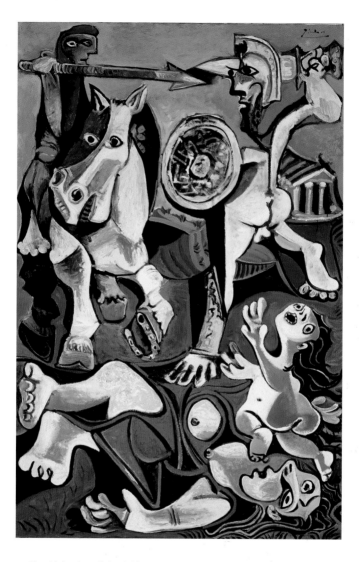

The Abduction of the Sabine Women · 9 January–7 February 1963
The Museum of Fine Arts, Boston, Juliana Cheney Edwards Collection
> **The Painter and his Model** · 3 and 8 April 1963
Museo Nacional Centro de Arte Reina Sofía, Madrid

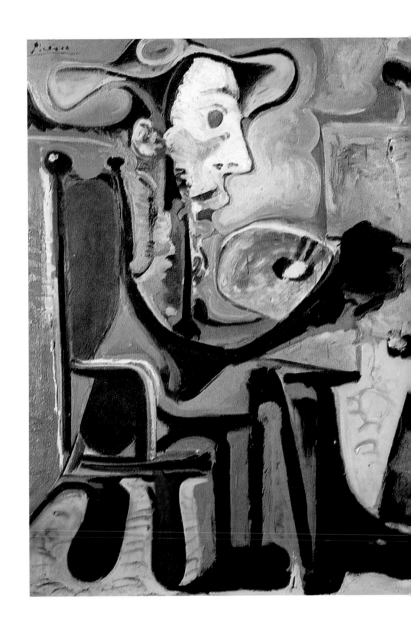

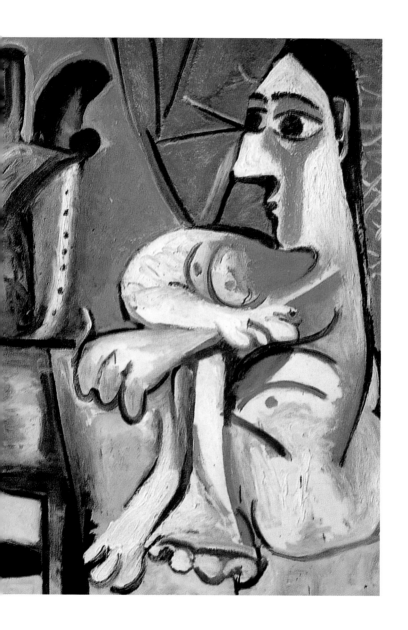

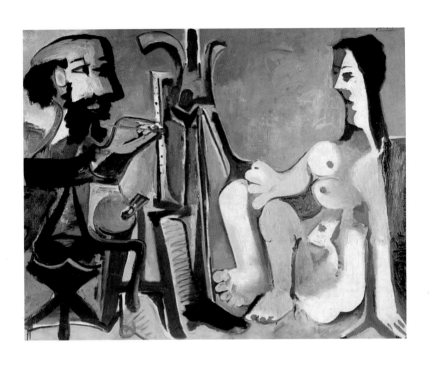

The Painter and his Model · 29 March and 1 April 1963
Galerie Beyeler, Basel

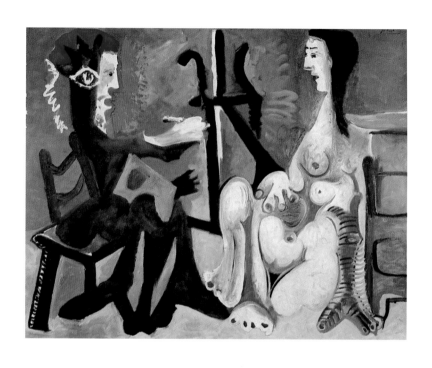

The Painter and his Model · 30 March 1963
Museo Nacional Centro de Arte Reina Sofía, Madrid

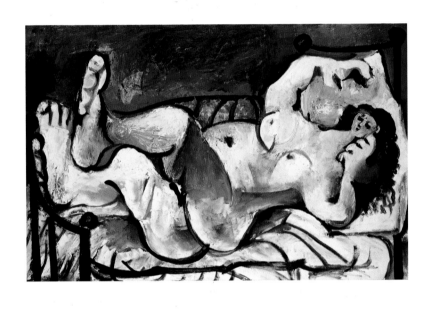

Reclining Nude · 9 and 18 January 1964
Rosengart Collection, Lucerne

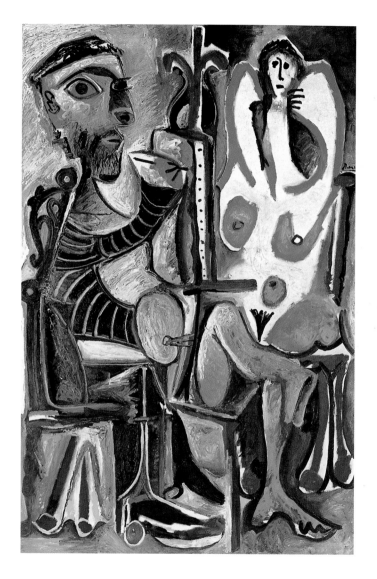

The Painter and his Model · 10 and 12 June 1963
Bayerische Staatsgemäldesammlungen, Staatsgalerie Moderner Kunst,
Bayerische Landesbank Collection, Munich

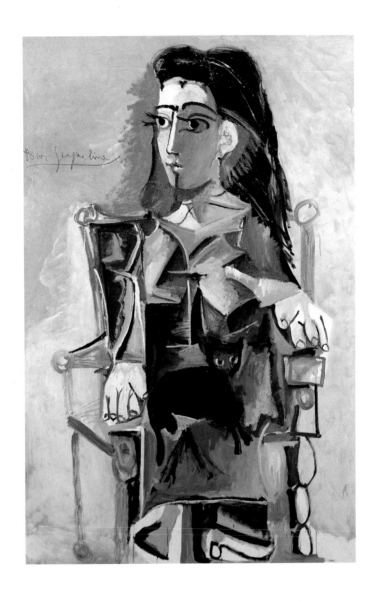

Jacqueline Seated with her Black Cat · 26 February–3 March 1964
Private collection

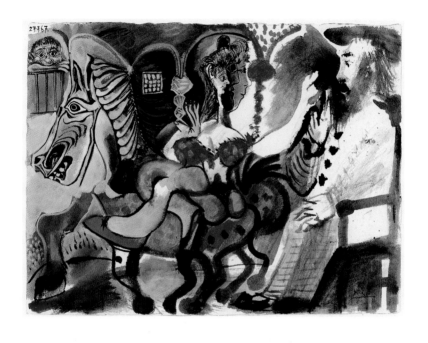

The Circus Rider · 27 July 1967
Private collection

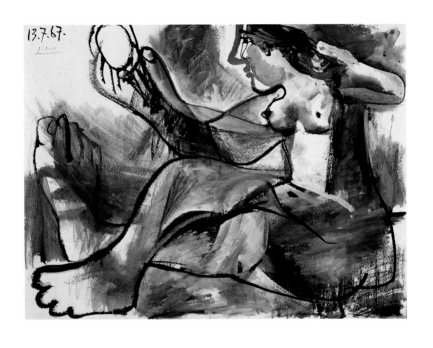

Reclining Nude with a Mirror · 13 July 1967
Picasso Museum, Lucerne

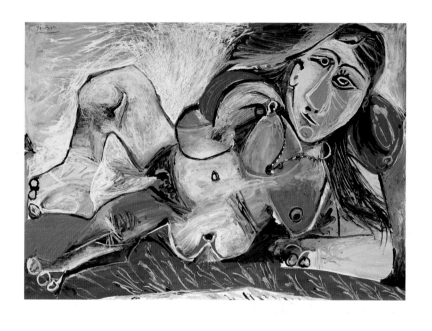

Reclining Nude with a Necklace · 8 October 1968
The Trustees of the Tate Gallery, London

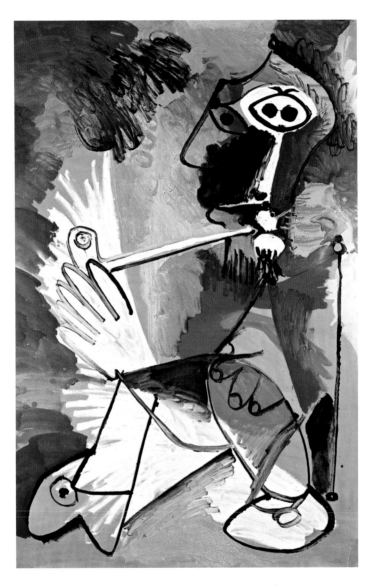

Man with a Pipe · 14 March 1969
Private collection

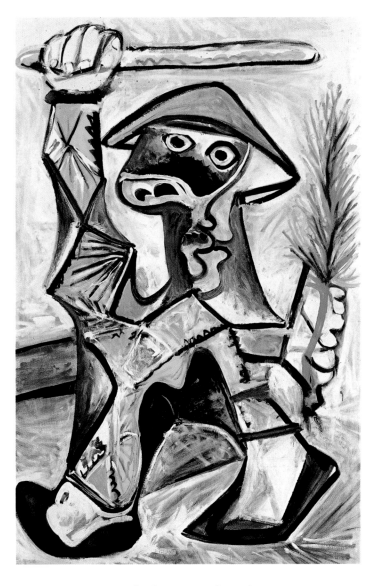

Harlequin · 12 December 1969
Private collection

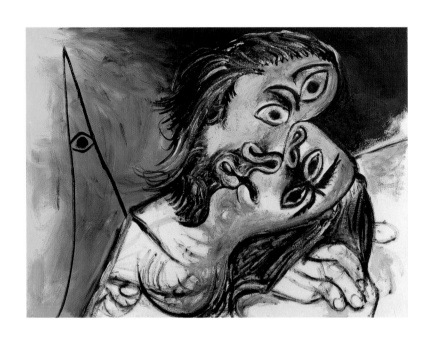

The Kiss · 24 October 1969

Private collection

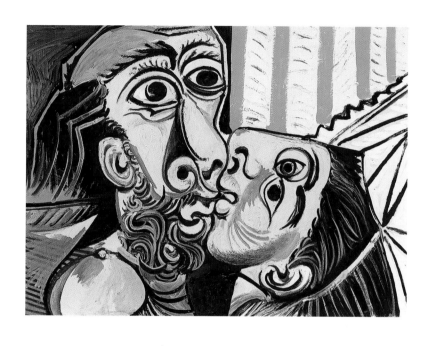

The Kiss · 26 October 1969
Musée Picasso, Paris

397

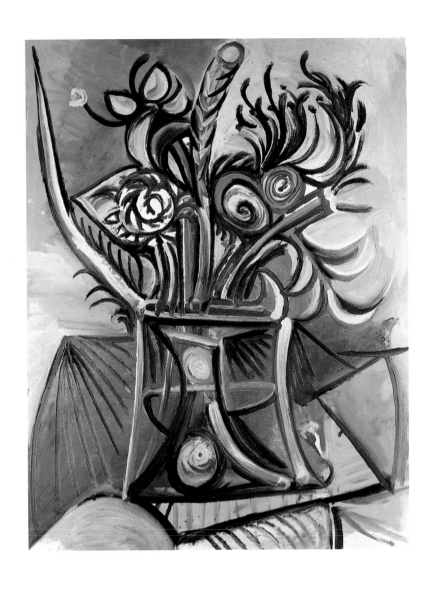

Vase of Flowers on a Table · 28 October 1969
Galerie Beyeler, Basel

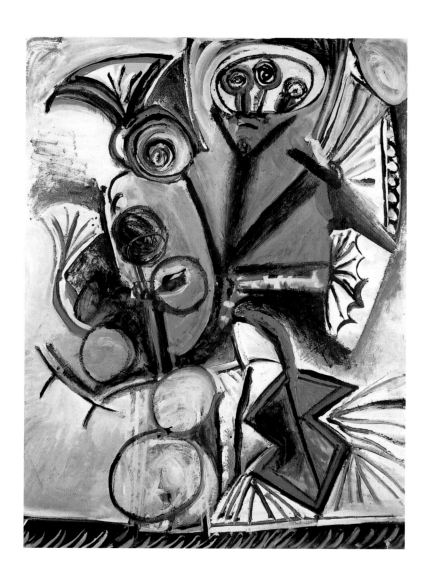

Bouquet of Flowers · 7 November 1969
Private collection, courtesy Galerie Jan Krugier, Ditesheim & Cie, Geneva

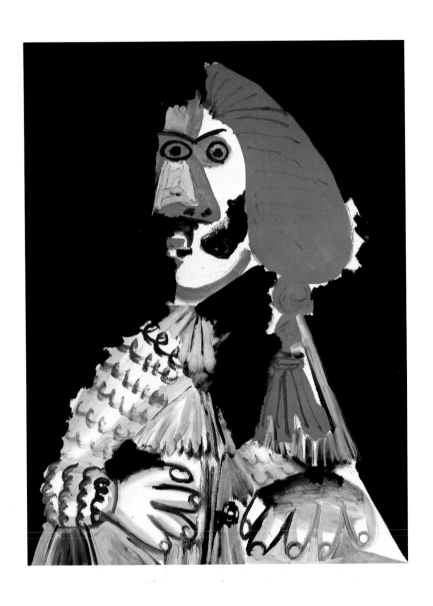

Matador · 4 May 1970
Private collection

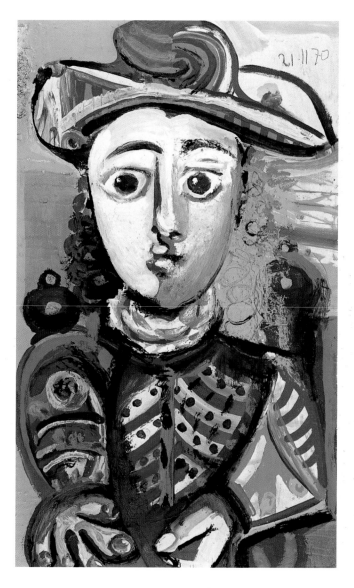

Seated Girl · 21 November 1970

Musée Picasso, Paris

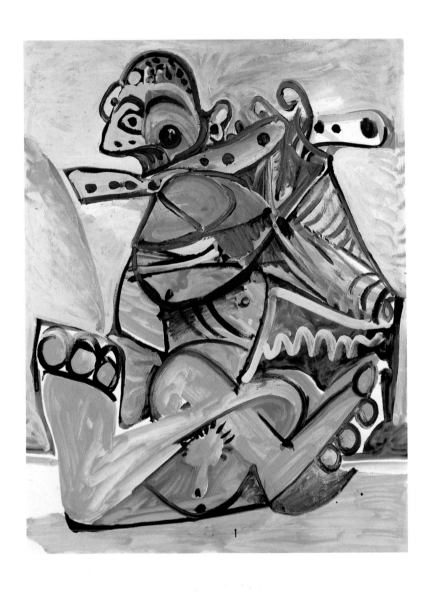

Flute Player · 30 July 1971

Private collection

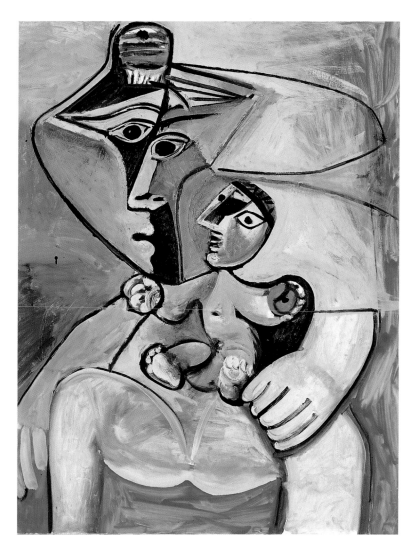

Maternity · 30 August 1971
Musée Picasso, Paris
> **Reclining Nude** · 14–15 November 1971
Private collection

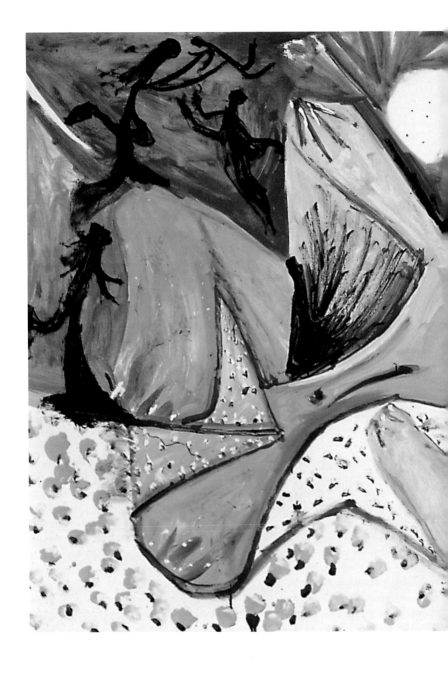

The Young Painter · 14 April 1972

Musée Picasso, Paris

Figure with a Bird · 13 January 1972
Courtesy Thomas Ammann, Fine Art AG, Zurich
> **Landscape** · 31 March 1972
Musée Picasso, Paris

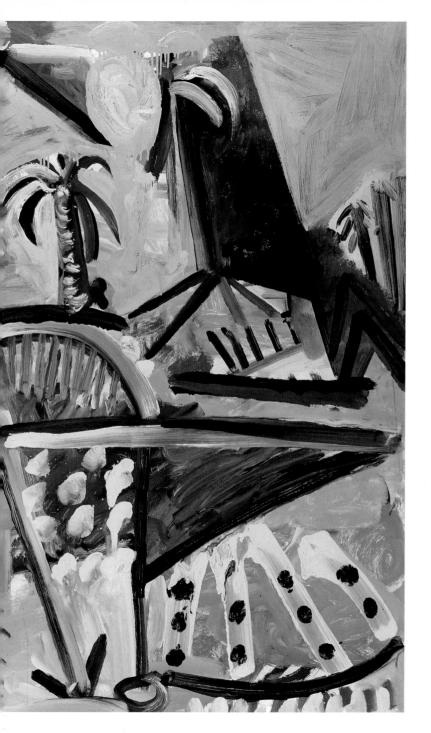

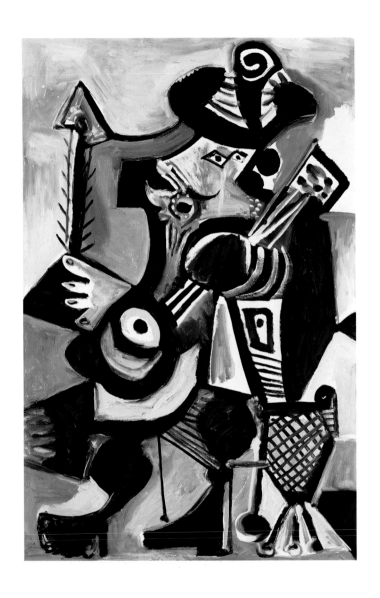

Musician · 26 May 1972

Musée Picasso, Paris

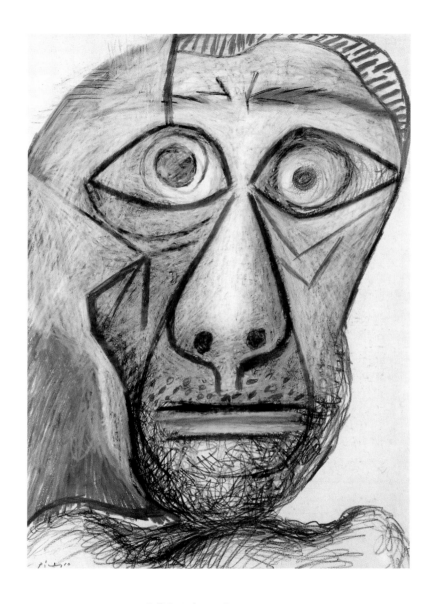

Self-Portrait · 30 June 1972
Fuji Television Gallery, Tokyo

Biographical Chronology

1881 Pablo Picasso is born in Málaga on 25 October. **1895** He attends La Lonja Academy of Fine Arts in Barcelona, where his father has been appointed teacher. **1896** *The First Communion*, his first large oil painting (1895; Museu Picasso, Barcelona), is shown in Barcelona, where Picasso moves into his first studio. **1897** He is accepted at the Real Academia de San Fernando, Madrid, but leaves the Academy, disappointed, in the autumn. **1899** Back in Barcelona from February, he starts frequenting the avant-garde circles of the Els Quatre Gats tavern. **1900** He shares a studio in Barcelona with his friend, the painter Carlos Casagemas. In February he shows 150 drawings at Els Quatre Gats. In October he makes his first trip to Paris with Casagemas, taking over the Montmartre studio of the Catalan painter Isidre Nonell. **1901** Casagemas's suicide in February marks the beginning of Picasso's "Blue Period" (1901–4) in which he explores themes of poverty, old age, loneliness, and the circus world. He meets the poet Max Jacob. In June: first exhibition at Ambroise Vollard. **1902** Hard-pressed for money, Picasso has to move repeatedly, staying temporarily with Max Jacob (87 Boulevard Voltaire); for the same reason he produces mainly drawings. In November: exhibition at Galerie Berthe Weill, Paris. **1904** In April, Picasso settles permanently in Paris, moving into the so-called Bateau-Lavoir (13 Rue Ravignan). The circus world is a major source of inspiration during his "Rose Period" (1903–6). In the autumn he falls in love with Fernande Olivier. **1905** He exhibits his first "rose" paintings at the Galerie Serrurier, Paris. From a short trip to Schoorl, near Alkmaar, in the summer, he returns with a number of portraits, including *Three Dutch Girls* (p.80). The Russian art dealer Sergey Shchukin starts collecting Picasso's work. In October the first public appearance of the Fauves causes a stir at the Salon d'Automne in Paris. **1906** Through Gertrude Stein, Picasso meets Henri Matisse and then André Derain. His style is influenced by the exhibition of Iberian sculpture in the Louvre: *Portrait of Gertrude Stein*; *Self-Portrait with Palette*; *Two Nudes* (pp.91, 92, 95). His financial worries come to an end when Vollard purchases most of his "rose" paintings. At the suggestion of Derain, he visits the ethnographic collections of the Musée du Trocadéro in Paris. **1907** In April and May, Picasso starts work on *Les Demoiselles d'Avignon*, making hundreds of preliminary drawings and studies (pp.104, 106). The painting itself, which was originally meant to depict a brothel scene in Carrer d'Avinyó in Barcelona, is finished in July (pp.104–5) and heralds the breakthrough of Cubism. He meets Daniel-Henry Kahnweiler in the summer and Georges Braque in the fall; Kahnweiler becomes their dealer. **1908** Picasso paints nudes influenced by African sculpture. Critical acclaim for the first joint exhibition of Picasso and Braque organized by Kahnweiler. **1909** Picasso spends the summer with Fernande at Horta de Ebro (now Horta de San Juan). "Analytical Cubism" takes shape in the relief-like fragmentation of landscapes, portraits, and still lifes (pp.116–18). In September he

leaves the Bateau-Lavoir and moves to 11 Boulevard de Clichy, where Braque is one of his neighbors. First exhibition in Germany, organized by Thannhauser. **1910** Portraits of Vollard (Pushkin Museum, Moscow), the German collector and critic Wilhelm Uhde (p.124), and Daniel-Henry Kahnweiler (p.125). Picasso spends the summer with Fernande and the Derains at Cadaqués in the province of Gerona (*The Guitarist*, p.122). Group shows in Budapest, Paris, and—together with Braque—in Düsseldorf, Munich, and London. **1911** Braque and Picasso introduce numbers and letters into their paintings (*The Fan—L'Indépendant*, p.127). In July he makes his first trip to Céret in the Pyrenees. Fernande and Picasso separate. Through Gertrude Stein he meets Eva Gouel (Marcelle Humbert), whom he nicknames "Ma Jolie" in his work (*Woman with a Guitar—Ma Jolie*, p.129). In March: first exhibition in New York of watercolors and drawings from the years 1905–10. **1912** Further exhibitions in London, Barcelona (Galería Dalmau), and Berlin (Der Sturm). Albert Gleizes and Jean Metzinger publish *Du Cubisme*. With Eva Gouel, who has taken the place of Fernande, he goes to Céret in May and then to Avignon. In September he moves into a new studio (242 Boulevard Raspail). The first papiers collés, collages (*Bottle on a Table*, p.133) and assemblages, and the introduction of trompe-l'œil effects in his painting mark the advent of "Synthetic Cubism." In December he enters into a three-year contract with Kahnweiler. Solo and group exhibitions in Moscow, Munich (Der Blaue Reiter), Berlin (Berliner Secession and III. juryfreie Kunstschau), Leipzig, London, and Cologne (Sonderbund). **1913** Apollinaire's *Les peintres cubistes* is published in Paris. Picasso and Eva spend the spring and summer in Céret, where they are joined by Braque, Max Jacob, and Juan Gris. In May his father dies in Barcelona. Picasso has a large retrospective exhibition in Munich (Thannhauser) and participates in the *International Exhibition of Modern Art* in New York, Boston, and Chicago, and further group shows in Budapest (April–May), London (October), Cologne, Prague, and Berlin (December). **1914** He paints still lifes and portraits (*Portrait of a Girl*, p.143) in brighter colors, with planes executed in a pointillist technique. The outbreak of World War I (2 August) ends the Cubist adventure: Braque and Derain are drafted, Apollinaire volunteers, while Kahnweiler's gallery is closed and its stock confiscated. Picasso, who had fled to Italy and then to Switzerland, is back in Paris by the end of October. Major exhibitions in Vienna (Miethke) and (together with Braque) in New York. **1915** Besides realistic portrait drawings of Jacob and Vollard, Picasso executes colorful, geometric compositions expanding the Cubist syntax. He meets the poet Jean Cocteau. Eva dies of tuberculosis in December. Group shows in Rome and Philadelphia in the spring; early paintings in Barcelona in the fall. **1916** The Dada movement is founded in the Cabaret Voltaire, Zürich. Cocteau introduces Picasso to the Russian impresario Sergey Diaghilev of the "Ballets Russes." Picasso designs the sets for the ballet *Parade* (libretto: Cocteau; choreography: Léonide Massine; music: Erik Satie). **1917** In February he travels to Italy to continue work on the sets with the Ballets Russes. *Parade* premieres in May at the Théâtre du Châtelet, Paris. In

Rome, Picasso falls in love with the ballerina Olga Khokhlova who, in the autumn, leaves the Ballets Russes and moves with him to Montrouge (22 Rue Victor Hugo): *Portrait of Olga in an Armchair* (p. 150). **1918** While painting harlequins in a neoclassical style, he also continues his late Cubist experiments (*Harlequin with a Violin*, p. 151). On 12 July, he marries Olga in Paris. Paul Rosenberg becomes his dealer. The Picassos move to a comfortable apartment in Rue La Boétie. **1919** In May he leaves for England in order to work on Diaghilev's ballet *Le Tricorne* (choreography: Massine; music: Manuel de Falla), the first performance of which takes place on 22 July in London's Alhambra Theatre (pp. 159–61). **1920** He works on the costumes and sets for the ballet *Pulcinella* (premiere on 5 May in Paris). Kahnweiler, whose *Der Weg zum Kubismus* has been published in Munich during his exile, returns to Paris and opens a new gallery (Galerie Simon). Picasso finishes realistic portraits in pencil of Igor Stravinsky, Satie, and De Falla. He spends the summer with Olga on the Côte d'Azur (Saint-Raphaël, Juan-les-Pins), painting colorful gouaches based on commedia dell'arte motifs and neoclassical compositions and landscapes. **1921** With the birth of his son Paul, the mother-and-child theme enters his work (pp. 176–7). Maurice Raynal publishes the first Picasso monograph in Munich. During the summer in Fontainebleau, Picasso continues to work in divergent styles, completing *Three Women at the Well* (pp. 170–71) and *Three Musicians* (pp. 172–3). Exhibitions in London in January and in Paris (Rosenberg) in the fall. **1922** The Picassos spend the summer in Dinard, in Brittany (*Mother and Child*; *Two Women Running on the Beach*; pp. 177, 178–9). Picasso designs stage sets and masks for Cocteau's *Antigone*. Exhibition in Munich (Thannhauser) in the fall. In November he is included in the exhibition *Les inconnus* in Kahnweiler's Galerie Simon. **1923** He meets André Breton. In the summer, Picasso, Olga, and Paul go to Cap d'Antibes on the Côte d'Azur (*The Pan-Pipes*, pp. 190–91). Exhibitions in Munich (Thannhauser), New York (Rosenberg), Paris (Simon), and Chicago (Arts Club). **1924** Constructions assembled from painted tinplate and wire (*Guitar*, p. 198) are created alongside monumental still lifes such as *Mandolin and Guitar* and *The Red Carpet* (pp. 199, 196–7). Picasso designs sets and costumes for the ballet *Mercure* (choreography: Massine; music: Satie), which premieres in June at the Théâtre de la Cigale in Paris. He takes *Two Women Running on the Beach* of 1922 (pp. 178–9) as his point of departure for the backdrop of the ballet *Le Train bleu* by Cocteau (choreography: Bronislava Nijinska; music: Darius Milhaud). Breton's *Manifesto of Surrealism* is published in October. The newly founded review *La Révolution Surréaliste* begins to publish work by Picasso. Picasso monograph by Pierre Reverdy. **1925** Tensions build up in Picasso's relationship with Olga. He participates in the first Surrealist group show in Paris (Galerie Pierre) in November. **1926** In January the periodical *Cahiers d'Art* is founded by Christian Zervos, whose thirty-four-volume *Catalogue général illustré de l'œuvre de Picasso* will be published between 1932 and 1978. Picasso paints *The Dress Designer's Workshop* and *The Painter and his Model* (pp. 205, 206) and produces a series of assemblages using objets trouvés. **1927** In January he meets the seventeen-year-old Marie-Thérèse

Walter, who becomes his model and his lover. Juan Gris dies on 11 May. Vollard commissions Picasso to illustrate Honoré de Balzac's *Le Chef-d'œuvre inconnu* (published in 1931). Exhibitions in Berlin (Alfred Flechtheim) in October and Paris (Galerie Pierre) in December. **1928** The Minotaur motif emerges in January (pp. 210–11). Revived contacts with the sculptor Julio González, whom Picasso had met in Barcelona in 1902. González initiates him in the art of metal construction in his Paris studio; together they work on metal and wire constructions. Wilhelm Uhde publishes *Picasso et la tradition française*. **1929** A series of aggressive paintings such as *Head of a Woman with Self-Portrait* (p. 218) reflect the crisis in Picasso's marriage. He meets Salvador Dalí in the spring. **1930** In July he buys a small castle at Boisgeloup (Eure). During the summer in Juan-les-Pins he experiments with sand-covered reliefs. The publisher Albert Skira asks him to illustrate a new edition of Ovid's *Metamorphoses* (published in 1931). Major shows in the United States include those at the Museum of Modern Art, New York, and the Arts Club of Chicago. **1931** In the spring: exhibitions in New York (*Picasso's Abstractions*), in London (*Thirty Years of Pablo Picasso*), and in Paris at Rosenberg's. Picasso makes sculptures of busts and heads at Boisgeloup (pp. 230–31) and paints *The Sculptor* (p. 233) in December. **1932** In the summer he continues work in Boisgeloup, while Olga and Paul go to Juan-les-Pins. Marie-Thérèse poses for a series of paintings of blonde female figures (p. 235). A special Picasso issue of *Cahiers d'Art* accompanies the retrospective exhibition at the Galerie Georges Petit in June–July, which receives a bad press. **1933** In the first part of the year, Picasso executes numerous etchings exploring the themes of the sculptor's studio and the Minotaur. These form the core of what has come to be known as the "Vollard Suite," a series of one hundred plates from the years 1930–37, so named after its publisher. In the autumn, Picasso, fearing Olga's jealous reaction, tries in vain to stop Fernande Olivier's book *Picasso et ses amis* from being published. **1934** Group exhibition with Braque, Gris, and Léger in the Arts Club of Chicago, and one-man shows in Hartford (Connecticut) and Buenos Aires. In August–September he makes a long trip through Spain with Paul and Olga. Back in Paris in the fall, he devotes himself to the bullfight theme in paintings, drawings, and etchings. **1935** In the spring he completes the "Minotauromachy" series of etchings. His marriage with Olga breaks down in June. Jaime Sabartés becomes his secretary. Maya, the daughter of Picasso and Marie-Thérèse, is born on 5 October. Picasso and the poet Paul Eluard become close friends. **1936** Through Eluard he meets the Yugoslavian painter and photographer Dora Maar, with whom he spends the summer in Mougins, in the south of France. When the Spanish Civil War breaks out in July, he takes sides with the Republicans, against General Francisco Franco. A major retrospective starting in January has successive venues in Barcelona, Bilbao, Madrid, Paris, London and New York. Picasso also participates in *Cubism and Abstract Art* in New York (March) and the *International Surrealist Exhibition* in London (June). **1937** Picasso moves into a studio at 7 Rue des Grands-Augustins. On 26 April, the Basque city of Guernica is bombed by a German squadron under Franco's com-

mand. In June he finishes two etchings entitled *The Dream and Lie of Franco* (begun in January). *Guernica* takes shape after numerous drawings and studies (pp. 272–4, 276–7). Soon after its completion, the huge monochrome allegory is shown in the Spanish Pavilion at the Paris Exposition Internationale. Picasso further explores the iconography in paintings such as *Woman in Tears* and *La Suppliante* (pp. 281, 285). The Museum of Modern Art in New York purchases *Les Demoiselles d'Avignon* of 1907 (pp. 104–5). **1939** Picasso's mother dies on 13 January, Ambroise Vollard on 22 July. After the fall of Madrid (28 March), Picasso completes *Cat Catching a Bird* (p. 298). He spends the summer in the south with Dora Maar (*Night Fishing at Antibes*, pp. 296–7). *Picasso: Forty Years of His Art* (November–January 1940; 344 exhibits) is mounted at the Museum of Modern Art, New York. After the outbreak of World War II, Picasso commutes between Paris and Royan on the Atlantic coast. *Guernica* goes on tour in the United States: New York, Los Angeles, Chicago, and San Francisco. **1941** In January, Picasso writes the Surrealist play *Le désir attrapé par la queue*. **1942** The death of Julio González on 27 March inspires him to paint *Still Life with Steer's Skull* and *L'Aubade* (pp. 302–3, 305). Preliminary studies for the sculpture *Man with a Sheep*, which he will finish in 1943 (pp. 308–9). **1943** Picasso meets the twenty-one-year-old Françoise Gilot, the "Femme Fleur" who becomes his model and his lover (p. 317). Exhibitions at Rosenberg's in New York and the Fogg Art Museum in Cambridge, Massachusetts. **1944** Max Jacob dies on 5 March in the Drancy camp. Exhibition at the Sociedad de Arte Moderno in Mexico in June. After the Liberation of Paris (25 August), Picasso returns to his studio in Rue des Grands Augustins. Picasso retrospective at the Salon d'Automne (this year called "Salon de la Libération"). He joins the French Communist Party in October. **1945** He meets the author André Malraux. In the summer he buys a house for Dora Maar in Ménerbes (Vaucluse). In November he is introduced to the Mourlot brothers and produces his first lithographs in their studio. **1946** Picasso moves in with Françoise Gilot, who is pregnant. Dor de la Souchère, the curator of the Musée d'Antibes, offers him rooms at the Palais Grimaldi during October and November. Afterwards, Picasso gives the works he has made there (including *La Joie de Vivre*, pp. 318–19) to the museum, which is renamed Musée Picasso. Death of Gertrude Stein (27 July) and Nusch Eluard (28 November). *Picasso: Fifty Years of his Art* by Alfred H. Barr, an adaptation of the 1939 exhibition catalogue, appears in New York. Sabartés publishes *Picasso: portraits et souvenirs*. **1947** At Jean Cassou's suggestion, Picasso donates ten paintings to the Musée National d'Art Moderne in Paris. Claude, the son of Picasso and Françoise Gilot, is born on 15 May. In August Picasso works in the Ramié pottery workshop in Vallauris. Death of Paul Rosenberg. **1948** First exhibition in Italy during the twenty-fourth Venice Biennale. Picasso continues to perfect his skills as a potter during the summer in Vallauris. At the end of August he attends the Congress of Intellectuals for Peace in Breslau (Wroclaw). He also visits Warsaw, Cracow, and Auschwitz. In November: first major showing of his ceramics at the Maison de la Pensée Française, Paris. **1949** *Sculptures de*

Picasso, with an essay by Daniel-Henry Kahnweiler and photos by Brassaï, is published in January. Aragon chooses *The Dove (La Paloma)* as the poster for the World Peace Congress in Paris in April. Paloma is also the name of Françoise and Picasso's second child, born on 19 April. Exhibitions in March–April in New York (Buchholz), in April in Toronto (Gallery of Arts), and in July in Paris (Maison de la Pensée Française). **1950** Claude and Paloma Picasso become models for their father (p. 336). He makes ceramics and sculptures in a mixed technique, using objets trouvés (*The Goat*, p. 334). On 25 July, the Korean War breaks out. In November, Picasso is awarded the Lenin Prize for Peace. Exhibitions in July–August in Knokke and in November–December in the Maison de la Pensée Française (sculptures and drawings). **1951** Picasso denounces the American invasion in *Massacres in Korea* (pp. 338–9). Large retrospective exhibition in Tokyo on the occasion of the artist's seventieth birthday; sculpture and ceramics are shown in Paris, drawings and watercolors at the Institute of Contemporary Art in London. **1952** Picasso decorates the "Temple de la Paix"—the former chapel of the Château at Vallauris—with the huge *War* and *Peace* murals (pp. 346–7). The relationship with Françoise Gilot falls apart after his meeting with Jacqueline Roque during the summer. Françoise moves with her children to the Rue Gay-Lussac. Paul Eluard dies on 18 November. **1953** Difference of opinion about a portrait of Stalin (d. 5 March) strains relations between Picasso and the French Communist Party. One-man shows in Rome (Galleria Nazionale d'Arte Moderna) and Milan (Palazzo Reale), Lyons, and São Paulo. The painter and his model is the theme of numerous drawings made at Vallauris in November. **1954** Retrospective shows in Munich, Brussels, Amsterdam, Paris, New York, and Chicago. Jacqueline moves in with Picasso. Death of Henri Laurens (5 May), Derain (8 September), and Matisse (3 November). Picasso paints variations on Delacroix's *Women of Algiers* (pp. 354–5). In the next few years he will also draw inspiration from other old and modern masters like Velázquez (pp. 366–9), Rembrandt, and Manet (pp. 375–9). **1955** Olga dies on 11 February. Picasso moves with Jacqueline into the villa La Californie in Cannes (p. 358). Exhibitions in January–February in Houston (Contemporary Arts Association), May–June in London (Marlborough Fine Arts), June–October in Paris (Bibliothèque Nationale), December in Barcelona (Syra). The official retrospective *Picasso: Peintures 1900–1955* is held at the Musée des Arts Décoratifs, Paris (June–October), with successive venues in Munich, Cologne, and Hamburg. **1956** Picasso celebrates his seventy-fifth birthday on 25 October in Vallauris. Ilya Ehrenburg mounts a Picasso show in Moscow. Picasso is one of the signatories of a letter of protest addressed to the French Communist Party in reaction to the invasion of Hungary by Soviet troops. **1957** He paints variations on *Las Meninas* by Velázquez (pp. 366–7, 368–9) and produces the series of etchings "La Tauromaquía." Asked by the United Nations to create a mural for the Paris headquarters of UNESCO, he starts work on *The Fall of Icarus*, which is completed in 1958 (p. 372). Starting in May, retrospective of paintings and sculptures in New York (Museum of Modern Art), Chicago (Art Institute),

and Philadelphia (Museum of Art). **1958** Picasso's sister Lola dies in Barcelona. Several versions of *The Bay of Cannes* (pp. 370–71), interiors of his studio, and numerous paintings of Jacqueline reflect the happiness of the artist's private life. In September he purchases the old Château de Vauvenargues, at the foot of Cézanne's beloved Montagne Sainte-Victoire. **1960** He makes a selection of some hundred paintings from his own collection for the Tate Gallery show organized by Roland Penrose (July–September). Major group show of ceramics by Picasso, Matisse, Chagall, Rouault and Léger in Faenza (August–October). **1961** In March, Picasso and Jacqueline Roque get married in Vallauris. In June they move to Notre-Dame-de-Vie, Mougins. Picasso's eightieth birthday is celebrated with exhibitions at the UCLA Art Gallery, Los Angeles (*Happy Birthday, Mr Picasso*), and at the Museum of Modern Art, New York, in the spring of 1962. David Douglas Duncan's *Picasso's Picassos* contains over a hundred unknown works from Picasso's own collection. **1962** Picasso receives the Lenin Prize for Peace for the second time. **1963** Jacqueline is his model for *Large Profile* (p. 382) and a dozen other portraits, as well as in further paintings on the painter-and-model theme (pp. 384–7, 389). In March the Museu Picasso in Barcelona opens to the public. Beginning of Picasso's collaboration with the prints workshop of the Crommelynck brothers. Braque dies on 31 August, Cocteau on 11 October. **1964** Major retrospective *Picasso and Man* in Toronto and Montreal. Françoise Gilot publishes *Life with Picasso* in collaboration with the critic Carlton Lake; Picasso fails in his attempts to stop the French edition from being published (1965). First multi-venue retrospective in Japan: Tokyo, Kyoto, and Nagoya. Publication of Brassaï's *Conversations avec Picasso* (English edition, Chicago 1999). **1965** Picasso is treated for an ulcer. Exhibitions: *Apollinaire et le cubisme* in Lille and Frankfurt; *Picasso et le théâtre* in Toulouse (Musée des Augustins). **1966** Huge retrospective *Hommage à Pablo Picasso* at three locations in Paris (more than 700 works). André Breton dies on 28 September. **1967** Major exhibitions of sculpture and ceramics at the Tate Gallery, London, and the Museum of Modern Art, New York. **1968–9** In memory of his friend and secretary Jaime Sabartés, who has died in February, Picasso donates the series of paintings after Velázquez's *Las Meninas* to the Museu Picasso in Barcelona (pp. 366–9). The "347 Suite" (consisting of 347 prints) is shown in Paris, Zürich, Hamburg, Cologne, Stockholm, Nagoya, and Toronto. **1970** Picasso also gives the works hitherto kept by his family in Spain to the Museu Picasso. Deaths of Yvonne (January) and Christian Zervos (September). *Picasso: Master Printmaker* (October–November) at the Museum of Modern Art, New York; *The Cubist Epoch* (December–February 1971) at the County Museum of Art, Los Angeles, and the Metropolitan Museum of Art, New York. **1971–2** Picasso's ninetieth birthday is celebrated in a variety of ways and places: he is the first living artist who is given an exhibition at the Louvre. **1973** Picasso dies on 9 April, at the age of ninety-one in Mougins.

Concise Bibliography

Christian Zervos. *Catalogue général illustré de l'œuvre de Picasso*. 33 vols. Paris 1932–78. **Alfred H. Barr, Jr**. *Picasso: Fifty Years of His Art*. New York: Museum of Modern Art, 1946; 2nd ed. 1966; paperback ed. 1974. **John Golding**. *Cubism: A History and an Analysis, 1907–1914*. New York 1959; 3rd ed. Cambridge, Mass., 1988. **David Douglas Duncan**. *Picasso's Picassos*. New York 1961. **Françoise Gilot and Carlton Lake**. *Life with Picasso*. New York 1964; paperback ed. New York 1989. **Pierre Daix, Georges Boudaille, and Joan Rosselet**. *Picasso, The Blue and Rose Periods: A Catalogue of the Paintings, 1900–06*. Greenwich, Conn., 1967. **Georges Bloch**. *Pablo Picasso: Catalogue de l'œuvre gravé et lithographié*. 4 vols. Berne 1968–79. **Douglas Cooper**. *Picasso Theatre*. New York 1968. **Werner Spies**. *Sculptures by Picasso, with a Catalogue of the Works*. New York 1971. **Douglas Cooper**. *The Cubist Epoch*. London 1971. **William Rubin**. *Picasso in the Collections of The Museum of Modern Art*. New York: Museum of Modern Art, 1972; rev. ed. 1980. **Ray Anne Kibbey**. *Picasso, A Comprehensive Bibliography*. New York 1977. **Pierre Daix and Joan Rosselet**. *Picasso, The Cubist Years, 1907–1916: A Catalogue Raisonné of the Paintings and Related Works*. Boston 1979. **Josep Palau i Fabre**. *Picasso, The Early Years, 1881–1907*. New York 1981. **Marie-Laure Bernadac, Michèle Richete, and Hélène Seckel**. *The Picasso Museum, Paris: Paintings, Papiers collés, Picture reliefs, Sculptures, and Ceramics*. New York 1985. **Marie-Laure Bemadac and Androula Michael, eds**. *Pablo Picasso: Collected Writings*. New York 1989. **John Richardson, with Marilyn McCully**. *A Life of Picasso: 1881–1906*. New York 1991; *1907–1917*. New York 1996. **Brassaï**. *Conversations with Picasso*. Chicago 1999.

Index of Works

2 July 1934, oil on canvas, 97 x 130 cm, private collection. **Bust 96**, spring 1907, oil on canvas, 60.5 x 59.2 cm, Musée Picasso, Paris. **Bust of a "Demoiselle d'Avignon" 106**, summer 1907, oil on canvas, 65 x 59 cm, Musée National d'Art Moderne, Centre Georges Pompidou, Paris. **Bust of a Man 100**, spring 1907, oil on canvas, 56 x 46.5 cm, Musée Picasso, Paris. **Bust of a Woman 230**, 1931, bronze (unique cast), 78 x 44.5 x 54 cm, Musée Picasso, Paris. **Bust of a Woman in front of a Still Life 118**, summer 1909, oil on canvas, 92 x 73 cm, private collection. **Bust of a Woman Leaning on an Elbow (Sketchbook, fol. 9r) 182**, 1922, charcoal on paper, 29.5 x 23.2 cm, Musée Picasso, Paris. **Bust of a Woman with Clasped Hands 97**, spring 1907, oil on canvas, 90 x 71 cm, Musée Picasso, Paris. **Café in Royan 299**, 15 August 1940, oil on canvas, 45.7 x 38 cm, Musée Picasso, Paris. **Card Player 139**, winter 1913–14, oil on canvas, 108 x 89.5 cm, The Museum of Modern Art, New York. **Cat Catching a Bird 298**, 22 April 1939, oil on canvas, 81 x 100 cm, Musée Picasso, Paris. **La Celestina 66**, March 1904, oil on canvas, 70 x 56 cm, Musée Picasso, Paris. **The Charnel House 312–313**, 1945, oil and charcoal on canvas, 199.8 x 250.1 cm, The Museum of Modern Art, New York. **The Checked Blouse 332**, 26 March 1949, lithograph, 65 x 50 cm, Musée Picasso, Antibes. **Child Playing with a Toy Truck 342**, 27 December 1953, oil on canvas, 130 x 96.5 cm, Musée Picasso, Paris. **Child with Doves 311**, 24 August 1943, oil on canvas, 162 x 130 cm, Musée Picasso, Paris. **The Circus Rider 391**, 27 July 1967, India ink and gouache on paper, 56.5 x 75 cm, private collection. **Claude and Paloma 336**, 20 January 1950, oil and Ripolin on plywood, 116 x 89 cm, private collection. **Claude Drawing, Françoise and Paloma 349**, 17 May 1954, oil on canvas, 116 x 89 cm, Musée Picasso, Paris. **Clown on a Horse 74**, 1905, oil on cardboard, 100 x 69.2 cm, private collection. **La Coiffure 82**, spring 1906, oil on canvas, 175 x 99.7 cm, The Metropolitan Museum of Art, New York, Catherine Lorillard Wolfe Collection. **La Coiffure 348**, 1954, oil on canvas, 130 x 97 cm, Picasso Museum, Lucerne. **Composition with Minotaur 260**, 9 May 1936, gouache and India ink on paper, 50 x 65 cm, private collection. **Costume design for the ballet "Tricorne": the Madman 160**, 1919, gouache and pencil on paper, 26 x 19.8 cm, Musée Picasso, Paris. **Costume design for the ballet "Tricorne": the Miller 159**, 1919, gouache and pencil on paper, 26 x 19.5 cm, Musée Picasso, Paris. **Costume design for the ballet "Tricorne": the Old Man with Crutches 160**, 1919, gouache and pencil on paper, 26.5 x 19.7 cm, Musée Picasso, Paris. **Costume design for the ballet "Tricorne": the Partner of the Woman from Seville 161**, 1919, gouache and pencil on paper, 27 x 20 cm, Musée Picasso, Paris. **Costume design for the ballet "Tricorne": a Picador 161**, 1919, gouache and pencil on paper, 26.5 x 19.7 cm, Musée Picasso, Paris. **Costume design for the ballet "Tricorne": a Woman 159**, 1919, pencil on paper, 25 x 16 cm, Musée Picasso, Paris. **The Couch 20**, 1899, charcoal, pastel, and colored crayon on paper, varnished, 26.2 x 29.7 cm, Museu Picasso, Barcelona. **Couple and Flowers 46**, 1902–3, ink and watercolor on paper, 17.6 x 23.2 cm, Museu Picasso, Barcelona. **Courtesan with a Jeweled Necklace 30**, 1901, charcoal and watercolor on paper, 65.5 x 54.5 cm, Los Angeles County Museum of Art, Mr. and Mrs. George Gard de Sylva Collection. **The Crucifixion 224–5**, 7 February 1930, oil on plywood, 51.5 x 66.5 cm, Musée Picasso, Paris. **The Dance 201**, June 1925, oil on canvas, 215 x 142 cm, The Tate Gallery, London. **Le Déjeuner sur l'Herbe, after Manet 375**, 12 July 1961, oil on canvas, 81 x 99.8 cm, Musée Picasso, Paris. **Le Déjeuner sur l'Herbe, after Manet 376–7**, 17 June

1961, oil on canvas, 60 x 73 cm, private collection. **Le Déjeuner sur l'Herbe, after Manet 378**, 16 July 1961, oil on canvas, 89 x 116 cm, Picasso Museum, Lucerne. **Le Déjeuner sur l'Herbe, after Manet 379**, 30 July 1961, oil on canvas, 130 x 97 cm, Louisiana Museum of Modern Art, Humlebæk, Denmark. **Les Demoiselles d'Avignon 104–5**, June–July 1907, oil on canvas, 243.9 x 233.7 cm, The Museum of Modern Art, New York. **Design for a drop curtain for the ballet "Pulcinella": Harlequin on the Stage with Dancer and Rider 162**, 1920, oil on paper, 16 x 25 cm, Musée Picasso, Paris. **Design for the cover of "Minotaure" 248**, May 1933, collage of pencil on paper, corrugated cardboard, silver foil, ribbons, plywood, artificial leaves, and drawing pens, 48.5 x 41 cm, The Museum of Modern Art, New York. **The Disinherited Ones 53**, 1903, pastel on paper, 47.5 x 41 cm, Museu Picasso, Barcelona. **The Dress Designer's Workshop 205**, January 1926, oil on canvas, 172 x 256 cm, Musée National d'Art Moderne, Centre Georges Pompidou, Paris. **Dwarf Dancer (La Nana) 28**, 1901, charcoal and watercolor on paper, 102 x 60 cm, Museu Picasso, Barcelona. **The Embrace 49**, 1903, pastel on paper, 98 x 57 cm, Musée de l'Orangerie, Paris, Collection of Jean Walter-Paul Guillaume. **Embrace in an Attic 21**, 1900, oil on cardboard, 51.2 x 55.3 cm, Pushkin Museum, Moscow. **The Enamel Saucepan 314**, 16 February 1945, oil on canvas, 82 x 106 cm, Musée National d'Art Moderne, Centre Georges Pompidou, Paris. **Erotic Scenes 39**, 1902, India ink on paper, 20 x 31.1 cm, Musée Picasso, Paris. **The Factory 117**, summer 1909, oil on canvas, 53 x 60 cm, Hermitage, Saint Petersburg. **The Fall of Icarus 372**, 1958, mural composition, 8 x 10 m, Lobby of the Hall of the Delegates, UNESCO headquarters, Paris. **Family by the Sea 180**, summer 1922, oil on panel, 17.6 x 20.2 cm, Musée Picasso, Paris. **Family of Acrobats with a Monkey 71**, 1905, India ink, gouache, watercolor, and pastel on cardboard, 104 x 75 cm, Göteborgs Konstmuseum, Göteborg. **The Fan (L'Indépendant) 127**, summer 1911, oil on panel, 61 x 50 cm, private collection. **Fat Clown Seated 74**, 1905, ink and watercolor on paper, 14.3 x 7.8 cm, Marina Picasso Collection, Galerie Jan Krugier, Ditesheim & Cie, Geneva. **Faun Unveiling a Woman 262**, 12 June 1936, etching and aquatint, 31.6 x 41.7 cm, The Museum of Modern Art, New York. **Female Nude against a Red Background 93**, summer–autumn 1906, oil on canvas, 81 x 54 cm, Musée de l'Orangerie, Paris, Collection of Jean Walter-Paul Guillaume. **La Femme Fleur 317**, 5 May 1946, oil on canvas, 146 x 89 cm, private collection. **Figure with a Bird 407**, 13 January 1972, oil on canvas, 146 x 114 cm, Courtesy Thomas Ammann, Fine Art AG, Zurich. **Figures by the Sea 226**, 12 January 1931, oil on canvas, 130 x 195 cm, Musée Picasso, Paris. **Figures by the Sea 240**, 1932, oil and charcoal on canvas, 130 x 97 cm, Museo Nacional Centro de Arte Reina Sofía, Madrid. **Flute Player 402**, 30 July 1971, oil on canvas, 146 x 114 cm, private collection. **Françoise Gilot against a Gray Background 335**, 19 November 1950, lithograph, 63 x 48 cm, Musée Picasso, Antibes. **Friendship 109**, 1907–8, oil on canvas, 152 x 101 cm, Hermitage, Saint Petersburg. **Girl at her Dressing Table 26**, 1900, pastel on paper, 48 x 53 cm, Museu Picasso, Barcelona. **Girl in a Hat with her Hands Crossed 168**, 1920–1921, pastel and charcoal on paper, 105 x 75 cm, Musée Picasso, Paris. **Girl with a Basket of Flowers (Flower of the Streets) 78**, 1905, oil on canvas, 152 x 65 cm, private collection. **Girl with a Mandolin (Fanny Tellier) 121**, spring 1910, oil on panel, 100.3 x 73.6 cm, The Museum of Modern Art, New York. **The Glass of Beer (Sabartés) 35**, 1901, charcoal and watercolor on paper, 82 x 66 cm,

Pushkin Museum, Moscow. **The Goat 334**, 1950, bronze, 120.5 x 72 x 144 cm, Musée Picasso, Paris. **Goat's Skull, Bottle and Candle 340**, 25 March 1952, oil on canvas, 89 x 116 cm, Musée Picasso, Paris. **Guernica 276–7**, 1 May–4 June 1937, oil on canvas, 349.3 x 776.6 cm, Museo Nacional Centro de Arte Reina Sofía, Madrid. **Guitar 198**, 1924, construction: cut-out and folded metal sheet, tin box, and steel wire, painted, 111 x 63.5 x 26.6 cm, Musée Picasso, Paris. **Guitar "J'aime Eva" 132**, summer 1912, oil on canvas, 35 x 27 cm, Musée Picasso, Paris. **Guitar on a Table 134**, autumn 1912, oil, sand, and charcoal on canvas, 51.1 x 61.6 cm, Hood Museum of Art, Dartmouth College, Hanover. **The Guitarist 122**, summer 1910, oil on panel, 100 x 73 cm, Musée National d'Art Moderne, Centre Georges Pompidou, Paris. **Harlequin 145**, autumn 1915, oil on canvas, 183.5 x 105 cm, The Museum of Modern Art, New York. **Harlequin 149**, 1917, oil on canvas, 116 x 90 cm, Museu Picasso, Barcelona. **Harlequin 395**, 12 December 1969, oil on canvas, 195 x 130 cm, private collection. **Harlequin (Portrait of the Painter Jacint Salvadó) 188**, 1923, oil on canvas, 130 x 97 cm, Kunstmuseum, Basel. **Harlequin and Woman with Necklace 147**, 1917, oil on canvas, 200 x 200 cm, Musée National d'Art Moderne, Centre Georges Pompidou, Paris. **Harlequin with a Violin ("Si tu veux") 151**, 1918, oil on canvas, 142 x 100.3 cm, The Cleveland Museum of Art. **Head of a Woman 106**, spring–summer 1907, oil on canvas, 64.5 x 50 cm, Národní Gallery, Prague. **Head of a Woman 220**, 1929–30, iron, metal plate, painted springs, and sieves, 100 x 37 x 59 cm, Musée Picasso, Paris. **Head of a Woman 230**, 1931, bronze, 86 x 32 x 48.5 cm, Musée Picasso, Paris. **Head of a Woman 231**, 1931, bronze (unique cast), 128.5 x 54.5 x 62.5 cm, Musée Picasso, Paris. **Head of a Woman or a Sailor 100**, spring 1907, oil on cardboard, 53.5 x 36.2 cm, Musée Picasso, Paris. **Head of a Woman with Self-Portrait 218**, February 1929, oil on canvas, 71 x 60.5 cm, private collection. **Homage to the Spaniards who Died for France 321**, 1946–7, oil on canvas, 195 x 130 cm, Museo Nacional Centro de Arte Reina Sofía, Madrid. **Horse before a Landscape 278**, 23 October 1937, pastel, pencil, and India ink on paper, 29 x 43 cm, private collection. **Houses on the Hill, Horta de Ebro 116**, summer 1909, oil on canvas, 65 x 81 cm, The Museum of Modern Art, New York. **Interior (Woman Painter and Nude in the Studio) 345**, 21 January 1954, India ink wash on paper, 23.5 x 31 cm, Mr. and Mrs. Daniel Saidenberg Collection, New York. **Interior of Els Quatre Gats 25**, 1900, oil on canvas, 41 x 28 cm, private collection. **Jacqueline in a Rocking Chair 353**, 9 October 1954, oil on canvas, 115 x 145 cm, private collection. **Jacqueline in the Studio 365**, 13 November 1956, gouache and India ink on a Spitzer reproduction transfer of the painting *The Woman in the Studio* of April 3, 1956, 63.5 x 80.8 cm, Musée Picasso, Paris. **Jacqueline Seated with her Black Cat 390**, 26 February–3 March 1964, oil on canvas, 194 x 128.5 cm, private collection. **Jacqueline with a Black Shawl 352**, 11 October 1954, oil on canvas, 92 x 73 cm, private collection. **Jacqueline with Crossed Hands 351**, 3 June 1954, oil on canvas, 116 x 88.5 cm, private collection. **Jacqueline with Flowers 350**, 2 June 1954, oil on canvas, 100 x 81 cm, private collection. **Jaime Sabartés Seated 23**, 1900, charcoal and watercolor on paper, 50.5 x 33 cm, Museu Picasso, Barcelona. **La Joie de Vivre (Antipolis) 318–19**, 1946, oil on fiberboard, 120 x 250 cm, Musée Picasso, Antibes. **Jug: Face of a Woman 344**, 10 July 1953, white clay, with incisions and engobe decoration, partly glazed, H: 35 cm, Galerie Beyeler, Basel. **The Kiss 219**, 25 August 1929, oil on canvas, 22 x 14 cm, Musée Picasso,

Paris. **The Kiss 232**, 12 January 1931, oil on canvas, 61 x 50.5 cm, Musée Picasso, Paris. **The Kiss 396**, 24 October 1969, oil on canvas, 97 x 130 cm, private collection. **The Kiss 397**, 26 October 1969, oil on canvas, 97 x 130 cm, Musée Picasso, Paris. **The Kitchen 324**, 9 November 1948, oil on canvas, 175 x 250 cm, The Museum of Modern Art, New York. **The Kitchen 325**, November 1948, oil on canvas, 175 x 252 cm, Musée Picasso, Paris. **Landscape 408-9**, 31 March 1972, oil on canvas, 130 x 162 cm, Musée Picasso, Paris. **Landscape with Two Figures 114**, autumn 1908, oil on canvas, 60 x 73 cm, Musée Picasso, Paris. **Large Bather 167**, 1921-2, oil on canvas, 180 x 98 cm, Musée de l'Orangerie, Paris, Collection of Jean Walter-Paul Guillaume. **Large Bather with a Book 270**, 18 February 1937, oil, pastel, and charcoal on canvas, 130 x 97.5 cm, Musée Picasso, Paris. **Large Profile 382**, 7 January 1963, oil on canvas, 130 x 97 cm, Kunstsammlung Nordrhein-Westfalen, Düsseldorf. **Lola, Picasso's Sister 17**, 1899, oil on canvas, 46.7 x 37.5 cm, The Cleveland Museum of Art. **The Lovers 62**, August 1904, pen, India ink, pencil, and watercolor on paper, 39.5 x 26.9 cm, Musée Picasso, Paris. **The Lovers 154**, 1919, oil on canvas, 185 x 140.5 cm, Musée Picasso, Paris. **The Lovers 192**, 1923, oil on canvas, 130 x 97 cm, The National Gallery of Art, Washington D.C. Chester Dale Collection. **The Madman 61**, 1904, blue watercolor on wrapping paper, 85 x 35 cm, Museu Picasso, Barcelona. **Man Holding a Horse 279**, 23 October 1937, India ink and pastel on paper, 29 x 43 cm, private collection. **Man in a Straw Hat with Ice Cream Cone 293**, 30 August 1938, oil on canvas, 61 x 46 cm, Musée Picasso, Paris. **Man Watching a Sleeping Woman 184**, 1922, pencil and oil on panel, 19 x 24 cm, private collection. **Man with a Guitar 130**, autumn 1911 and spring 1912, oil on canvas, 154 x 77.5 cm, Musée Picasso, Paris. **Man with a Mandolin 128**, autumn 1911, oil on canvas, 162 x 71 cm, Musée Picasso, Paris. **Man with a Pipe 394**, 14 March 1969, oil on canvas, 195 x 130 cm, private collection. **Man with a Sheep 309**, February–March 1943, bronze, 222.5 x 78 x 78 cm, Musée Picasso, Paris. **Mandolin and Guitar 199**, summer 1924, oil and sand on canvas, 140.6 x 200.2 cm, Solomon R. Guggenheim Museum, New York. **Marie-Thérèse 287**, 7 January 1938, oil on canvas, 61 x 46 cm, private collection. **Marie-Thérèse with a Garland 267**, 6 February 1937, oil on canvas, 61 x 46 cm, private collection. **Massacres in Korea 338-9**, 18 January 1951, oil on plywood, 110 x 210 cm, Musée Picasso, Paris. **Matador 400**, 4 May 1970, oil on canvas, 116 x 89 cm, private collection. **Maternity 403**, 30 August 1971, oil on canvas, 162 x 130 cm, Musée Picasso, Paris. **Maternity by the Sea 45**, 1902, oil on canvas, 83 x 60 cm, private collection. **Las Meninas 366-367**, 17 August 1957, oil on canvas, 194 x 260 cm, Museu Picasso, Barcelona. **Las Meninas (Infanta Margarita Maria) 368**, 14 September 1957, oil on canvas, 100 x 81 cm, Museu Picasso, Barcelona. **Las Meninas (Isabel de Velasco) 367**, 30 December 1957, oil on canvas, 33 x 24 cm, Museu Picasso, Barcelona. **Menu for Els Quatre Gats 24**, 1900, pen and color crayon on paper, 22 x 16 cm, private collection. **Minotaur 211**, 1 January 1928, charcoal and papel stuck to canvas, 139 x 230 cm, Musée National d'Art Moderne, Centre Georges Pompidou, Paris. **Minotaur 251**, 12 November 1933, India ink on paper, 34 x 51.4 cm, Musée des Beaux-Arts, Dijon. **Minotaur 282**, 7 December 1937, pen, India ink, charcoal, and pencil on paper, 57 x 38.5 cm, Musée Picasso, Paris. **Minotaur Abducting a Woman 250**, 28 June 1933, India ink wash on paper, 47 x 62 cm, Musée Picasso, Paris. **Minotaur and Dead Mare before a Cave Facing a Girl in a Veil 261**, 9 May 1936, gouache and India ink on paper, 50 x 65 cm,

Musée Picasso, Paris. **The Mistletoe Seller 47**, 1902–3, gouache on paper, 55 x 38 cm, private collection. **Mother and Child 101**, summer 1907, oil on canvas, 81 x 60 cm, Musée Picasso, Paris. **Mother and Child 176**, 1922, Pencil on paper, 30.5 x 42 cm, Musée Picasso, Paris. **Mother and Child 177**, summer 1922, oil on canvas, 100 x 81.1 cm, Baltimore Museum of Art, The Cone Collection. **The Muse 256–7**, 1935, oil on canvas, 130 x 162 cm, Musée National d'Art Moderne, Centre Georges Pompidou, Paris. **Musician 410**, 26 May 1972, oil on canvas, 194.5 x 129.5 cm, Musée Picasso, Paris. **Night Fishing at Antibes 296–7**, August 1939, oil on canvas, 205.7 x 345.5 cm, The Museum of Modern Art, New York, Mrs. Simon Guggenheim Collection. **Nude (page from a sketchbook) 229**, 31 August 1931, pencil and ink on paper, 32.3 x 25.4 cm, The Museum of Fine Arts, Boston, Arthur Mason Knopp Fund. **Nude Boy 94**, autumn 1906, oil on canvas, 67 x 44 cm, Musée Picasso, Paris. **Nude in a Turkish Hat 360**, 1 December 1955, oil on canvas, 116 x 89 cm, Musée National d'Art Moderne, Centre Georges Pompidou, Paris. **Nude in the Garden 254**, 4 August 1934, oil on canvas, 162 x 130 cm, Musée Picasso, Paris. **Nude Seen from Behind (Sketchbook, fol. 11r) 183**, 1922, charcoal on paper, 29.5 x 23.2 cm, Musée Picasso, Paris. **Nude with a Bouquet of Irises and a Mirror 252**, 22 May 1934, oil on canvas, 162 x 130 cm, Musée Picasso, Paris. **Nude with a Towel 108**, winter 1907–8, oil on canvas, 116 x 89 cm, private collection. **Nude with Crossed Hands 81**, summer 1906, gouache on canvas, 96.5 x 75.6 cm, The Art Gallery of Ontario, Toronto, gift of Sam and Ayala Zacks. **Nude with Crossed Legs 51**, 1903, pastel on paper, mounted on canvas, 57 x 43 cm, Fondation Socíndec, Martigny. **Nude with Drapery 107**, summer–autumn 1907, oil on canvas, 152 x 101 cm, Hermitage, Saint Petersburg. **Nude with Raised Arms, Profile View 112**, spring 1908, oil on panel, 67 x 25.5 cm, private collection. **Nude Woman Seated in a Red Armchair 239**, 1932, oil on canvas, 130 x 97 cm, Musée Picasso, Paris. **Odalisque, after Ingres 103**, summer 1907, blue ink and gouache over pencil on paper, 47.7 x 62.5 cm, Musée Picasso, Paris. **The Old Guitarist 54**, 1903, oil on panel, 122.3 x 82.5 cm, The Art Institute of Chicago. **The Old Jew 55**, 1903, oil on canvas, 125 x 92 cm, Pushkin Museum, Moscow. **Olga in a Pensive Mood 195**, 1923, pastel and black pencil on paper, 104 x 71 cm, Musée Picasso, Paris. **Owl-Shaped Vase 328**, 1949, white clay, with incisions and engobe decoration, 49 x 36 x 33 cm, Musée Picasso, Antibes. **The Painter and his Model 142**, summer 1914, oil and pencil on canvas, 58 x 55.9 cm, Musée Picasso, Paris. **The Painter and his Model 206**, 1926, oil on canvas, 172 x 256 cm, Musée Picasso, Paris. **The Painter and his Model 384–5**, 3 and 8 April 1963, oil on canvas, 130 x 195 cm, Museo Nacional Centro de Arte Reina Sofía, Madrid. **The Painter and his Model 386**, 29 March and 1 April 1963, oil on canvas, 130 x 162 cm, Galerie Beyeler, Basel. **The Painter and his Model 387**, 30 March 1963, oil on canvas, 130 x 162 cm, Museo Nacional Centro de Arte Reina Sofía, Madrid. **The Painter and his Model 389**, 10 and 12 June 1963, oil on canvas, 195 x 130 cm, Bayerische Staatsgemäldesammlungen, Staatsgalerie Moderner Kunst, Bayerische Landesbank Collection, Munich. **Painter and Model 209**, 1928, oil on canvas, 128.8 x 163 cm, The Museum of Modern Art, New York. **The Pan-Pipes 190–91**, summer 1923, oil on canvas, 205 x 174 cm, Musée Picasso, Paris. **Paulo as Harlequin 204**, 1925, oil on canvas, 130 x 97.5 cm, Musée Picasso, Paris. **Paulo Drawing 186**, 1923, oil on canvas, 130 x 97.5 cm, Musée Picasso, Paris. **Paulo, the Artist's Son, at Age Two 193**, 1923, oil on canvas, 100 x

81 cm, private collection. **Peace 346-7**, 1954, oil on hardboard, 4.7 x 10.2 m, Chapel of the Château, Temple de la Paix, Vallauris. **Pierrot 153**, 1918, oil on canvas, 92.7 x 73 cm, The Museum of Modern Art, New York. **Pierrot and Columbine 27**, autumn 1900, oil on panel, 38 x 46 cm, private collection. **Playing Ball on the Beach 215**, 15 August 1928, oil on canvas, 24 x 34.9 cm, Musée Picasso, Paris. **The Port of Cadaqués 123**, summer 1910, oil on canvas, 38 x 45.5 cm, Národní Gallery, Prague. **Portrait of a Girl 143**, summer 1914, oil on canvas, 130 x 97 cm, Musée National d'Art Moderne, Centre Georges Pompidou, Paris. **Portrait of a Woman 280**, 8 December 1937, oil on canvas, 55 x 46 cm, private collection. **Portrait of Benedetta Canals 69**, 1905, oil on canvas, 88 x 68 cm, Museu Picasso, Barcelona. **Portrait of Daniel-Henry Kahnweiler 125**, autumn–winter 1910, oil on canvas, 100.6 x 72.8 cm, The Art Institute of Chicago, Gift of Mrs. Gilbert W. Chapman, in memory of Charles R. Goodspeed. **Portrait of Dora Maar 265**, 1937, oil on canvas, 92 x 65 cm, Musée Picasso, Paris. **Portrait of Dora Maar 304**, 9 October 1942, oil on canvas, 92 x 73 cm, private collection. **Portrait of Gertrude Stein 91**, spring–summer 1906, oil on canvas, 100 x 81.3 cm, The Metropolitan Museum of Art, New York. **Portrait of Jacqueline 362**, 13 February 1957, collage and charcoal on paper, 64 x 50 cm, private collection. **Portrait of Josep Cardona 16**, 1899, oil on canvas, 100 x 63 cm, private collection. **Portrait of Madame P. (Hélène Parmelin) 341**, 1952, oil on plywood, 145.5 x 96.5 cm, private collection. **Portrait of Marie-Thérèse 264**, 6 January 1937, oil on canvas, 100 x 81 cm, Musée Picasso, Paris. **Portrait of Marie-Thérèse 266**, 21 January 1937, oil on canvas, 41 x 33 cm, private collection. **Portrait of Max Jacob 98**, winter 1907, gouache on paper, 62.7 x 48 cm, Museum Ludwig, Cologne, Ludwig Collection. **Portrait of Olga 174**, 1921, pastel and charcoal on paper mounted on canvas, 127 x 96.5 cm, Musée Picasso, Paris (on deposit at the Musée de peinture et de sculpture de Grenoble). **Portrait of Olga in an Armchair 150**, autumn 1917, oil on canvas, 130 x 88.8 cm, Musée Picasso, Paris. **Portrait of Señora Soler 58**, 1903, oil on canvas, 100 x 73 cm, Staatsgalerie Moderner Kunst, Munich. **Portrait of Wilhelm Uhde 124**, spring 1910, oil on canvas, 81 x 60 cm, private collection. **The Prostitute 29**, 1901, oil on cardboard, 69.5 x 57 cm, Museu Picasso, Barcelona. **Prostitutes at a Bar 43**, 1902, oil on canvas, 80 x 91.5 cm, Hiroshima Museum of Art. **Reading the Letter 19**, 1899–1900, charcoal and watercolor on paper, 48 x 63 cm, Musée Picasso, Paris. **Reading the Letter 175**, 1921, oil on canvas, 184 x 105 cm, Musée Picasso, Paris. **Reclining Man and Seated Woman 306**, 13 December 1942, India ink on paper, 50 x 65 cm, private collection. **Reclining Man and Seated Woman 307**, 1942, India ink on paper, 51 x 66 cm, private collection. **Reclining Nude 110**, spring 1908, oil on panel, 27 x 21 cm, Musée Picasso, Paris. **Reclining Nude 236-7**, 4 April 1932, oil on canvas, 130 x 161.7 cm, Musée Picasso, Paris. **Reclining Nude 388**, 9 and 18 January 1964, oil on canvas, 64 x 100 cm, Rosengart Collection, Lucerne. **Reclining Nude 404-5**, 14–15 November 1971, oil on canvas, 130 x 195 cm, private collection. **Reclining Nude before a Window 364**, 29–31 August 1956, oil on canvas, 130 x 162 cm, Stedelijk Museum, Amsterdam. **Reclining Nude with a Mirror 392**, 13 July 1967, India ink and gouache on paper, 56 x 75 cm, Picasso Museum, Lucerne. **Reclining Nude with a Necklace 393**, 8 October 1968, oil and lacquer paint on canvas, 113.5 x 161.7 cm, The Trustees of the Tate Gallery, London. **Reclining Woman 337**, 1951, pen and wash on plywood, unknown, private collection. **Reclining Woman Reading 294**, 21 January 1939, oil

on canvas, 96.5 x 130 cm, Musée Picasso, Paris. **Rectangular Plate Decorated with a Bunch of Grapes and Scissors 323**, 1948, white clay, stamped form, decorated with blue wash, incised with impressions of fingers, redecorated with wash and white enamel, all covered with brushwork, 31 x 37.2 x 4 cm, Musée Picasso, Paris. **Rectangular Plate Decorated with Corrida 329**, 1949, white clay, painted, 32 x 38 cm, Musée Picasso, Antibes. **Rectangular Plate Decorated with Corrida 329**, 1949, white clay, painted, 32 x 38 cm, Musée Picasso, Antibes. **Rectangular Plate Decorated with Corrida 330**, 1949, white clay, painted, 32 x 38 cm, Musée Picasso, Antibes. **Rectangular Plate Decorated with Corrida 330**, 1949, white clay, painted, 32 x 38 cm, Musée Picasso, Antibes. **Rectangular Plate Decorated with Corrida 331**, 1949, white clay, painted, 32 x 38 cm, Musée Picasso, Antibes. **Rectangular Plate Decorated with the Head of a Faun 323**, 20 October 1947, white clay, stamped form, decorated with wash, white enamel, and incisions, all coated by dipping in paint, 32 x 38.2 x 3.5 cm, Musée Picasso, Paris. **The Red Carpet 196–7**, 1924, oil on canvas, 98.5 x 131.5 cm, private collection. **Running Minotaur 210**, 1 January 1928, oil on canvas, 162.5 x 130 cm, Musée Picasso, Paris. **Salomé 76**, 1905, drypoint, 40 x 34.8 cm, Musée Picasso, Paris. **The Saltimbanques 75**, 1905, oil on canvas, 212.8 x 229.6 cm, The National Gallery of Art, Washington D.C. Chester Dale Collection. **Science and Charity 15**, 1895–6, oil on canvas, 197 x 249.4 cm, Museu Picasso, Barcelona. **The Sculptor 233**, 7 December 1931, oil on plywood, 128.5 x 96 cm, Musée Picasso, Paris. **The Sculptor and his Model 247**, 2 April 1933, etching, 19.3 x 26.8 cm, Musée Picasso, Paris. **Sculptor and Model with Statue of Centaur Kissing a Girl (Vollard Suite No. 58) 246**, 31 March 1933, etching, 19.3 x 26.8 cm. **Sculptor and Reclining Model at Window Viewing a Sculptured Torso (Vollard Suite No. 53) 244–5**, 30 March 1933, etching, 19.3 x 26.7 cm. **Sculptor and Seated Model before a Sculptured Head (Vollard Suite No. 45) 242**, 23 March 1933, etching, 26.8 x 19.4 cm. **The Sculptor and the Statue 249**, 20 July 1933, pen, watercolor, and gouache on paper, 39 x 49.5 cm, private collection. **Sculptural Head 238**, 1932, charcoal on canvas, 92 x 73 cm, Galerie Beyeler, Basel. **Seated Bather by the Sea 225**, early 1930, oil on canvas, 163.5 x 129.5 cm, The Museum of Modern Art, New York, Mrs. Simon Guggenheim Collection. **Seated Bather Drying her Feet 169**, summer 1921, pastel on paper, 66 x 50.8 cm, Berggruen Collection, Berlin. **Seated Girl 401**, 21 November 1970, oil on plywood, 130.3 x 80.3 cm, Musée Picasso, Paris. **Seated Harlequin (Portrait of the Painter Jacint Salvadó) 187**, 1923, tempera on canvas, 130 x 97 cm, Musée National d'Art Moderne, Centre Georges Pompidou, Paris. **Seated Harlequin with Mirror 189**, 1923, oil on canvas, 100 x 81 cm, Museo Thyssen-Bornemisza, Madrid. **Seated Male Nude 115**, winter 1908–9, oil on canvas, 96 x 76 cm, Musée d'Art Moderne, Villeneuve-d'Ascq. **Seated Man, Girl with Monkey and Apple 345**, 26 January 1954, watercolor on paper, 24 x 32 cm, private collection. **Seated Nude 68**, 1905, oil on cardboard, 106 x 76 cm, Musée National d'Art Moderne, Centre Georges Pompidou, Paris. **Seated Nude 120**, winter 1909–10, oil on canvas, 92 x 73 cm, The Tate Gallery, London. **Seated Nude 373**, 1959, oil on canvas, 146 x 114.2 cm, private collection. **Seated Nude, Back View 42**, 1902, oil on canvas, 46 x 40 cm, private collection. **Seated Woman 166**, 1920, oil on canvas, 92 x 65 cm, Musée Picasso, Paris. **Seated Woman 208**, 1927, oil on canvas, 129.9 x 97.2 cm, The Museum of Modern Art, New York. **Seated Woman 286**, 1938, oil on canvas, 98 x 77.5 cm, Musée

National d'Art Moderne, Centre Georges Pompidou, Paris. **Seated Woman 289**, 27 April 1938, ink, gouache, and colored chalk on paper, 76.5 x 55 cm, Galerie Beyeler, Basel. **Seated Woman 316**, 5 March 1945, oil on canvas, 131.5 x 81 cm, Musée Picasso, Paris. **Seated Woman in a Garden 291**, 10 December 1938, oil on canvas, 131 x 97 cm, private collection. **Seated Woman in a Hat 194**, 1923, charcoal and chalk on canvas, unknown, private collection. **Seated Woman in a Hat 295**, 27 May 1939, oil on canvas, 81 x 54 cm, Musée Picasso, Paris. **Seated Woman in a Hat 374**, 27 January 1961, oil on panel, 117 x 89 cm, Rosengart Collection, Lucerne. **Seated Woman in a Yellow and Green Hat 380**, 2 January 1962, oil on canvas, 162 x 130 cm, private collection. **Sebastià Junyer Vidal with a Woman 56**, June 1903, oil on canvas, 126.4 x 94 cm, Los Angeles County Museum of Art. **Self-Portrait 22**, 1899–1900, charcoal and watercolor on paper, 22.5 x 16.5 cm, Museu Picasso, Barcelona. **Self-Portrait 36**, late 1901, charcoal and watercolor on paper, 81 x 60 cm, Musée Picasso, Paris. **Self-Portrait 99**, spring 1907, oil on canvas, 50 x 46 cm, Národní Gallery, Prague. **Self-Portrait 411**, 30 June 1972, pencil and colored crayons on paper, 65.7 x 50.5 cm, Fuji Television Gallery, Tokyo. **Self-Portrait with Palette 92**, spring–summer 1906, oil on canvas, 92 x 73 cm, The Philadelphia Museum of Art, E.A. Gallatin Collection. **The Shadow 343**, 29 December 1953, oil and charcoal on canvas, 129.5 x 96.5 cm, Musée Picasso, Paris. **Sleeping Peasants 156**, 1919, tempera, watercolor, and crayon on paper, 31.1 x 48.9 cm, The Museum of Modern Art, New York. **Sleeping Woman (Contemplation) 62**, autumn 1904, pen and watercolor on paper, 36.8 x 27 cm, private collection. **Sleeping Woman with Shutters 259**, 25 April 1936, oil and charcoal on canvas, 54.4 x 65.2 cm, Musée Picasso, Paris. **The Sleepy Drinker 40**, 1902, oil on canvas, 80 x 62 cm, Kunstmuseum, Berne. **Small Seated Nude 102**, summer 1907, oil on panel, 17.6 x 15 cm, Musée Picasso, Paris. **The Soler Family (Le Déjeuner sur l'Herbe) 59**, summer 1903, oil on canvas, 150 x 200 cm, Musée d'Art Moderne, Liège. **The Soup 52**, 1903, oil on canvas, 38.5 x 46 cm, The Art Gallery of Ontario, Toronto. **Standing Nude 320**, 28 June 1946, colored crayons on paper, 51 x 32.5 cm, Musée Picasso, Paris. **Standing Nude, Front View 112**, spring 1908, oil on canvas, 67 x 26.7 cm, private collection. **Still Life on a Table in front of an Open Window 155**, 26 October 1919, gouache on paper, 15.9 x 10.5 cm, Musée Picasso, Paris. **Still Life with a Black Bull, Book, Palette and Chandelier 292**, 19 November 1938, oil on canvas, 97 x 130 cm, private collection. **Still Life with a Lamp 263**, 29 December 1936, oil on canvas, 97 x 130 cm, Musée Picasso, Paris. **Still Life with a Violin and a Glass of Bass 136**, 1913–14, oil on canvas, 81 x 75 cm, Musée National d'Art Moderne, Centre Georges Pompidou, Paris. **Still Life with an Antique Bust 203**, summer 1925, oil on canvas, 97 x 130 cm, Musée National d'Art Moderne, Centre Georges Pompidou, Paris. **Still Life with Bust, Bowl and Palette 234**, 3 March 1932, oil on canvas, 130.5 x 97.5 cm, Musée Picasso, Paris. **Still Life with Candle 315**, 21 February 1945, oil on canvas, 92.2 x 73 cm, Musée Picasso, Paris. **Still Life with Glass and Card Game (Homage to Max Jacob) 141**, 1914, graphite pencil, gouache, and papier collé on paper, 35 x 46 cm, Berggruen Collection, Berlin. **Still Life with Pitcher and Apples 157**, 1919, oil on canvas, 65 x 43 cm, Musée Picasso, Paris. **Still Life with Steer's Skull 305**, 5 April 1942, oil on canvas, 130 x 97 cm, Kunstsammlung Nordrhein-Westfalen, Düsseldorf. **Student with a Newspaper 135**, winter 1913–14, oil and sand on canvas, 73 x 59.5 cm, private collection. **Studies for "Guer-**

nica": **Hooves and Heads of a Horse 273**, 10 May 1937, pencil on paper, 45.4 x 24.3 cm, Museo Nacional Centro de Arte Reina Sofía, Madrid. **Studies of Couple Embracing and Heads 48**, 1902–3, ink on paper, 55 x 38 cm, Marina Picasso Collection, courtesy Galerie Jan Krugier, Ditesheim & Cie, Geneva. **The Studio 217**, 1928–9, oil on canvas, 162 x 130 cm, Musée Picasso, Paris. **The Studio 359**, 23 October 1955, oil on canvas, 195 x 130 cm, Picasso Museum, Lucerne. **The Studio at La Californie, Cannes 358**, 29 October 1955, oil on canvas, 114 x 146 cm, Musée Picasso, Paris. **Studio with Plaster Head 202**, summer 1925, oil on canvas, 98.1 x 131.2 cm, The Museum of Modern Art, New York. **Study for "Guernica" 274–5**, 9 May 1937, pencil on paper, 24 x 45.3 cm, Museo Nacional Centro de Arte Reina Sofía, Madrid. **Study for "Guernica": Horse and Mother with Dead Child 272**, 8 May 1937, pencil on paper, 24.1 x 45.4 cm, Museo Nacional Centro de Arte Reina Sofía, Madrid. **Study for "Les Demoiselles d'Avignon" 104**, May 1907, charcoal on paper, 47.6 x 65 cm, Kunstmuseum, Basel. **Study for "Man with a Sheep" 308**, 19 February 1943, India ink and wash on paper, 66 x 50.2 cm, Musée Picasso, Paris. **La Suppliante 285**, 18 December 1937, gouache and ink on panel, 24 x 18.5 cm, Musée Picasso, Paris. **Susanna and the Elders 356**, 1955, oil on canvas, 80 x 190 cm, private collection. **Tanagra with Amphora 331**, 1949, white clay, with incisions and engobe decoration, 45 x 33 x 11 cm, Musée Picasso, Antibes. **Three Dutch Girls 80**, summer 1905, gouache and ink on paper and cardboard, 77 x 66 cm, Musée National d'Art Moderne, Centre Georges Pompidou, Paris. **Three Heads 322**, 1 November 1947, India ink, 33 x 50.5 cm, Galerie Louise Leiris, Paris. **Three Musicians 172**, summer 1921, oil on canvas, 203 x 188 cm, The Philadelphia Museum of Art, E.A. Gallatin Collection. **Three Musicians 173**, summer 1921, oil on canvas, 200.7 x 222.9 cm, The Museum of Modern Art, New York, Mrs. Simon Guggenheim Collection. **Three Women at the Well 170**, 1921, red chalk on canvas, 200 x 161 cm, Musée Picasso, Paris. **Three Women at the Well 171**, 1921, oil on canvas, 203.9 x 174 cm, The Museum of Modern Art, New York. **La Toilette 83**, spring–summer 1906, oil on canvas, 151 x 99 cm, Albright-Knox Art Gallery, Buffalo. **Torso of Sleeping Woman (Repose) 113**, spring–summer 1908, oil on canvas, 81.3 x 65.5 cm, The Museum of Modern Art, New York. **The Tragedy 57**, 1903, oil on panel, 105.4 x 69 cm, The National Gallery of Art, Washington D.C. Chester Dale Collection. **The Two Brothers 84**, spring–summer 1906, oil on canvas, 143 x 97 cm, Kunstmuseum, Basel. **The Two Brothers 85**, spring 1906, oil on canvas, 80 x 59 cm, Musée Picasso, Paris. **Two Figures and a Cat 50**, 1902–3, watercolor, crayon, and pencil on paper, 18 x 26.5 cm, Museu Picasso, Barcelona. **Two Nudes 95**, autumn–winter 1906, oil on canvas, 151.3 x 93 cm, The Museum of Modern Art, New York. **Two Nudes on the Beach 271**, 1 May 1937, India ink and gouache on panel, 22 x 27 cm, Musée Picasso, Paris. **The Two Sisters (The Meeting) 44**, 1902, oil on canvas, 152 x 100 cm, Hermitage, Saint Petersburg. **Two Women in an Interior 255**, 12 February 1935, oil on canvas, 130 x 195 cm, The Museum of Modern Art, New York. **Two Women on a Bed 77**, 1905, India ink on paper, 21 x 15.5 cm, private collection. **Two Women on the Beach 361**, 6 February–26 March 1956, oil on canvas, 195 x 260 cm, Musée National d'Art Moderne, Centre Georges Pompidou, Paris. **Two Women Running on the Beach (The Race) 178–9**, summer 1922, gouache on plywood, 32.5 x 41.1 cm, Musée Picasso, Paris. **Two Youths 86**, spring–summer 1906, oil on canvas, 157 x 117 cm, Musée de l'Orangerie, Paris, Collection of Jean

Walter-Paul Guillaume. **Two Youths 87**, spring–summer 1906, oil on canvas, 151.5 x 93.7 cm, The National Gallery of Art, Washington D.C. Chester Dale Collection. **Unhappy Mother and Child 72**, early 1905, gouache on canvas, 88 x 69.5 cm, Staatsgalerie, Stuttgart. **Vase of Flowers on a Table 398**, 28 October 1969, oil on canvas, 116 x 89 cm, Galerie Beyeler, Basel. **Vase: Woman in a Mantilla 328**, 1949, white clay, thrown and modeled piece; decorated with wash, 47 x 12.5 x 9.5 cm, Musée Picasso, Paris. **Le Vert-Galant 310**, 25 June 1943, oil on canvas, 64.5 x 92 cm, Musée Picasso, Paris. **La Vie 60**, May 1903, oil on canvas, 197 x 127.3 cm, The Cleveland Museum of Art. **The Village Dance 181**, 1922, fixed pastel and oil on canvas, 139.5 x 85.5 cm, Musée Picasso, Paris. **Violin 140**, winter 1913–14, papier collé and charcoal on newspaper, 62 x 47 cm, Musée National d'Art Moderne, Centre Georges Pompidou, Paris. **Violin 144**, 1915, construction, metal sheet cut out, folded, and painted, iron wire, 100 x 63.7 x 18 cm, Musée Picasso, Paris. **Woman at a Bidet 46**, 1902–3, ink and watercolor on paper, 19.8 x 13 cm, Museu Picasso, Barcelona. **Woman at the Mirror 235**, 14 March 1932, oil on canvas, 162.3 x 130.2 cm, The Museum of Modern Art, New York. **Woman at the Mirror 268–9**, 16 February 1937, oil on canvas, 130 x 195 cm, Kunstsammlung Nordrhein-Westfalen, Düsseldorf. **The Woman in a Bonnet 32**, 1901, oil on canvas, 41.3 x 33 cm, Museu Picasso, Barcelona. **Woman in a Chemise 67**, 1904, oil on canvas, 72.5 x 60 cm, The Tate Gallery, London. **Woman in a Chemise in an Armchair 138**, autumn 1913, oil on canvas, 148 x 99 cm, private collection. **Woman in a Hairnet 288**, 12 January 1938, oil on canvas, 65 x 54 cm, private collection. **Woman in a Mantilla (La Salchichona) 148**, 1917, oil on canvas, 116 x 89 cm, Museu Picasso, Barcelona. **Woman in a Straw Hat against a Flowered Background 290**, 25 June 1938, oil on canvas, 73 x 60 cm, Rosengart Collection, Lucerne. **Woman in a Turkish Jacket 353**, 20 November 1955, oil on canvas, 81 x 100 cm, private collection. **Woman in an Armchair 146**, early 1916, watercolor and gouache on paper, 20 x 23 cm, private collection. **Woman in an Armchair 207**, summer 1927, oil on canvas, 131 x 97 cm, Musée Picasso, Paris. **Woman in an Armchair I 326**, 17 December 1948, lithograph, 69.1 x 51.1 cm, Musée Picasso, Paris. **Woman in an Armchair I (The Polish Coat) 327**, 1949, lithograph (final state), 70 x 55 cm, Musée Picasso, Paris. **Woman in Blue 31**, 1901, oil on canvas, 133.5 x 101 cm, Museo Nacional Centro de Arte Reina Sofía, Madrid. **Woman in Tears 281**, 26 October 1937, oil on canvas, 60 x 49 cm, private collection. **Woman in the Garden 221**, 1929–30, soldered and painted steel, 206 x 117 x 85 cm, Musée Picasso, Paris. **Woman Ironing 65**, 1904, oil on canvas, 116.2 x 73 cm, Solomon R. Guggenheim Museum, New York. **Woman Seated before the Window 284**, 11 March 1937, oil and pastel on canvas, 130 x 97.3 cm, Musée Picasso, Paris. **Woman Seated near the Window (Jacqueline) 363**, 11 June 1956, oil on canvas, 162 x 130 cm, The Museum of Modern Art, New York. **Woman Throwing a Stone 228**, 8 March 1931, oil on canvas, 130.5 x 195.5 cm, Musée Picasso, Paris. **Woman with a Crow 63**, 1904, gouache and pastel on paper, 60.5 x 45.5 cm, private collection. **Woman with a Fan 111**, late spring 1908, oil on canvas, 152 x 101 cm, Hermitage, Saint Petersburg. **Woman with a Guitar ("Ma Jolie") 129**, winter 1911–12, oil on canvas, 100 x 65.4 cm, The Museum of Modern Art, New York. **Woman with a Helmet of Hair 64**, 1904, gouache on cardboard, 42.9 x 31.2 cm, The Art Institute of Chicago, Gift of Kate L. Brewster. **Woman with a Shawl 41**, 1902, oil on canvas, 63 x 52.4 cm, private collection. **The Woman with a Tam-**

bourine 200, 1925, oil on canvas, 97 x 130 cm, Musée de l'Orangerie, Paris, Collection of Jean Walter-Paul Guillaume. **Woman with a Watch 258,** 30 April 1936, oil on canvas, 65 x 54.2 cm, Musée Picasso, Paris. **Woman with an Artichoke 301,** summer 1941, oil on canvas, 195 x 130 cm, Museum Ludwig, Cologne. **Woman with Loaves 88,** spring–summer 1906, oil on canvas, 100 x 69.8 cm, The Philadelphia Museum of Art. **Woman with Pigeons 222,** 1930, oil on canvas, 200 x 185 cm, Musée National d'Art Moderne, Centre Georges Pompidou, Paris. **Women at the Well 33,** 1901, oil on canvas, 81 x 65 cm, private collection. **Women in Striped Stockings 38,** 1902, India ink on paper, 20 x 31 cm, private collection. **The Women of Algiers, after Delacroix 354–5,** 14 February 1955, oil on canvas, 114 x 146 cm, private collection. **Wounded Faun 283,** 31 December 1937, oil and charcoal on canvas, 46 x 55 cm, private collection. **Wounded Faun and Woman 212,** 1 January 1928, oil and charcoal on canvas, 46 x 55 cm, private collection. **Young Boy with a Crayfish 300,** 21 June 1941, oil on canvas, 130 x 97.3 cm, Musée Picasso, Paris. **The Young Girl with Bare Feet 14,** 1895, oil on canvas, 75 x 50 cm, Musée Picasso, Paris. **Young Gosolan Wearing a Barretina Hat 90,** spring–summer 1906, gouache and watercolor on paper, 61.5 x 48 cm, Göteborgs Konstmuseum, Göteborg. **Young Man Dressed as Pierrot 185,** 27 December 1922, gouache and watercolor on paper, 11.8 x 10.5 cm, Musée Picasso, Paris. **The Young Painter 406,** 14 April 1972, oil on canvas, 91 x 72.5 cm, Musée Picasso, Paris. **Young Sculptor at Work (Vollard Suite No. 46) 243,** 25 March 1933, etching, 26.7 x 19.3 cm.

Photo Credits

Albright-Knox Art Gallery, Buffalo; The Art Gallery of Ontario, Toronto; The Art Institute of Chicago; Baltimore Museum of Art; Berggruen Collection, Berlin; The Bridgeman Art Library, London; Chapel of the Château, Temple de la Paix, Vallauris; The Cleveland Museum of Art; Fondation Socindec, Martigny; Fuji Television Gallery, Tokyo; Galerie Beyeler, Basel; Galerie Louise Leiris, Paris; Göteborgs Konstmuseum, Göteborg; Lobby of the Hall of the Delegates, UNESCO headquarters, Paris; Hermitage, Saint Petersburg; Hiroshima Museum of Art; Hood Museum of Art, Dartmouth College, Hanover; Kunstmuseum, Basel; Kunstmuseum, Berne; Kunstsammlung Nordrhein-Westfalen, Düsseldorf; Los Angeles County Museum of Art; Louisiana Museum of Modern Art, Humlebæk (Denmark); Mr. and Mrs. Daniel Saidenberg Collection, New York; Mrs. John Hay Whitney Collection; Marina Picasso Collection, Galerie Jan Krugier, Ditesheim & Cie, Geneva; The Metropolitan Museum of Art, New York; Musée d'Art Moderne, Villeneuve-d'Ascq; Musée d'Art Moderne, Liège; Musée de l'Orangerie, Paris; Musée des Beaux-Arts, Dijon; Musée National d'Art Moderne, Centre Georges Pompidou, Paris; Musée Picasso, Antibes; Musée Picasso, Paris; Museo Nacional Centro de Arte Reina Sofía, Madrid; Museo Thyssen-Bornemisza, Madrid; Museu Picasso, Barcelona; Museum Ludwig, Cologne; The Museum of Fine Arts, Boston; The Museum of Modern Art, New York; Národní Gallery, Prague; The National Gallery of Art, Washington D.C.; Norman Granz Collection, Beverly Hills; The Philadelphia Museum of Art; Picasso Museum, Lucerne; Pushkin Museum, Moscow; RMN Réunion des Musées Nationaux, Paris; Rosengart Collection, Lucerne; Scala, Florence; Solomon R. Guggenheim Museum, New York; Staatsgalerie Moderner Kunst, Munich; Staatsgalerie, Stuttgart; Stedelijk Museum, Amsterdam; The Tate Gallery, London.

First published in the United States of America in 2003
By UNIVERSE PUBLISHING
A Division of Rizzoli International Publications, Inc.
300 Park Avenue South
New York, NY 10010

Designed by Griet Van Haute and Johnny Bekaert

Cover: *Self-Portrait with Palette* (detail, see p. 92), spring–summer 1906, The Philadelphia
Museum of Art, E. A. Gallatin Collection, and *Harlequin*, autumn 1915, The Museum
of Modern Art, New York
Frontispiece: *Large Nude in a Red Armchair*, 5 May 1929, Musée Picasso, Paris

Color separations: Die Keure, Bruges
Printed in China
Library of Congress Control Number: 2002115770
ISBN 0-7893-0879-7